SWIMMING WITH
DALI

SWIMMING WITH
DALI

AND OTHER ENCOUNTERS
WITH ARTISTS

Edward Mullins

UNICORN

FOR ANNE

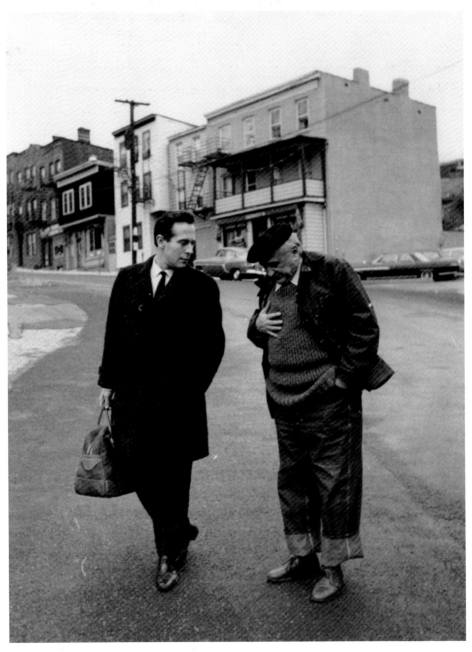

Edwin Mullins and Jacques Lipchitz.
Hastings-on-Hudson, USA, 1964

Contents

Preface

I am a journalist who loves art. And for much of my working life I have managed to put the two together – as art critic for various national newspapers and magazines, chairing radio programmes such as Kaleidoscope and Critics Forum, and scripting and presenting documentary films for television in this country and in France and Germany. During these years it has given me the greatest pleasure to get to know many of the leading artists of our time, and in some cases to have become friends with them.

This book is an account of my personal memories of some of those artists. I think of it as a collection of portrait-sketches, and these vary both in size and texture. Some trace a working relationship and friendship over a span of many years; others are more like snapshots taken at an unguarded moment. But each belongs to a particular time in my life, and I value them all.

Here, then, is my private Gallery of Artists.

It begins on the most personal of notes, with this frontispiece. The Goan-Indian artist Francis Newton Souza was the first painter to become a close friend, and he became the subject of my first book in 1962. Two years earlier Francis had been a guest at my wedding and presented me with this drawing, inscribed on the back with the following words:

'King Edwin playing the lute to his bride.'

Henry Moore

HENRY MOORE was the most courteous of men. It was as though his role as unofficial ambassador for British art throughout the world bestowed on him a certain regal modesty. I was on the receiving end of that courtesy any number of times over the course of more than twenty years, until his death in the 1980s. The first of such occasions embarrasses me when I think about it. In the late-50s, to add a note of adventure to a routine job as junior sub-editor on the *Illustrated London News*, I became the English editor of one

of those heroic little literary magazines that flourished bravely in the post-war years. It was entitled *Two Cities,* and it was published by a Mauritian poet-friend of mine in Paris, which did give the mSunagazine a certain exotic *chic* when I hawked it round London bookshops in my rucksack on my way to work.

Not having a penny to offer contributors, we relied on their goodwill and latent vanity. If they declined to send us anything to publish my second line of attack was to ask if I could perhaps interview them. This invariably won – which meant that in either event we could put their names on the jacket. In this way we netted some of the literary lions of the day, among them Lawrence Durrell, Henry Miller, William Golding, Aldous Huxley, C. P. Snow and William Burroughs.

But I was keen to include eminent figures in the art world, starting at the top. So I wrote to Henry Moore. Might he consider setting down his thought processes when planning a major new sculpture, I suggested? (I repeat, I now wince.) Another artist would have ignored such pretentious cheek. Not Henry. 'Dear Mr. Mullins,', he answered on March 21st 1960, 'I am sorry to have been so long replying to your invitation to contribute to *Two Cities.* I am awfully sorry not to be able to do so.' He explained that he was 'very much behind with my sculpture. So I do hope you will understand, because I very much appreciate that you should have invited me.'

It was five years before I actually met Henry. By this time I was the art critic for *The Sunday Telegraph* and was keen to write an article about the huge bronze reclining figure Moore had been commissioned to create for the Lincoln Centre in New York, to stand in a large water basin in front of the building. I contacted Henry and he invited me to his house in Much Hadham, in the Hertfordshire countryside to the north of London. He greeted me warmly in his rich Yorkshire accent and while we talked he showed me round the large studio in the grounds where the two-piece figure for the Lincoln Centre had been made, then to the tiny studio within the house where Moore made his maquettes. Here he showed me the original idea for the sculpture in the palm of his hand – with a laugh as he did so. 'Scale is a matter of where you look at it,' he explained, holding the figure up to the window so that it appeared huge against the far landscape.

Irina, Henry's wife, brought us tea in the sitting room and, as I gazed round the room, I caught sight of a small painting of a ship in full sail which a mere glance told me must be by Alfred Wallis. I told Henry I was writing a book about Wallis, which seemed to please him. Herbert Read had given it to him, he explained, and he would be delighted if I wanted to include it in my book.

I left in a glow of warmth and pleasure at having spent an afternoon with one of the most natural and engaging people I had ever worked with. Then, in October that year, 1965, I received a letter from Henry assuring me he would be 'glad to get the little Alfred Wallis painting photographed for you.' He had just returned from New York, he explained, where the Lincoln Centre ceremony for his reclining figure in the water basin had gone well, 'except there was a water shortage in New York and they had to buy water from another county to fill the pool' – which he suspected may have cost as much as his sculpture (a speculation I found myself questioning, knowing the cost of an Henry Moore bronze).

We met intermittently over the next two years, always with the warmest of greetings. Then I encountered one of the hazards of being a journalist as well as a friend of artists. The news editor of *The Sunday Telegraph* rang and asked for my comment as the paper's art critic on a story that was about to break, now being handled by a reporter I knew to be *The Telegraph's* most ruthless news-hound. The story leaked to the paper was Henry Moore's decision to leave the bulk of his estate to the nation; his sculpture to go to the Tate Gallery in London and to a foundation to be established as a charity for educational purposes. This news put me on the spot. I knew the reporter in question and had seen him in action before. I was convinced that right now he would be doing everything in his power to drag Henry's extraordinarily generous gift through the mud by claiming it was just a way of avoiding death duties and that the charity was a 'front' for a bunch of cronies at the Tate Gallery to have lots of 'freebies' at the tax-payer's expense.

I rang the news editor back and suggested that if I could persuade Henry Moore to talk to me I would be happy to write the story myself. He agreed, and I immediately called Henry from a phone box to explain the situation. The piece duly appeared the following Sunday under my name. A week later the other 'quality' Sundays suggested I should be handed a D-Notice for having disregarded an unwritten code of confidentiality among critics. Then, on March 16th 1967, I received a handwritten letter from Henry. 'Dear Edwin Mullins,' it began, 'I realise that the story of my gift to the Tate was bound to break sooner or later. So I am glad that it came to *The Sunday Telegraph* and that the editor asked you to write about it.' He added that he was very relieved with the way I had presented the facts. 'Thank you for having taken so much care and trouble with it. With all best wishes, Henry.' I felt bruised and kept a certain distance from my fellow critics for a while.

The following year was Henry's 70th birthday and the BBC asked me to do a radio interview with him to mark the occasion. I was in the studio with the producer running over the questions to ask him when the receptionist at Broadcasting House rang to

announce that 'a Mr Moore' was here. Henry was duly escorted to the studio where he greeted me with a cheery 'Ullo!' He proved to be a joy to interview because he invariably reacted as though he had never before been asked those same old questions about 'truth to materials' and the relation of sculpture to architecture, or had even thought about such matters. His answers had a freshness which always suggested he was enjoying himself. I certainly was. And the conversation continued over lunch when I took him to one of my favourite restaurants, The Gay Hussar in Soho.

A leading topic over lunch was the large retrospective of his life's work which the Tate Gallery was mounting that summer, and which I knew I would be writing about for *The Sunday Telegraph*. In his typically understated way, Henry still made it clear that the exhibition was the crowning accolade of his career. Then, before we parted, he thanked me for the interview and for the lunch and suggested I come down to Much Hadham. He'd enjoy showing me his new work, he said, and in particular his 'hill', he added with a chuckle. I was mystified, but took him up on his offer and arranged to drive down the following week.

It was clear when I arrived that the Moore industry was in full production in spite of the Tate exhibition opening in a few weeks. The temporary studio in the garden was partly open to reveal a massive bone-like shape in plaster which he had been working on that morning, he explained. Back in the small indoor studio where he made his maquettes and kept the bits and pieces of flint and bone, Henry showed me the massive elephant skull Sir Julian Huxley had given him and which had found a new life in several monumental sculptures. But what Henry most wanted to show me was a sheaf of photographs of marble figures, some free-standing, some badly damaged, others forming a frieze on the façade of a church, or an entire pulpit. I shook my head. I could get as far as 'early Italian'. Then I tried 'Donatello?' Henry shook his head. 'Not bad. Giovanni Pisano. I discovered him as a student. No one knows about him.' This made me feel better. 'Now I've persuaded Thames and Hudson to do a book on him,' he went on. 'These are the photographs specially taken for it. What d'you think?'

Thanks to Henry this was my introduction to a sculptor I came to admire as one of the greatest artists of the Early Renaissance. As he said on that afternoon in his studio – 'Pisano brought drama into his figures even though they are still, just as Masaccio did, and Michelangelo, but not many others.' The book came out in 1969, most of it the work of Michael Ayrton who, like Moore, a sculptor who hugely admired Pisano. Their enthusiasm sent me travelling to Italy at the earliest opportunity to see his work,

in Pisa, Pistoia and Siena. I wrote a feature about him for the *Telegraph Magazine,* and even managed to persuade BBC Television to let me present a short documentary on his sculpture – all as a result of that chance conversation in Henry Moore's studio.

Henry had wanted to show me his 'hill'. Now came the moment. We went outside again down the length of his garden past the large studio. Then I saw what he meant. In the neighbouring field rose what might have been a tumulus or an Iron Age long-barrow. It was clearly man-made and right on top rested a Henry Moore reclining figure. There was a boyish look on Henry's face as he told me the story. He had needed permission from the council to construct it, he explained; the planning committee had asked why it was so important for him to see his work in that kind of perspective. And he had explained that most of his large commissions came from abroad and he needed to be able to test the appropriate size and scale of a piece outside the confines of his studio. As he described this need for perspective I remembered him holding a tiny maquette up against the sky the first time I came here, when he had stressed the importance of scale. Now he had built his own horizon. 'The committee then asked me about those "foreign commissions",' Henry explained, 'and how much tax I reckoned to pay in a year as a result.' The boyish expression turned to one of modest pride as he went on – 'and when I told them they were amazed!'

Before long I had good reason to recall Henry's words about perspective and how important it was to see a work of sculpture in relation to the place for which it has been commissioned. They came back to me over the coming years when I studied Giovanni Pisano's majestic carvings for the façade of Siena cathedral, for the fountain in Perugia, and for the great marble pulpits in the Tuscan cathedrals of Pisa and Pistoia.

On a lighter note, Henry's words about the context of sculpture also invaded my thoughts not long after that memorable session in Henry's garden. The Greek cultural authorities persuaded him that the link between his own work and classical Greek art and architecture could be emphasised by a Henry Moore exhibition to be mounted in a public park in Athens in the very shadow of the Acropolis (even without the Elgin Marbles). By courtesy of Olympic Airways I was invited to the opening, which was a lavish affair with long and ponderous speeches. On my return to London I managed to resist informing readers of *The Sunday Telegraph* that I had enjoyed the ultimate aesthetic experience of appreciating the Parthenon through a hole in a Henry Moore.

I became aware that Henry could be all too accessible, and that I was at times guilty of exploiting that openness. Ever since the story I had broken of his gift to the Tate I found myself cast as something of a go-between. Henry would ring me from time to time seeking

my view on some intrusive journalist from Australia or Japan who kept pestering him. I felt honoured that he trusted me. At the same time I enjoyed having something of a 'hot line' to Henry. I presented a number of arts programmes on radio during the 70s, and BBC producers were forever asking 'could we get Henry Moore?' I'd then phone him. There would be the usual warm 'Ullo! And he would generally agree. 'Fix a time with Mrs Tinsley (his secretary),' was the usual response. It was in the days when interviewers away from Broadcasting House were conducted by means of a cumbersome tape-recorder called a Uher. I had been trained to operate the monster, but a producer I greatly liked called Helen Rapp refused to believe this, and insisted on accompanying me to Much Hadham to ask Henry about something I have entirely forgotten. What I have not forgotten is that Henry gave a brilliant dissertation, whereupon Helen announced she had failed to turn the Uher on. Henry smiled, and gave his dissertation flawlessly a second time.

One of the pleasures of being with Henry was to hear him talk about the artists he especially admired. His perceptions, coming from a fellow-artist, were always sharp and to the point and often unexpected – like his comment to me one day that Cézanne's figures, particularly those in his sketches, were like sculptures. He then showed me several small figures he had made from those in Cézanne's watercolours.

Another French 19th-century painter he held in the highest esteem was Gustave Courbet. Whereas with Cézanne it was the standing figures that appealed to him most strongly, with Courbet it was the reclining figures. 'Those luscious nudes, how heavily they lie. How deeply they sleep.' I jotted down that comment immediately so as not to forget it. I had a special reason for raising the subject of Courbet with Henry. The following year, 1977, would be the centenary of Courbet's death. A major exhibition was planned for the autumn in Paris, travelling to the Royal Academy in London in the New Year of 1978. I had persuaded the Arts Features department of BBC Television to let me write and present a fifty-minute documentary on Courbet, largely I suspect on the strength of the artist's colourful career as a political revolutionary and his spectacular alcoholic feats.

My producer-friend Christopher Martin and I were looking forward to a filming spree in France and Switzerland early next year, so I wrote to Henry expressing my hope that he would be prepared to participate in the film. On February 21st 1977 he replied, 'Dear Edwin, I am delighted to hear that you are preparing a film for the BBC on Courbet, and I'll be most happy to contribute a bit towards it, if it can be short. You are quite right, I am a great admirer of Courbet.' My delight at his acceptance was matched by the fact that after all these years Henry had finally addressed me as 'Edwin'. A traditional Yorkshire

formality lay behind the warm welcome and the 'Ullo!'

I became aware of the pressure on the life of one of the world's most successful artists when it came to trying to pin Moore down to a filming date. His eagerness to cooperate went hand-in-hand with a roller-coaster schedule imposed on him by the demands of museums and galleries all round the world for huge bronzes to be delivered. Furthermore his bronze founder was in Berlin. Henry also had a second house in Tuscany close to the Carrara quarries where Pisano and Michelangelo had obtained their marble.

'I am pleased to hear there is no hurry about doing the little bit towards your Courbet film,' Henry wrote on March 3rd. 'Some time in the summer is all right for me, except...' he then went on to list his commitments over the coming months. He needed to be in Paris for three or four weeks 'setting up two exhibitions I am having.' One was a retrospective at the Orangerie, the other of his graphic work at the Bibliothèque Nationale. So, from mid-April until well into May he needed to be in Paris. 'Then I have to go to the United States over siting large sculptures in Washington and Dallas.' This would take until the middle of June. There might be time, he hoped, to squeeze in 'an afternoon in the second half of May. If some time you would fix it with Mrs Tinsley that would be O.K. All the best, Yours, Henry.'

One further bid to involve him in filming turned out to be entirely straightforward since it involved nothing more than his goodwill – never a quality hard to find in Henry. I had been asked by the BBC to present a film on the history of tapestry. There were certain obvious highlights to be filmed, in particular the magnificent *Apocalypse* tapestries in Angers and the *Dame à la Licorne* series in the Paris Musée de Cluny. Then, of our own times the Graham Sutherland tapestry in Coventry Cathedral was an obvious candidate, and so was John Piper's *Four Evengelists and the Four Elements* in Chichester Cathedral. But a film about tapestries needed to show exactly how they were made. It was then that we learned how one of the few tapestry workshops in England, West Dean College in West Sussex, had received a commission to create a series of tapestries interpreting Henry Moore's wartime shelter sketches.

We arranged to film them as they were being woven. What particularly fascinated me was to watch as every delicate line and tiny mark in the sketches lying open by the side of the loom found their equivalent in one or more of the skeins of wool that dangled beneath the tapestry. It was like watching some delicate surgical operation as the weaver's fingers deftly cut and pressed each strand of wool into place. I wished Henry could have been there: I should have enjoyed his thoughts on the art of interpreting one medium in terms of another. It made me think of his comment to me some years earlier that

Cézanne's figures struck him as sculptural and how he had actually made small figures from them.

The subject of Cézanne came up again in a very different context. In 1978 Henry was eighty, and the BBC asked me to do the birthday interview on radio just as I had done for his seventieth. As I waited for him in Broadcasting House nothing seemed to have changed, the receptionist still phoned up to say, 'a Mr Moore is here.'

Henry took interviews in his stride. They were part of the business of being successful. Interviewing him was almost too easy, and it was hard to find anything challenging to say. All the obvious questions had been asked a hundred times before; sometimes by me. After a while I began to anticipate winding-up gestures from the producer, so I put an end to the drift and asked Henry if he ever acquired other artists' work, adding that the only picture I had ever seen on his walls was a little Alfred Wallis of a sailing ship which I knew had been given to him. Henry suddenly looked very alert. 'That's not entirely true,' he said. 'I only ever wanted to own one painting.' He went on to describe how in a dealer's gallery his eye fell on a tiny Cézanne of bathers – 'only a sketch about a foot square. I was stunned by it. I couldn't sleep for nights. So I bought it and it's become the joy of my life.' He described how, though just a tiny sketch, it possessed all the monumentality of Cézanne's *Large Bathers,* now in Philadelphia, which measures seven feet across. Then he added, poignantly, 'I don't like absolute perfection, I believe one should struggle towards something one can't do rather than go for the thing that comes easily.'

The theme of struggle led Henry to the sculptor who had obsessed him ever since his student days – Michelangelo – and in particular the last of his monumental carvings, the *Rondanini Pietà.* 'I don't know any other single work of art that is more moving,' he said. And he described how if you looked at the sculpture carefully it becomes clear that Michelangelo had grown so dissatisfied with it that he hacked off the head of Christ. 'He never could finish it.'

There was no longer any hint of winding-up gestures from the producer. We were both of us riveted by the words of this 80-year-old speaking passionately not about his own remarkable achievements, but identifying with the despairing struggles of another octogenarian in the same profession by the name of Michelangelo. In the silence that followed I remember saying, 'Thank you Mr Moore.' Then, as we rose and the producer came into the studio to offer his congratulations and wish Henry a happy birthday, I suggested lunch – 'How about the Gay Hussar?' Henry nodded. 'Well, I'm not a man of sentiment,' he said. 'But I enjoy good memories.'

Salvador Dalí

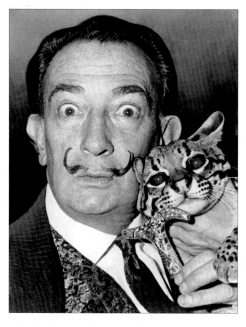

IT WAS NEVER a name to drop lightly: the very sound of it – Dalí – with a heavy emphasis on the final 'i' – carried a disturbing echo, as if we were about to be offered some prurient revelations about the artist's dreams, or listen to a tirade about his 'genius'. Whatever was about to happen, it would certainly be unexpected – the unexpected being Dalí's trademark. Even those in high art circles on both sides of the Atlantic who enjoyed being snooty about him as a ludicrously vulgar showman, and who disparaged his recent work as more suited to a Hollywood billboard, still found it hard to ignore him. I never met anyone in the art world during the 1960s and 1970s who had actually turned down the opportunity to meet him. He was everyone's favourite *monstre sacré*.

My own chance to meet Dalí came about through one of those happy strokes of luck that have occasionally blessed my life. In 1964, the proprietor of *The Daily Telegraph* decided this was the moment to add a glossy newcomer to the weekend's entertainment in the form of a colour supplement. It was to be called *The Weekend Telegraph,* calculated to appeal to readers of both the daily *and* the Sunday paper. He appointed an adventurous

editor, John Anstey, a man known to have an eye for most of the good things in life, and a gift for sharing them with readers. Accordingly the pages of the magazine soon dazzled the eye with beautiful women, beautiful clothes, beautiful cars, beautiful food and – if not exactly beautiful journalism – then some excellent writing by authors not usually associated with popular newspapers, including Graham Greene, Anthony Burgess, Harold Pinter, Kingsley Amis, John Betjeman, H. E. Bates and Arthur Miller. It was a rewarding time to be in journalism, often rubbing shoulders with the literati.

For the very first issue, to be published on September 20th of that year, John Anstey felt the need to include a figure in the art world who would contribute to the classy and glamorous image he was cultivating for the new magazine. In the 1960s there were very few artists whose names were guaranteed to make newspaper readers rush out and buy a copy: Picasso obviously; but John would not have rated his chances of obtaining an interview with accompanying photographs very high. Andy Warhol was a possibility, but was known to be virtually monosyllabic, and the lugubrious face was scarcely camera-friendly. There remained Salvador Dalí, famous even in Tunbridge Wells for his Surrealist imagery of limp watches and his erotic dream-world of exploding eggs and decomposing body parts. What was more, Dalí was known to feed on publicity.

It was now late-May. I was in *The Sunday Telegraph* office correcting the proof of my weekly review of exhibitions when the editor, Donald McLachlan, put his head round the door and beckoned me come and see him. 'You're being poached,' he announced as I closed the door behind me. 'On loan only – to the *Daily's* new colour magazine. My fault, I recommended you. They want you to go and interview Salvador Dalí for your sins. Next weekend. It's all fixed apparently. Spain. Somewhere on the Costa Brava, I believe. But go and see Anstey. He's the editor. You might like him; some don't.'

With that cryptic summons, I took my leave. The offices of the embryo *Weekend Telegraph* were round the corner from the main *Telegraph* building in Fleet Street. I was greeted by a long-legged blonde who smiled and told me to wait; the editor would be with me shortly. A tall man I realised must be Anstey was at the far end of the open-plan office poring over a light-box with a bearded figure who turned out to be his art editor. I waited for the best part of half an hour. Nobody said anything, and every so often one or other of the flock of beautiful women who seemed to inhabit the place would parade to and fro past what I took to be the editor's office. Then suddenly Anstey appeared and greeted me with effusive apologies for keeping me waiting so long. He was an imposing figure, immaculately dressed, who exuded an immediate and fluent charm which I felt

sure had served his career well. He ushered me past the guard-of-honour of luscious blondes seated at typewriters into the inner sanctum. 'Do take a seat,' he insisted, and I took a chair on one side of a vast desk, while Anstey sat facing me across a pile of papers and photographs. He then pressed a bell and one of the guard-of-honour appeared. 'A drink?' he asked me. 'Two vodka and tonics please, Sue,' he said to the girl. He then leaned back comfortably, and as Sue placed the glasses of vodka in front of us said, 'Well! Dalí!'

It was my first assignment for Anstey. Over the next eighteen years until the new regime at the *Telegraph* sacked him, I was to do more than a hundred features for him. In that time I came across a number of people – writers and photographers – who disliked or distrusted him, as Donald had suggested. He could certainly be ruthless and insensitive; but he was invariably good to me. I came to enjoy the luxury of working for an editor who was prepared to let me write more or less whatever story I wanted, often with the photographer of my choice. It was invariably the same routine. I'd come along with a shopping list of ideas. John would press the bell for vodka, then sit back and listen in silence and either nod or shake his head. These meetings rarely lasted as long as twenty minutes. The only variation was in the vodka service. While there was always a guard of honour lining the entrance to his office, there was a good deal of changing of the guard over the years; to be one of John's secretaries was hardly a job for life.

That first evening I thought of little beyond how I was going to approach Dalí, and what on earth I should ask him about. It was an unnerving prospect. There was just time to do some reading, including his *Diary of a Genius,* and to brush up on surrealism. Then on impulse I rang Roland Penrose at the Institute of Contemporary Art. Himself a surrealist painter, as well as a friend and biographer of Picasso, Roland had been responsible for the landmark Surrealist exhibition in London in 1936, on the occasion when Dalí had appeared at an accompanying lecture wearing a large diving helmet symbolising his intention to plunge into the dark depths of the human psyche. My mother had been a witness to this event and used to describe how Dalí couldn't get the helmet off and nearly suffocated. Roland, the most gentle of men, confirmed this story with a chuckle, adding, 'Edwin, whatever you do, don't be bamboozled by the old fraud.

He'll rant on and on. Remember you're dealing with an ego of Olympian proportions. Everything is seen through the lens of his own vanity. And it's a very distorting lens.'

The following Friday my wife drove me to the airport and wished me good luck with a slightly uneasy note in her voice. I suspect she feared I might become transformed into some kind of zoomorphic protoplasm being consumed by ants. Her unease was catching. Everywhere I looked in the Departure lounge I imagined Dalí images. My coffee cup was a skull. The sugar lump was an eye which blinked at me. My croissant had a dirty thumbnail at one end. I began to understand the disturbing power of Dalí's imagination and how it could disrupt our comfortable certainties about the world we live in. This, it seemed to me, was his primary contribution to the art of our time, even if the fruits of that imagination bore little or no relation to anything we recognised in our own experience of life. His art was a psychological horror show, performed with a magic touch.

In Barcelona I checked into the hotel booked for me near the Ramblas. There was a message to ring the photographer Anstey had commissioned to accompany me. He was Robert Freson, a Belgian living in France, and one of the best photo-journalists around. Robert had recently made a *coup* with a story on the 20th anniversary of D-Day by discovering a private wood left untouched since the allied armies swept through Normandy. His photographs were as if the Germans had hastily departed the day before, leaving everything behind – guns, helmets, equipment, bedding, tins of food. I was thrilled to get in touch with him. He'd visited Dalí once before, he explained, and would drive down tomorrow and meet me in the local restaurant around lunch time. 'There's no way you'll be offered lunch *chez* Dalí,' he assured me.

It was time to pluck up the courage and ring Dalí's number that Anstey had obtained for me. Another Dalí image presented itself as I picked up the receiver – the famous phone in the form of a lobster. This time I found myself smiling. The phone rang and rang. Finally a woman's voice answered, strangely in French. I guessed it must be Gala, Dalí's wife. She was Russian, but had been married to the French poet Paul Eluard before leaving him for Dalí – no one ever seemed to be clear why, Dalí being famously impotent and Gala famously promiscuous.

The voice was low and rather flat. Yes, I was expected tomorrow, I was relieved to hear – 'at about ten: Dalí will see you', she said. It sounded like an order. I wondered whether she, or anyone else, ever called him 'Salvador'.

Early the next morning I took the local train which ran northwards along the Costa Brava. The carriages were packed and the train trundled along at a holiday speed linking

resort to resort. I stood squeezed and jostled in the corridor for the best part of two hours until we eventually reached Cadaqués. I just had time to check into a hotel on the seafront and drop my bags before taking the short walk up the coast to Port Lligat. I had never been here before, yet as I came round the headland and gazed down at the village and the bay it felt strikingly familiar. Before me lay the vast spread of rock and sea that has been the setting of so many of Dalí's early paintings, often with something unexplained going on in the foreground, or Christ on the Cross floating magically overhead. It was here on this prehistoric coastline, where the last limbs of the Pyrenees fall into the Mediterranean, where Dalí had built his dazzling white house on the edge of the water.

I approached with some trepidation. I found myself wondering what kind of conversation one could have with Salvador Dalí. Or perhaps one just listened. The door opened, and Gala introduced herself coolly. I was led through the house past a large stuffed bear standing sentinel, draped in jewellery and holding an umbrella stand; beyond that a larger room whose walls were lined with birds of prey with wings outstretched like a huntsman's trophy store. There seemed to be a great deal of death around. I expected any moment to be confronted by the celebrated pink sofa made from the image of Mae West's lips. Finally I was ushered into a room furnished with twisted olive-wood chairs that were set against a wall of rock that was the bare hillside. Here I was told to wait. 'Dalí is expecting you,' she said, leaving me to the uneasy silence of the house.

The silence did not last long. I began to hear shuffling footsteps, first overhead, then on either side, as if someone was systematically patrolling the building, accompanied by muttering sounds and the creaking of furniture being moved and drawers opened. Suddenly a door was flung open and a figure advanced towards me, the unmistakable moustache striking upwards in the direction of two ferociously-staring eyes. He was wearing a sky-blue jacket embroidered with sequins, a conical red hat and a blue blob was planted on his nose. 'Dalí!' he announced, coming to a halt and staring straight at me. Then he added more solemnly – 'In summer I am Hermes as Harlequin. Let me show you round.' And he turned towards the door with an authoritative flick of the head.

This was my introduction to Dalí at the age of 60. All the shuffling and creaking I had heard must have been him assembling the outfit in which he had chosen to greet this gentleman from Fleet Street – as no less than the messenger of the gods descended from Mount Olympus for the occasion. Naturally I followed him from the room. Dalí removed the blue blob from his nose and began to show me round the garden. This was a steep stony area above the house planted out with olive trees and clumps of lavender, and with

glorious views over the bay towards Cape Creus. Dalí had equipped himself with a long shepherd's crook which he brandished from time to time in the direction of the sea as if offering a greeting to Poseidon. We passed a row of garden seats shaped like eggs from which some gigantic chicken has just hatched. I noticed Gala was seated in one of them reading a magazine. Nearby rose a white dovecote from which an olive-wood pitchfork protruded as a perch for the birds.

Dalí had remained entirely silent all this time. Then he beckoned me to follow him. A rough track through the olive grove led to a curious arrangement of debris laid out on the ground, made out of splinters of wood, broken oars, fragments of a bench-seat,

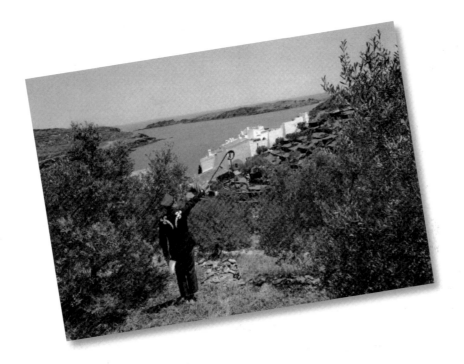

all evidently the remains of a small boat but reassembled in a roughly-human form with motor tyres as appendages. Dalí broke his silence. 'My fisherman-Christ,' he announced with a toss of the head. Before I had time to register surprise he added in a loud voice, 'Now it is time to swim.' As I turned to look at him a woman's voice behind me explained – 'Dalí likes to talk in water.' The voice was Gala's; she had emerged from her egg and followed us. 'He is at home with the elements,' she explained.

The three of us walked back through the olive-grove and the lavender towards the house. Ahead was the open bay, translucent and still, with a scattering of distant islands stretching out before us. It was a magnificent panorama and it struck me at that moment that I had just been introduced to one of the most artificial environments I could possibly imagine in a setting of bewildering natural beauty. Perhaps this was precisely Dalí's intention – to have created the greatest possible contrast between nature and artifice while using nature's own tools to make the contrast the more disturbing and enigmatic. It was yet another of those psychic shock waves that pulsed through his earlier Surrealist paintings, but are entirely absent from his recent work. Here was one more Dalí enigma: that his lifestyle should have remains as surrealist as ever, while the vast historical allegories he was now creating possessed nothing surrealist at all.

And now we were to go swimming so that Dalí could communicate with the elements, apparently for my benefit. I felt as though I was playing Blind Man's Bluff, with absolutely no idea what to expect any longer. Dalí duly disappeared into the house, re-emerging a short while later in a surprisingly conventional swim-suit; though he had retained his conical red hat. Without a glance in my direction he made his way very precisely across the rocks and into the water, disturbing a pair of swans who seemed to take offence at this surrealist apparition. I decided that since I was the required audience the only course of action was to strip down to my underpants and follow him into the sea. I found myself wondering how many tyro journalists on their first big assignment had found themselves about to interview one of the world's most colourful celebrities while being virtually naked in a Spanish rock-pool without the aid of notepad, tape recorder or camera.

The next half hour I have treasured in my memory. There was no need to ask questions. Dalí began to utter, as though he was in a trance. As he did so he gave me my own surrealist moment, as his head appeared to be floating disembodied on the water, his eyes huge and staring past me towards the open sea, with the moustachios raised a little above the surface like twin periscopes. I found myself imagining the head might simply float away across the Mediterranean, still talking. It was a continuous impassioned flow, about his love for Catalonia and how he had always felt the need to define himself in terms of this region where he was born and which he loved, 'as all great artists have to do,' he insisted.

It was surprisingly moving and not at all what I had expected from this showman consorting with the elements. And as we continued this curious pantomime, splashing about in the water and gazing out towards the far ocean and the rocky headlands, I could see in my mind's eye those jewel-like early paintings in which this precise setting is

captured as if in a dream, sometimes with a tiny figure of the boy Dalí in the distance on the shore. Suddenly, as if the same thought had crossed his mind, he began to talk about his childhood and his youth. He explained how he had always needed to prove he was not his dead brother after whom he was named; how at seventeen he had wanted to be Napoleon, and how his ambitions had grown ever since. Roused by the thought, his head still bobbing above the water and the twin periscopes still proudly raised, he launched into a declaration which I wrote down as soon as I retrieved my biro and notebook – 'Every morning upon waking I experience the supreme pleasure of being Salvador Dalí, and I ask myself what prodigious thing will he do today, this Salvador Dalí?'

Many years later I read those precise words in Dalí's autobiography *Diary of a Genius*. As we splashed about in the waters of Port Lligat on that spring morning Dalí had simply been quoting his own vainglorious words.

Gala found me a towel to dry myself, and I discreetly laid my underpants on a rock to dry. As Robert Freson had predicted there was no invitation to lunch; so I took myself to the village where an open-air restaurant overlooked the bay and where Robert had arranged to meet me. I wished he could have arrived earlier as I would have relished shots of Dalí's free-floating head declaiming Napoleonic ambitions. The only other customer in the place was a young man I had caught sight of in Dalí's house. I joined him at the lunch table and he told me he was from New York. His name was William, and Dalí had brought him over from the States as a model because, William explained with a laugh, 'He said I looked like the young Dalí.' He would be posing for him that afternoon 'looking a right idiot with a wand,' he added. I ordered fried octopus for us both, at which point Robert Freson arrived and introduced himself. I in turn introduced him to William, whom he would no doubt soon be photographing.

Dalí had arranged that we all meet in his studio at three o'clock. I was to watch the master at work; Robert was to record the moment. This was to be for a British national newspaper, Dalí had been informed by Gala, so everything had to be correct. We duly arrived on time. It was more an audience than a photographic session. Dalí had dressed for the occasion in a black velvet jacket with embroidered silver cuffs. William had undressed for the occasion. He was standing naked on the far side of the studio, holding a wand in his right hand which he was directing towards the large canvas nearby which Robert had back-lit so that the images on the surface became transparent. They were a series of enormous dollar signs; the painting itself was to be entitled *The Apotheosis of the Dollar*, Dalí explained solemnly. With a glance at Robert who was setting up his

camera on a tripod, he began to take on the air of a matador, his right arm extended as if brandishing a rapier as he prepared to apply a stroke of his charcoal pencil to the canvas. There was a glance at William brandishing the wand; then another glance at Robert behind the camera. A twist of the head. A rapid twirl of the moustaches. Another glance at Robert. The rapier raised a little. Then – 'OK? *Cache-sexe! Cache-sexe!* OK?' The rapier needed to conceal William's genitals.

How right he was. No British newspaper in the 1960s was going to published a photograph of a beautiful naked male model, even if he was being painted by Salvador Dalí. As it was, Robert's photograph appeared full-page in the first *Weekend Telegraph* Magazine that September, and was reprinted in the 40th Anniversary issue in the year 2004. I have it in front of me as I write this.

Fifty years have passed since that day in Port Lligat. The afternoon of the photo session feels now like some unwritten chapter in a book to be called something appropriate like *The True Confessions of a Genius.* What I witnessed was Dalí painting a boy posing naked as the young Salvador waving a magic wand to transform dollars into glory – or maybe the other way round, transforming his genius into money. With that thought I am inevitably reminded of the French poet André Breton's observation that the name Salvador Dalí could be read as an anagram of 'Avid-a-Dollars'.

I thought of those intense early paintings of the 1930s, jewel-like in their attention to detail, each canvas an inventory of his personal obsessions and fetishes, each painting tiny in scale compared to the grandiloquent compositions of his post-war years. It was as though all the homo-erotic narcissism that filled Dalí's early paintings had been replaced by a flamboyant celebration of Wall Street. His claim to greatness had been an ability to bring his subconscious world to life in pictorial terms, making his dreams seem real. We are asked to believe that watches can be soft and that the skull on a beach really is sodomising a grand piano. He introduced us to his dark gods who presided over a spiritual wasteland in which simple things like humanity and human love find no place. It is a disquieting world and its power rests precisely in its power to disturb us. No other painter of our time can have revealed so much about his secret life, or made it so public. Unforgettable paintings come to mind – *The Persistence of Memory*, where his soft watches first made their appearance hanging on a twig; or the weirdly apocalyptic *Apparition of Face and Fruit Dish on a Beach;* the hallucinatory *Couple with Clouds in their Heads.* Or perhaps, most of all, his rare venture into the Spanish political arena, *Premonition of the Civil War,* in which all the horrors and fetishes of Dalí's dreams come to life in a manner

worthy of an earlier Spanish artist, Francisco Goya.

For the life of me I could not possibly see *The Apotheosis of the Dollar* in the same light as these.

There was one early painting in particular that intrigued me, partly because it seemed to offer an unexpected insight into Dalí's mind and the nature of his bizarre gifts. It was also one of the tiniest pictures he ever painted (as so often with Dalí it is a case of 'small is beautiful'). It carries several titles, both typically cryptic – *Enigmatic Events in a Landscape*, or *Ghost of Vermeer*. The painting shows Dalí at his easel in the parched Catalan landscape dressed as the 17th-century Dutch artist Jan Vermeer; nearby is the minute figure of Dalí as a young boy in his sailor-suit.

Dalí's obsession with Vermeer intrigued me. It seemed so unlikely that his erotic fantasies and fetishes should have any connection with the quiet domestic interiors of the great painter from Delft. I felt determined to ask him. Now that the photo session with Robert was finally over and the all-important *cache-sexe* satisfactorily in place, I sensed that my chance had come. Dalí had re-emerged from the house casually dressed in a pink shirt, shorts and open sandals, and had seated himself in a shady area under the olive trees with a sketchpad. Robert was now occupying himself taking shots of the garden. Dalí looked up as I approached, and to my surprise gestured to me to pull up a seat. He saw that I had my notebook with me, and it prompted him to ask what I'd like him to talk about. 'Vermeer,' I said confidently. He looked surprised, then pleased.

I had done some homework over the past week on some of Dalí's voluminous writings. His *Secret Journal,* I noted, included a list of things he was 'For and Against'. 'For' included: dreams, the Marquis de Sade, snails, coastlines, myself . . . and Vermeer! As early as the 1920s he wrote that the art of perception 'had its sweet and excellent moment in the paintings of Vermeer.' And in 1955 he had given a lecture at the Sorbonne in Paris during which he expounded on the connection between Vermeer's *The Lacemaker* and the horn of a rhinoceros – a similarity, he explained to his baffled audience, of minute details of texture. Could I get him to expand on this?

'Why Vermeer especially?' I asked. Dalí put down his sketchpad and stared ahead intently just as he had that morning when gazing out to sea. 'Great art is about perception,' he said, his eyes seeming to crinkle at the thought. 'And the art of perception reached its highest point in Vermeer. The Italians understood it of course: Francesca, Raphael. But Vermeer most of all. His eyes were the sharpest.' There was a long pause, then he continued: 'I have been a man who knew how to paint every crumb in a slice of bread.

It's all a matter of illusion.' His voice was gaining strength as he warmed to his theme. 'It's the art of making paint-marks look like the real thing.' He turned to look at me almost fiercely. 'I've said it before, I would willingly emulate Van Gogh and allow my ear to be cut off if I could witness Vermeer seated at his easel for just ten minutes.' He gave a dismissive laugh. 'Instead, look at poor Cézanne, struggling for so long to paint a convincing apple – mile upon mile of defeat.'

In those few minutes I felt I may have grasped a couple of basic truths about Dalí. His scornful dismissal of Cézanne as a 'failure' displayed an astonishing blindness to what the artist was aiming to achieve; as if the sole criterion of excellence lay in an artist's ability to create the illusion of physical reality – the very opposite of what Cézanne was aiming for. Dalí's worship of Vermeer appeared to rest entirely upon his admiration for the Dutch artist's technique: the sharpness of his eye; the gift he shared with Dalí of being able to describe every crumb in a slice of bread. Yet the use to which they put that shared gift could hardly have been more different. For Dalí it was a magic trick, a pure demonstration of the artist's technical skill. For Vermeer, on the other hand, that minute sharpness of eye was an instrument for achieving the most profound degree of intimacy – what a girl was wearing, what she was doing, the look on her face, the character of the room in which she stands.

Dalí made one further comment about Vermeer, almost as an afterthought as he was returning to the house. He suddenly mentioned Lorca, the republican poet and friend of Dalí's killed in the Spanish Civil War. They used to exchange letters and thoughts for many years, he said. He remembered explaining his admiration for Vermeer. 'I wrote about the humble patience in the process of his painting; that it was the same mode of patience as that of the ripening of fruit on a tree.' There followed a brief pause before he added – 'or the exquisite death throes of St. Sebastian.'

It was an afterthought that made me shudder, coming immediately after the delicate and poetic image of fruit slowly ripening in the sun. But I realised that was Dalí all over. Sharpness of eye. Sharpness of mind. Then the sharpness of shock – in the worst possible taste to make it even more shocking. And all this delivered in the context of Vermeer, that most intimate of artists with the most gentle of eyes. Dalí's eye could scarcely be more different: it was that of a voyeur. Voyeurism inevitably creates a sense of distance, and distance by its nature is the very opposite of intimacy.

Later that evening Dalí, in his embroidered finery once again, took his place in the garden next to Gala. Now they were like a pair of royals as they became serenaded

by a motley collection of travelling young who had somehow been rounded up from Cadaqués along with their guitars and marijuana to pay court to the master. I had no idea who was responsible for recruiting these happy wanderers to the court of King Salvador, but as I watched Dalí settling contentedly among them I got the impression this was a fairly regular occurrence. Dalí was a man who enjoyed observing the passing world, and being observed by it. As dusk fell there was a general drift towards a barbecue not far away to which Robert and I were neither invited nor uninvited. When the royal court was on the move it seemed natural to move with it; so we followed the party as it made its way to a nearby beach where a fire was already blazing, and an ever-swelling band of travelling young were gathering. Chairs appeared as if miraculously for Dalí and Gala, and they seated themselves among a body of attendant youths all singing and dancing around them and in and out of the sea. I thought of Gala's remark – 'He is at home with the elements.' Now he had them all – sea, fire and the night air. Dalí was relishing the bacchanalia held in his honour. Robert and I slipped away.

Alexander Calder

IN THE 1960s the eyes of the art world were turned towards New York. Paris, for so long the powerhouse of modern art, was now *passé:* its former *enfants terribles* were by now venerable old masters like Picasso, or they were dead. The new wave was flowing from across the Atlantic: names like Mark Rothko, Clyfford Still, Mark Tobey, Franz Kline, Willem de Kooning, Robert Motherwell, Robert Rauschenberg and, of course, Jackson Pollock, still little known in London though he'd been dead more than a decade. Abstract Expressionism was the buzz phrase.

My editor at *The Sunday Telegraph*, the genial Donald McLachlan, agreed that the art critic he had plucked out of nowhere should be seen to be in touch with this brave new world unlike his stuffy counterpart on the daily paper. As a result I found myself in the happy position of making the occasional round of galleries and museums in New York, a city I came to love. And, in the autumn of 1966, one of these forays brought me in touch with an American artist I greatly admired and had long wanted to meet. He was Alexander Calder, best known as the sculptor who had invented the 'mobile' – many decades before the word became associated with telephones.

New York seemed to be full of Calder that autumn. A huge insect-like steel sculpture had recently been installed outside the Lincoln Centre facing Central Park, causing some ruffled feathers among the park authorities. This was one of his giant 'stabiles', so named to distinguish them from his familiar 'mobiles' that move in the wind. Another stabile had just been acquired for the United Nations. In that vertiginous spiral of a museum, the Solomon Guggenheim, one of the artist's magical floating mobiles was now suspended

ghostlike in the central atrium of the museum. As I stood gazing up at it a man turned to me and asked if I knew that an exhibition of Calder's jewellery had just opened at the Perls Gallery downtown. 'Some of them are mobiles in miniature', he added with a laugh. 'I think my wife might take off if she wore them.' I had to go and see them. Calder's versatility astonished me: mobiles; stabiles; jewellery. Then there were the witty figures sculpted in twisted wire. The mechanical toys. The stage sets. The acoustic ceiling. And, of course, the famous miniature circus from which he used to give performances to pay the rent on his studio in Paris. In addition there was the extraordinary bed-head with wire fishes attached to it which he'd made for Peggy Guggenheim and which I'd seen in Venice only a few months earlier. I found myself reminded of artists in the Italian Renaissance who might progress from painting a cathedral altarpiece to staging a court pageant and designing war machines. Calder appeared an unlikely figure for the mid-20th century, and I became increasingly keen to meet this extraordinary man.

I knew the Perls Gallery; Klaus Perls had been a German Jewish refugee in the 1930s. Now a successful art dealer, he dealt principally in the work of leading European artists – Picasso and Braque among them – and Calder on account of the American's longstanding relationship with France, where he lived for much of the year. When I reached the gallery early that evening a party was in progress, and in the midst of a crowd of guests holding glasses of wine stood the unmistakable figure of Calder, large and shambling, with a tousled mop of grey hair and the famous grin that wobbled about as he talked. And, as if acting out the ebullient nature of this man, the jewellery he had made for this show, all whorls and spirals, seemed to be doing an ethnic dance all round the walls of the gallery.

Klaus greeted me to what was evidently the private view and immediately led me over to meet Calder. 'Sandy,' he announced, 'I know you don't care for critics much, but you might like this one from London.' With that he left me with Calder. I felt thrilled and nonplussed at the same time, and managed a few platitudes before deciding to tell him that I'd recently seen the bed-head he'd made for Peggy Guggenheim. Calder gave a chuckle. 'I made her earrings too, you know. But she only ever wore one of them.' He explained that Peggy would wear Yves Tanguy's earring on the other side to demonstrate her loyalty to Surrealism. Calder gave me one of his big wobbly grins and asked what I was doing here in New York, and what did I think of his piece outside the Lincoln Centre. 'Big, isn't it!' And he gave another rich laugh.

It was impossible not to warm to Calder. I was a captive audience from that moment. I'd grown accustomed to artists – invariably the least interesting ones – who seized every

opportunity to talk about themselves, often with obsessive earnestness. Calder was quite the opposite. Over the months and years when I came to know him I grew accustomed to his habit of talking about his work jokingly, as if it wasn't to be taken seriously. This was apparent on that very first evening in the Perls Gallery. We were standing in a crowded room drinking wine, with Calder explaining to those gathered around him how he loved making things with his hands, especially human figures out of wire. As he spoke he spread out his hands and began twisting imaginary pieces of wire with his fingers, his face contorting into all manner of agonised expressions as he pretended to be creating a face, a mop of hair or a pair of legs. By now most of the people in the gallery had formed an admiring audience round him, laughing and smiling.

Calder was a natural entertainer, and entertainment was an important ingredient of his sculpture. Like Paul Klee in painting and Eric Satie in music, he made humour compatible with serious art. Yet, as I came to understand, it was also a distraction, a form of camouflage which protected his private thoughts. Calder was the most serious joker I ever met.

Suddenly the performance was over and he turned to me. 'So, what are you doing back in London?' I explained that I wrote for one of the national newspapers, but that I was also preparing a book on Georges Braque for the art-publishers Thames and Hudson. Calder nodded. He had known Braque right up until his death three years ago, he said. And they'd shared the same dealer in Paris, the Galerie Maeght. I explained I needed to go there in a month or so to consult their archives. 'In that case you should take a day off and come and come and see us,' he said. 'We're near Tours. Not that far from Paris. That would be good.' I felt astonished and flattered. Klaus Perls, who had overheard our conversation, said as I left, 'You should go. You'll have fun. And the wine is good.'

A few months later I picked up a hire-car in Paris and set off early for the Loire Valley, which is a region of France I especially enjoy, and booked into a hotel in Tours. Then I headed a short distance south-west for the village of Saché. Calder had scrawled directions on a postcard followed by the words 'Feb 25 will be OK, Calder.' The photograph on the face of the card was a detail of one of his huge metal stabiles – an intriguing slab of steel which could have been almost anything. Over the next couple of years I was to receive a number of such postcards, each displaying a different detail of the same sculpture. It was like a jigsaw puzzle, and it occurred to me that if I were a specially-favoured correspondent I might be able to build up the complete stabile. It was another of Sandy's quiet jokes. I was coming to realise that his life was full of them. And they were soon to colour each day I spent with him.

The Calder house in Saché was known locally as *La Maison François 1e,* which made it sound grander than it was. I doubt if the French king, Leonardo da Vinci's last patron, had anything to do with it. A modest stone-and-brick farmhouse, it had a weathered charm, but had been a wreck when the Calders bought it a few years earlier. 'When I first saw it I thought I'd make mobiles out of the cobwebs and propel them with bats,' he chuckled as he showed me round the place. His wife Louisa proposed coffee; she was a quiet and gracious woman who was the granddaughter of the American novelist Henry James. Calder decided that a glass of wine would be more appropriate given that it was approaching midday. Louisa duly reappeared with two large glasses of greenish Loire wine. They were the first of a great many I was to share with Sandy in the months to come. Then, glass in hand, he led the way across the garden to an outbuilding which turned out to be his studio – or, more appropriately, his workshop.

As he pushed open the door and ushered me in I got the feeling that in his disarmingly casual way Calder was welcoming me into his working world – this was what it was all about; this was the engine-room. A huge wooden work-bench filled the centre of the room, laden with sheets of glass, coils of wire, pliers, saws, files, shears, soldering iron, scraps of wood, paint pots, brushes and, right in the middle, the glass of wine he had just brought in. As I looked on, his hands would be coiling a length of wire into a spiral, or arranging glass shapes on a sheet of paper accompanied by the occasional grunt. This was just another working day and there were moments when he might have forgotten I was there. But then he would pause and take a sip of his wine; then look across at me with that famous grin. 'Messy in here, isn't it!'

Over lunch he became more expansive. 'I always loved making things,' he said. 'Especially things that move.' Louisa looked on as he poured the wine and spoke about his earlier days. He'd never thought about being an artist for a long time, he explained. He'd first studied engineering, emerging with a degree in 1919. (How many artists, I wondered, have possessed a degree in mechanical engineering?) He then took a variety of engineering jobs before travelling to Paris, where to earn a living he began to make children's toys. This led to creating his famous miniature circus. 'I'd always loved the circus,' he said, 'ever since being taken to see the Ringling Brothers.'

So in Paris he decided to make a circus of his own 'just for fun,' he explained. The figures were made of wood and wire and he manipulated them himself with the aid of various ingenious gadgets. Circuses had become fashionable venues for artists of the Paris *avant-garde* of the 1920s, and soon the word got round that this young American

was doing something extraordinary. So, to pay the rent on his Montparnasse studio Calder took to giving performances, culminating in a four-horse chariot race based on one he'd seen in a tournament in Pasadena. The *Cirque Calder* became something of a cult in Left Bank Paris, and visitors to the Calder studio began to include the likes of Joan Miró and Marcel Duchamp. The travelling circus eventually occupied five suitcases, which he took with him whenever he returned to see his family in the United States. On one such trip a fellow-passenger on the Transatlantic liner was a young American woman who had been dispatched to Paris to absorb the intellectual climate in the spirit of her celebrated grandfather. Louisa James had been less than impressed until she encountered a fellow-American on board who introduced himself as a Sculptor in Wire. 'I didn't think that went down too well,' he said. None the less they were married two years later.

Louisa kept a watchful eye on her husband throughout lunch. Her silence seemed protective and knowing; she had doubtless heard it all many times before. As the stories and the wine flowed I was conscious that Calder was giving a performance for my benefit. It was his form of welcome. I had seen his private world – his workshop – now he was showing me his public world, which was a stage on which he performed, just as his circus was a performance.

He proposed a siesta after lunch and showed me to a huge bedroom under ancient oak beams. The late-winter sun shone on the spirals and coloured discs of the Calder lithographs along the walls and they swirled and danced happily around my head as the Loire wine sent me into a fragrant world – until a large figure with an infectious grin leaned over me to announce 'I'm going up to my new studio. Want to come?'

On the brow of a hill behind the house, fringed by vineyards and overlooking the gentle valley of the Indre, Calder had built a large brightly-lit studio. South-facing walls of glass invited every blade of winter sunlight, and there could hardly have been a more dramatic contrast to the workshop he had showed me that morning. Calder himself seemed to expand in it as he threw back one of the glass doors onto a broad cobbled terrace which then extended into a meadow sloping down towards the river valley. As I gazed out from the open door of the studio, the entire landscape seemed alive. Spread out across the terrace and the meadow beyond stood a dozen or more Calder stabiles – spiky, spiderlike creatures, half-insect and half-monument, all of them inhabiting the place as if we had come across some zoomorphic park created by the sculptor's outsize imagination. I was too stunned by the impact of them *en masse* to find words. Calder broke the silence with a laugh. 'You can see why I needed a large studio.' Then he added,

'I also wanted some place where the sky was the ceiling.'

It was a remark that gave me much food for thought. Standing there on the terrace surrounded by these huge painted sculptures I was vividly aware of the extreme contrasts in everything Calder chose to make. There was the contrast between miniature circus figures and his serene floating mobiles that evoke the movement of clouds; between Calder the toy-maker and the creator of public monuments in many of the world's cities some of them large enough to drive a bus through; between the engineer and the visionary, the lover of amusing gadgets and the sculptor for whom only the sky is the limit.

The evening sky was beginning to darken as we stood there. I thanked him for showing me his two working worlds, the private workshop and the sculpture park under the sky. Now I needed to get back to Tours, then to Paris tomorrow and to London and my family. I found myself considering what my two-year-old daughter would make of this giant adventure playground of painted monsters. Calder's hospitality towards me had been spontaneous and warm, born of a chance meeting in New York a few months earlier. He had shown me his contrasting worlds and I was left to make what I might of them. There had been no explanations and no commentary, only a shield of bonhomie and anecdotes. The enigmas and unanswered questions would remain with me. Now it was back to London and my book on Georges Braque.

A few weeks later a familiar postcard arrived. It was another piece of the Calder jigsaw – a different slice of metal this time, incorporating a large arrow pointing skywards. There were just a few words scrawled in black ink: 'Would you like to come with your wife and spend a day or two? We rather liked you! Cordially, Sandy Calder.'

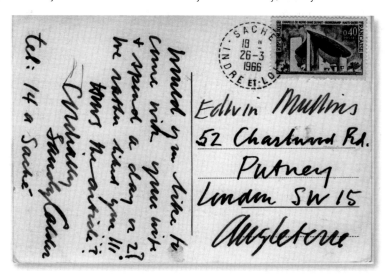

I was touched, and much appreciated being 'rather liked'. Calder was also now 'Sandy', and he had included his telephone number at the bottom of the card. So, later that day I phoned. The growly voice suggested that some time in the spring would be best, but he'd come back to me. There would only be me, I explained, as my wife was tied up with our two-year-old daughter. A week later another postcard followed (another piece of the jigsaw, looking like a sword-blade this time). He explained he'd be away in the States after all. 'So let's let it go till summer. We'll fix it. Cordially, Sandy.'

It was July when I returned to Saché. Louisa welcomed me graciously. She was glad I was staying this time, she added, and showed me to the large oak-beamed room where I had enjoyed a wine-filled siesta five months earlier. Then she brought a tray with a pot of very English-looking tea into the garden. 'Sandy would say it was time for a bottle of wine,' she said. Then she explained he was up at the studio. 'He knows you'd be here about this time, so he won't be long. He's looking forward to seeing you again. He said you were a very good listener and he liked the questions you asked.' I said I was delighted to hear it, but that I'd often been thrown by Sandy's answers. 'They were usually a joke or an anecdote.' Louisa gave me a knowing smile. 'I know. That's Sandy . . . But persist. You'll get there.'

In the months since I'd last been here I'd become increasingly intrigued by what seemed to me the enigma of Calder. How had a man trained as an engineer got to making children's toys in Paris, then a miniature circus with tiny animals manipulated by pulleys and wire, only to go off at an apparent tangent and create huge cloudlike mobiles and even larger earthbound sculptures some of them sixty feet high? How could he explain such a transformation? Somehow I had to get past the jokes and the anecdotes. As Louisa suggested, I needed to 'persist.'

The opportunity came sooner than I expected. Sandy arrived looking hot and rather harassed and mumbled that there'd been a problem with the foundry in Tours. Tomorrow he needed to go in and sort it out. He let out a deep breath in irritation. Suddenly he seemed to acknowledge my presence and awarded me the trademark Calder grin and a hefty handshake. 'Glad you made it,' he said. Then after another deep breath he announced that he could badly do with some fresh air and suggested we take a walk. 'And you can tell me what you've been up to. How's Braques?'

From that moment the easygoing warmth of Sandy took over. As we walked through the vineyards below the new studio on the hill it began to feel as if I'd known Sandy a long time. He seemed in quite a different mood from when we'd met in February. There

was no hint of a performance, and the jokes were rationed. Maybe last time I'd been just another visiting journalist he'd felt the need to amuse and entertain. Now I was close to being a friend. This pleased me greatly; it also made me feel able to put some of the questions to him that had been sitting in my head for months.

The most basic of these was – 'How did the engineer become an artist?' I asked him straight out.

Sandy gave a deep growl of a laugh and said nothing for a while as we continued to stroll among the neat rows of vines laden with ripening grapes. Then he stopped and looked thoughtful. 'I can see you're one of those people who asks questions too simple to be answered,' he said. 'And those are generally the questions that really matter.' And he gave another laugh. 'The truth is, it just happened, like so much in life. And Paris helped, of course. Meeting people.' I pressed him to talk about those Paris years and the people he'd come into contact with. He gave a nod as if I'd finally asked the right question again, and began to talk intently, pausing every so often as if to focus his memory.

The most important friendship he made in Paris, he explained, was the Spanish artist Joan Miró. They shared a great deal, not least a sense of humour – the idea that a serious work of art could also be fun. That was quite a breakthrough. This was in the late-1920s and the time when Calder was making his miniature circus figures out of wood and wire. Miró was one of a growing number of Paris Left Bank artists who would attend the circus performances Calder gave in his Montparnasse studio. Another was the Dutch painter Piet Mondrian, who then invited Calder to his own studio. As he told me this Sandy threw me a glance. 'You asked about becoming an artist. I suppose this was as important a moment as any. The visit to Mondrian's studio gave me a shock which started something.' Then he went on: 'It was an even greater shock than the one I had eight years earlier.' He explained how he'd been working as a mechanic on a passenger ship heading for New York. 'Off the coast of Guatemala I was on deck and saw a fiery red sunrise on one side of the ship and the moon like a silver coin on the other.

As he described it, that key moment sounded like a premonition of the sculpture he was drawn to create many years later – sun and moon seeming to move across the sky as if they were natural mobiles. Listening to Sandy describe those moments made me feel I'd struck gold. Then as we walked back towards the house Sandy added a few more comments about his Paris life. 'So, at the age of thirty-two I suddenly found I wanted to work in the abstract. And what was strange was that it brought me closer to reality.' It seemed a deeply revealing comment. What I understood him to mean was

that working in the abstract became a liberation. It allowed him to embrace experiences far beyond the miniature world of gadgets, toys and miniature circus figures: instead a vastly expanded world became opened up to his imagination – the natural world of flowers, animals and insects, the movement of clouds, and further still a cosmic world of sun, moon and stars such as had first astonished him as a young mechanic on the deck of a ship in the Caribbean. From a miniature world to a universe, this seemed to be the transformation in Calder's creative life that I'd been trying to understand.

Then, Sandy went on, not long after the 'shock' of seeing Mondrian's studio, a friend brought an even more radical artist to see his work. This was Marcel Duchamp, who was so impressed he promptly arranged for Calder to hold an exhibition of his mechanical sculptures. 'I asked Duchamp what I should call my work. And straightaway he said "mobiles". And that's how it all came about. Mobiles they became.'

Our walk had taken us on a broad circuit and we were soon back at the house. Louisa was reading in the garden and greeted us. She looked at me as Sandy disappeared into the house. 'How did you get on?' she asked. 'Brilliant!' I replied. 'I persisted, as you said.' She merely smiled. Sandy reappeared with a bottle of chilled white wine and the three of us sat in the warmth of the evening, accompanied by the persistent sound of crickets all around us and the screech of swifts overhead.

I had another day in Saché before returning to Paris where my wife and baby daughter were staying with friends. Sandy needed to go into Tours to see the foundry where many of his giant stabiles were created and cast. He was keen to show me and I suggested I drive him in. The foundry was a longstanding firm of boiler-makers by the name of Biémont. On the drive into Tours Sandy explained how he would take in a *maquette* and the foundry would make the finished sculpture to his precise measurements under his supervision. I asked Sandy what metalworkers who normally made industrial boilers felt about making abstract sculpture. Sandy gave one of his grins and said, 'You'll see.' I wasn't sure what to expect. But as we left the car in the middle of a yard of rusted boilers a man who was clearly the boss came out and threw his arms round Sandy. We were promptly escorted to the man's office, Sandy and he chatting amicably the whole way. On his desk, when we arrived, was one of Sandy's *maquettes*. Several others were on shelves around the walls. I sat quietly while the two of them energetically sorted out whatever the problem had been, accompanied by much laughter and back-slapping. Then coffee and glasses of brandy were produced. What I realised, watching this animated performance, was that this was not a factory-owner discussing creative

details with an artist, here were two engineers meeting on common ground. For all the huge sculptures dominating city squares across the world Sandy was once again just a man who loved making things and exchanging experiences with a colleague who also loved making things.

Sandy was in a storytelling mood as we drove back to Saché. We passed under a skein of telephone wires at one point and he explained how a particularly tall stabile had once snagged the wires, knocking out the phone system for the entire region. He chuckled. 'I apologised profusely and got Biémont to cut off the offending limb.' The jovial mood continued. He explained that he was the third generation of sculptors in Philadelphia. His Scottish grandfather had emigrated there and was commissioned to make the huge statue of William Penn which still stands proudly on the roof of the City Hall. Then, not far away, is the Swann Memorial Fountain, created by Sandy's father, Sterling Calder. I was beginning to wonder where this story was leading when he added that the Philadelphia Museum of Art had now acquired a mobile of his, called *The Ghost*. 'So the city's now got all three of us, the Father, the Son and the Holy Ghost.'

We were still laughing as we arrived back in Saché. Louisa had the look of one who knew her husband had been entertaining me with stories again. Then she announced, 'Sandy, the paper says the Tour will be passing through the village around three.' Sandy nodded, then explained that the 'tour' was the annual Tour de France cycle race, due here this afternoon. 'We must be there, Edwin.' And so we were. After a good lunch, and a fair amount of Loire wine, the two of us were standing by the roadside alongside most of the inhabitants of Saché, awaiting the arrival of the world's most famous cycle race.

One of my abiding memories of that visit is of the large robust figure of Sandy, a little flushed with wine, standing four-square by the roadside and enthusiastically waving a miniscule stars-and-stripes flag as the first cyclists came into view. I doubt if any American cyclists were taking part as this was several decades before the era of Lance Armstrong. Nonetheless Sandy felt this was the moment to show the flag.

We returned to the house in high spirits, and the following morning I drove back to Paris and the more solemn matter of the George Braque archives.

I saw Sandy only a few times in the years following, though my collection of handwritten postcards grew until the jigsaw puzzle was almost complete and I felt I could have reassembled the entire stabile. There was one sad note which I've regretted ever since. I wrote a piece on Sandy for *The Telegraph* a while later to accompany some striking photographs of a giant new stabile being placed in Los Angeles. The journalist

in me placed too much emphasis on the jokey side of Sandy and his work. His silence suggested that I may have offended him, and I wrote and apologised if this was so. In reply he wrote: 'There was no offence. I just couldn't think of anything *bright* to say.'

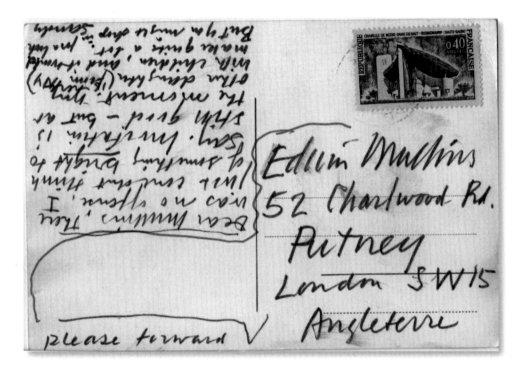

There are times for feeling small and that was one of them. This present account of my days with Sandy is an attempt to make some reparation. I have learnt in the years since that with Sandy it was important to recognise that for every joker in his pack there was likely to be an ace of diamonds.

Sandy died in 1976, ten years after those summer days I spent with him. Seven or eight years later, my wife and I were travelling in the Loire Valley and spent a couple of nights at Azay-le-Rideau where the most enchanting of the Loire chateaux rises out of the transparent waters of the Indre as if the river had given birth to it. I realised that we were only a mile or so downstream from Saché, so one afternoon I decided to make a sentimental visit to Sandy's former village. Soon, as we were descending a low hill above the river valley, I caught sight of a field on the left of the road which was immediately familiar. I stopped the car and said to my wife, 'Look!' We both got out of

the car and leaned on the gate. In front of us, strewn across the open field, were half-a-dozen or more Calder stabiles, brightly painted and shining in the sunlight. No one was around, but there was the empty studio and the cobbled terrace, a little overgrown now with weeds. And beyond, stretching down towards the village, was the familiar park of Sandy's sculpture, hunched and spiky, inhabiting the place just as I'd seen them sixteen years before. Presumably the Calder estate used the field to store pieces that were still to find a permanent home. It felt uncanny, as if Sandy was still there, and I could hear his laughter. 'A pity we don't have a bigger car,' my wife said, smiling.

Oskar Kokoschka

MEETING ONE of the *enfants terrible* of the early-20th century came about through the welcome appearance of a new national newspaper in England. The *Sunday Telegraph* was launched in 1961. Its first editor, Donald McLachlan, was an amiable donnish figure who was keen to assemble a team of young critics rather than the fogies who had been writing for the sister paper *The Daily Telegraph* for decades, among them the theatre critic who was by this time blind. Donald also loved the idea of art, perhaps more than the reality of it, and he was determined to find an art correspondent capable of writing on the subject without slipping into the customary jargon. He seemed to think that person was me, mainly because I was a journalist with a passion for art rather than a scholar and an academic. As a result, in 1962 he appointed me as the paper's first regular art critic. I was twenty-eight, and a very lucky man. I had parachuted into a top job in a somewhat specialist profession.

There was an instinctive directness about Donald which made him an outstanding editor. One afternoon he summoned his team of critics to his office and made a pronouncement which has become glued in my memory: 'All you young chaps know famous people in your field who are likely to die soon. I should like you to get interviews with them – in depth. We can then run your piece as a tribute when they die, and if they don't we can run it anyway at some appropriate moment. So, who do you suggest? Mullins?'

I came up with several names, among them that of Oskar Kokoschka. The following year, 1966, I pointed out, the great Austrian painter of 'Degenerate Art', as dubbed by Hitler, would be eighty. And the Tate Gallery in London was preparing to mount a major retrospective of his work as a tribute to one of the pioneering figures in 20th century art. Donald listened attentively. I wasn't sure if he knew who Kokoschka was; nonetheless he seemed to sniff cordite in the air and told me to get on with it.

Kokoschka had been a refugee in England throughout the Second World War but was now living in Switzerland. I had never met him, but had the deepest admiration for his work, particularly for the penetrating and disturbing portraits he had made of leading literary and musical figures in Vienna shortly before the First World War, and more recently for his panoramic cityscapes of the River Thames painted from high up in the Savoy Hotel. I also felt a good-humoured respect for an artist able to sign his work 'OK', which for a 'degenerate' artist seemed an entirely appropriate response to Hitler. So the next morning I approached his dealers in Bond Street, Marlborough Fine Art, who seemed keen on the idea of an 'in depth' interview with one of their most valued artists. They gave me a personal introduction to 'Okka', and when I enquired what I should take him as a present the reply was 'a bottle of Famous Grouse whisky would be extremely welcome, though it might be wise not to tell Olga, his wife.'

I picked up a hire car from Geneva Airport on a summer afternoon and drove along the length of the lake. It was in the years before motorways and the journey was more beautiful than I had imagined, with steep slopes laced with vines on one side and the broad sheen of water on the right against a backdrop of snow-crowned Alps. I passed through a series of lakeside towns including Vevey, which rang a bell as a place where posh English girls used to be packed off to 'finishing school'. Then towards the eastern end of the lake, Lord Byron's Chateau de Chillon jutted arrogantly into the lake. Finally, at the far end, the small town of Villeneuve, where Kokoschka had lived since he purchased a plot of land overlooking the water and the distant mountains in 1951, and built the Villa Dolphin for himself and his wife.

It was Olga who greeted me and straight away led me into the garden. 'I'll call Okka,' she said. 'He'll be with you. He loves it out here in the evening,' and she smiled affectionately. She was a gracious, soft-spoken woman, with a gently protective note in her voice when speaking of her husband. 'Here he is. He heard you coming.' The tall, lean figure familiar from so many photographs, crossed the lawn towards us, holding out his hand. 'My visitor from England,' he said with a deep thick accent '… who's going

to get me to say all the things I probably shouldn't say.' Olga smiled and made her way back to the house.

'This was a place of peace,' he said '... at last!' We stood gazing out at the lake in the evening sunshine. 'It was always a very special place for me.' Kokoschka's long, deeply-lined face wore a wistful expression as he explained how he felt he had come home here after a wandering life that had been torn apart by two world wars and years of exile. The view from here, he explained, was exactly the scene he had painted the very first time he came to Switzerland in 1910 – the distant Dents du Midi across the lake.

'It was wonderful to be able to come back. I'm lucky to be here', he added. 'And all this too.' He made a sweeping gesture, then led me on a tour of the garden which Olga so lovingly tended, he explained. 'She's an artist with flowers. I just paint them.' He laughed and bent down to peer closely at a cluster of Madonna lilies. 'Such beautiful things, flowers. Like butterflies. And such short lives.' I found myself thinking of the extraordinary contrast between the long battlefield of his life and this peaceful moment in old age as he, in his garden, was touched by the beauty of a flower.

Olga reappeared and called out, 'Time to come in, Okka. It's getting cold.' He gave a nod and we went indoors where Olga had prepared supper for the three of us.

Later I helped clear away the dishes as Kokoschka left to return to his studio. There were last-minute thoughts he needed to put down before they disappeared, he said. This seemed the cue for me to leave and make my way to the hotel where I had checked in earlier. Olga accompanied me to the car. 'Okka likes young people around him,' she said. 'He'll enjoy talking to you tomorrow. It'll take him back.'

Kokoschka was waiting for me the following day and seemed eager to begin. Olga brought us coffee and little biscuits during the course of the morning as we sat in the rather claustrophic studio cluttered with large unfinished canvases along with numerous sketchbooks, scraps of paper and newspaper cuttings, which he swept to one side to give me space for my tape-recorder and notepad. The bottle of Famous Grouse I had brought him was only half-hidden behind pots of paint. I got the impression Olga kept a watchful eye on Okka's secrets without the need to say anything. I had prepared a whole list of questions to ask, but now I was actually here I found myself saying quite simply, 'Tell me how it began?' Kokoschka looked surprised for a moment, then laughed. 'All right,' he said as if relieved. And he started to talk – first about his early life and school days, then his years as a student in Vienna. And as he talked he walked methodically up and down the studio, pausing from time to time to address me and sip his coffee. He chose

his words precisely, sometimes idiosyncratically, and I was reminded that he was a writer as well, author of several plays and his own recent autobiography.

What he offered me that morning was a précis of his life, unwinding it before me just as from time to time he enjoyed winding back my tape-recorder to listen to it again, savouring it and making sure he'd got it right. It was like listening to someone reading a play about himself.

It had been a violent and traumatic life, much of which I already knew from his autobiography, but in the retelling it became punctuated by dramatic moments he liked to emphasise – like the prize and grant he had won to enter the arts and crafts school in Vienna, which Hitler had failed to win, so explaining the Führer's hatred of his work.

'He got his revenge later,' Kokoschka added wryly. This led him to reminisce about having been included in the famous exhibition of Degenerate Art which Hitler's cultural minions mounted in Munich in 1937, aimed at ridiculing the European *avant-garde* – though since the show included works by some of the major artistic talent of the day (including Chagall, Kandinsky and Paul Klee) it had backfired with much hilarity outside Nazi circles. And Kokoschka's response had been to paint his *Self-Portrait as a Degenerate Artist* (now in the Scottish National Gallery of Modern Art, Edinburgh).

'The whole attitude of the Nazi establishment towards us was laughable,' he went on. 'We'd already had twenty-five years of opposing the conventional ideas of beauty – those absurd heroic figures and anaemic nudes looking as though they were made of bone china. The Nazis were the ones stuck in a dream world. We wanted art that was about emotions. Expressiveness. Vitality. About love. About life and death.' And he talked of his relationship with other painters central to the German Expressionist movement during those decades before the Nazis came to power – artists like Beckmann, Kandinsky, Macke and Franz Marc; and art movements like Der Blaue Reiter group in Munich and the Die Brücke painters in Dresden and Berlin. As he described them I thought of all those dark passions and dark gods that fill German art of Kokoschka's era, and nothing could possibly have been further from Hitler's ideal of Aryan purity. No wonder the Führer loathed them.

Yet Kokoschka never felt close to other artists in the Expressionist movement, either individually or as a group, he explained. He always remained a loner, generally avoiding the company of artists. 'But I always loved being with musicians,' and he spoke enthusiastically of having painted portraits of Schoenberg and Nijinsky.

The conversation had drifted well into the afternoon and before long the talk of music and musicians led to the love of his life: Alma Mahler. Kokoschka's affair with the widow

of the composer Gustav Mahler is widely documented and was widely publicised by Kokoschka himself in his paintings, in particular the fantasy-portrait of the two of them together, *Bride of the Wind*, which he painted in 1919 in a moment of romantic grief after Alma had left him for the architect Walter Gropius, founder of the Bauhaus.

Kokoschka stood by the open window of his studio as he spoke in an almost matter-of-fact way about one of the most publicly erotic love affairs of the 20th century. 'I was in love with the most beautiful woman in Austria,' he said casually. 'It was all very clandestine. I had to climb up into her room at night. Oh, I was in heaven . . . But then after several years it came to an end.'

He gave a shrug as though the end had always been inevitable. In fact she confessed later that she began to find her younger lover too demanding and their life together claustrophobic. Kokoschka's reaction was typically extreme. He explained, quite prosaically, 'when life is at its most beautiful, then you have to dive out of it, plunge into darkness.'

The plunge Kokoschka took propelled him into the Austrian cavalry during the latter stage of the First World War. He was sent to the Russian front dressed in his plumed helmet and resplendent epaulettes, as he showed me in a photograph. 'I may have been in the very last cavalry charge in the true tradition of the 18th century,' he explained. The outcome was horrific. Kokoschka was shot several times, bayoneted and left for dead on the battlefield. 'I lay there a long time, I lost touch how long. Curiously I found myself thinking about Wagner, in particular *Tristan*, and how he had taught me that life is only lent to you.'

His account of being eventually discovered by the fast-retreating Russians was pure black comedy. Fearful of being massacred, the Russians held up their half-dead captive at the window of their hut in full view of the advancing Austrians so that he could announce to his fellow-countrymen that he had a troop of soldiers here who wished to surrender. Which they gratefully did. Kokoschka himself was carried to safety and to hospital.

Back in Vienna, and recovered from his multiple wounds, he resumed his life as a painter. Now his lost love for Alma Mahler took a bizarre turn. He had a full-size female doll made for him. 'I'd take it to the theatre; she became my female companion – until one day at a party I destroyed it.'

Listening to these baroque tales in this setting of lakeside tranquillity was bewildering. It made me understand why he had found peace here *at last*. For so long he had lived his life in a storm – the magazine he regularly illustrated in Berlin before the First World

War was even called *Der Sturm*. At the same time I wondered if in old age he sometimes missed the storm, perhaps regretted that it had blown elsewhere. The *avant-garde* of the sixties was now across the Atlantic, with abstract painters in the wake of Mark Rothko and Jackson Pollock, whose work was entirely alien to Kokoschka and everything he believed painting should be. 'I don't give a damn about modern art,' he said fiercely. I got the feeling that much of that resentment was that artists in today's spotlight mostly saw him as irrelevant, and yesterday's fame a mere footnote in history. Younger artists were now writing the script.

He gave a shrug, then became reflective. 'My painting is my life story. Think of my love of red,' he went on. 'Red is my life-blood.' He went on to explain how much of his home town in Austria had burnt down two days after he was born. And, he chuckled, 'I think at heart I must be a pyromaniac.'

He talked of the restless years of travel between the two world wars. All round Europe, North Africa, the United States. He loved America, even the size of the steaks – 'hanging over the side of your plate like one of Salvador Dalí's limp watches.' He particularly loved London. In 1926 he painted the first of his panoramas of the River Thames. 'That long view to Westminster, I was always bewitched by its beauty. A river shapes a city; that's why I love London.'

And it was London that rescued him. At the outbreak of the Second World War he and Olga were in Prague, where ironically they had fled the Nazis. Then the Germans invaded Czechoslovakia. Somehow Olga managed to get hold of two tickets on the last plane to leave for London. 'It was all a rush. We had no visa, no money, just one half-finished painting and a few addresses of friends who might help us. And yet, you know,' and he made an expansive gesture with his arms, 'when I finally stepped out on to English soil, for me it felt like heaven.'

Friends did help them. They managed to get a flat in London which was cheap because it was high up without a lift. 'No one wanted to be that close to the German bombers. We were surrounded by chimneys. We'd look out in the morning and there was nothing but chimneys as far as you could see, except for the spaces where houses had been destroyed the night before. Holes that had been houses yesterday. That was eerie. You never knew what the next night would bring.'

Then for much of the war they moved to Polperro, in south Cornwall, and for periods of time to Scotland, which he loved – hence perhaps the taste for Famous Grouse. 'And after the war I became a British citizen.'

Finally to Switzerland, and peace. And with peace, and funds at last through his new dealers in London and New York, came the urge to share with younger people his experiences of being an artist throughout so many turbulent decades. He opened an annual summer school in Salzburg, calling it – significantly – his School of Seeing. 'I would tell my students never to miss the things in life that are astonishing. Things that move you, wake you up. For example', he went on, 'I love to go to a great museum like the Louvre or your National Gallery and talk, say to old Rembrandt. I can have wonderful discussions with him about one of his major works. That makes me happy and I have a surge of vitality.'

My days with Kokoschka were over. 'Okka has been happy talking to you,' Olga said on my last evening there. 'It makes him feel he's not forgotten. So many people are surprised he's still alive.' She gave a laugh. 'So am I sometimes, the life he's led.' I wondered whether she was thinking of the Famous Grouse or the Cossacks.

I took away a great many abiding memories of Okka during those few days. Among the most vivid was the account of his struggles to survive as a young artist in Vienna rebelling against the cultural conventions of the time, and the acrimony and scandal his art aroused. Then there was his ambivalent relationship with the German Expressionist movements in Vienna and Berlin; his exotic affair with Alma Mahler; his Byronic experiences in the First World War; his denunciation as 'degenerate' by the Nazis; and his last-minute flight to England. His life had been a crowded canvas.

But just as memorable for me were the unexpected cameos which felt like private insights into a gentler and more reflective self than the dramas of his public life: There was the Kokoschaka who enjoyed private discussions with Rembrandt; who imagined American steaks to be Salvador Dalí's limp watches; and his love of flowers – the flowers Olga lovingly tended in their garden of peace, and which Okka painted in delightful rapid watercolours that were alas far too expensive for me to buy. Then a final touch as we were seated in a favourite local restaurant on my last evening. I let on that I'd become a father for the first time two months earlier. Okka called the waitress over and asked her to bring three glasses of champagne 'to wet the baby's head.' And so we raised a toast to my baby daughter Frances. Then he added, 'You need a cuckoo clock for her room.' Tomorrow I'll take you to where you can buy one.'

Jacques Lipchitz

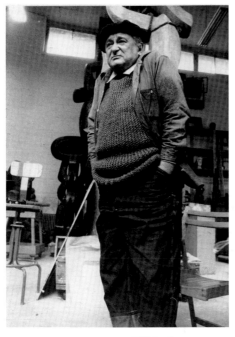

I am writing this on the 50th anniversary of the assassination of the American President John F. Kennedy on November 22nd 1963. This morning I took the London Underground to Regent's Park and walked the short distance along the Marylebone Road to where a memorial statue of Kennedy is mounted on a raised terrace between ornamental trees that were planted on the occasion when the statue was unveiled in May 1965 by the late-President's brother Senator Robert Kennedy (himself assassinated three years later). I took a few photographs, then walked round the corner into Great Portland Street and into the courtyard of the International Students House. Three blue flags bearing the letters ISH flew above the wall behind the memorial, demonstrating that the Students House is its custodian.

In the lobby I enquired if there was perhaps someone who could tell me how the memorial statue came to be here. I was told to wait. A few minutes later a smiling dark-haired lady introduced herself as Shireen Aga and she handed me her card which described her as Head of Alumni Relations, which sounded very Transatlantic. Yes, she said, the ISH was extremely proud to have the Kennedy memorial on its premises. It was also most touching that people often laid flowers around it; she imagined there might well be some there later today since it was the anniversary of his death. She wasn't

entirely sure of the history of the statue, except that there was a plaque behind the memorial which referred to a public subscription of some sort; if I wished she could put me in touch with someone who knew more. I thanked her politely, but declined the offer.

I could have told her the following story.

A few days after the Kennedy assassination in November 1963 the *Sunday Telegraph* invited its readers to contribute to a fund which the paper was setting up to sponsor a memorial in London to the much-loved American president. The paper had been launched only a few years earlier and there was an element of Fleet Street one-upmanship about the initiative taken by its first editor, Donald McLachlan. At the same time Donald had a strong egalitarian streak in him and he insisted that individual donations to the fund be limited to £1. He wished it to be the people's memorial, not some lavish corporate endeavour. Knowing that Donald secretly fancied himself as a patron of the arts I had a hunch that as his art critic I was going to be drawn into this venture. Sure enough a short while later I was summoned to his office. The response of readers was most heartening, he said. So it looked as though there would be enough in the kitty to commission something really good. What did I think?

I was fairly sure that a memorial to a man as well-known and well-loved as Kennedy would need to be a portrait in some form, and that our readers who had paid for it would certainly expect that. Donald agreed. 'Right, Mullins! It's a portrait bust, then, suitably mounted and all that. Who would do it? You know about these things. You come up with an idea.'

It was an alarming gesture of confidence, considering that I'd been with the paper little more than a year. There were fleeting moments when I felt like a Renaissance pope about to summon Michelangelo to do a portrait for me. Rather longer moments were spent wishing to hell someone could make the choice for me. Eventually I calmed down and began to see it as a daunting challenge and that I'd better get it right.

But what exactly *was* right? Various respectable bodies such as the Royal Academy and the Society of Portrait Sculptors no doubt possessed members with the skills needed to produce a decent likeness in bronze, and it would take its place among the scores of other portrait busts of yesterday's politicians and generals in London's squares and open spaces. Furthermore, I didn't imagine that any among them would turn up their noses at £50,000 for producing a portrait of the world's most celebrated statesman to be placed in some prominent location in England's capital city. I would only have needed to click my fingers.

Perhaps if the subject had been a former Governor of the Bank of England or Chief of

the Imperial General Staff this would have been the route to take, and I might never have thought twice about it. But something else nagged at me. This was Jack Kennedy, the most charismatic and powerful political leader of our day – a beacon for a new age, a pioneering figure who personified the hopes and aspirations of the modern world – and who had just been murdered. The world was in mourning. To honour such a man appropriately it seemed to me important that an artist of international stature be chosen. On a parallel line of thought, as someone whose job was to frequent public museums and galleries I was acutely aware of how resistant this country had been to the leading currents of modern art, and how poorly represented they were in our national collections. Parochialism and mediocrity ruled. It was only a few years since a former Director of the Royal Academy, Sir Alfred Munnings, had pronounced in a BBC radio broadcast that Cézanne, Matisse and Picasso had corrupted art –an outburst prompting Picasso's response, 'Who is this Sir Munnings? I haven't heard of him.'

At the arrogant age of thirty I may have become infused with cultural snobbery. As far as I was concerned everything about the Royal Academy stank, while everything about Paris smelled of roses; New York even more so. Nonetheless it seemed of the greatest importantance at that time that the Kennedy memorial be created by someone Picasso *might* have heard of, and not some workaday hack who earned a living doing portraits for company boardrooms and regimental HQs. Alas my bright vision of 'modern art' somehow storming the Victorian barricades of London possessed one colossal flaw. Portrait sculpture was hardly the burning preoccupation of today's *avant-garde,* and there were dark moments when I began to imagine myself required to explain to the readers of the *Sunday Telegraph* why the late American president was an apparent candidate for famine relief or had one eye where his ear should be.

I consulted books. I spoke to friends and to people in museums and galleries. It became clear that a painted portrait would not have been a problem; a number of eminent artists had recently produced outstanding portraits that were naturalistic without being in the least dreary and academic, Oskar Kokoschka, Graham Sutherland and Lucien Freud among them. But with sculpture it was different. Since Rodin and Maillol, naturalistic portraiture had become a dead art. One bright light lit up this grey landscape. He was Jacques Lipchitz. Lithuanian by birth he had moved to Paris as a young man before the First World War where he enrolled at the Ecole des Beaux-Arts and soon became drawn into the *avant-garde* community of the Paris Left Bank which included Pablo Picasso, Juan Gris and Amadeo Modigliani (who painted his portrait). Hence Lipchitz's

own career was launched at the very birthplace of modernism at a time when artistic innovation was in full flood, and Paris was the capital of this brave new world. His early sculpture was Cubist, tastefully formal and impersonal, though before long he found his feet and began to create strange expressionist fantasies in a variety of forms and imagery. His work was dynamic and disturbing.

I was aware of the wild, manic aspect of his sculpture because I had recently seen examples of it in the United States, where Lipchitz had fled as a Jew at the outbreak of the Second World War. Barely a month before President Kennedy's assassination I had made a tour of east-coast museums on my first-ever visit to America; in the Philadelphia Museum I had come across his huge bronze entitled *Prometheus strangling the Vulture* which he had begun towards the end of the war and had occupied him for a number of years. My own taste in modern sculpture had always been for the purer lines of Brancusi, Arp, Barbara Hepworth and Alexander Calder. None the less this startling bronze of Lipchitz exuded an explosive energy, as if the battle between Prometheus and the vulture was being re-enacted before our eyes in a tangle of limbs and muscles. Like it or not, this was sculpture striving to embody naked forces of human energy. And much the same dramatic impact was made by a second bronze which had only recently been set up not far from the Philadelphia Museum in Fairmount Park, entitled *Spirit of Enterprise*. Here again was sculpture on a grandiloquent scale.

It seemed most unlikely that an artist so committed to dehumanising the body's physical powers should also be in the business of making naturalistic portraits. Yet exhibition catalogues I consulted demonstrated that this was so, as did examples of his portraiture shown to me at the Philadelphia Museum, as well as at the nearby Barnes Collection in Merion, put together by one of Lipchitz's principal patrons, that insatiable devotee of contemporary art whom I would dearly love to have known, the late Dr. Albert Barnes.

My most prominent thought as I reflected on all this was that if Lipchitz could channel the explosive energy of his monumental work into a portrait, then the memorial to Kennedy might express something of the stature and character of the man rather than offer just another reminder of what he looked like. I tried to imagine what Rodin would have made of such a commission and I dreamed that this might possibly match it.

Such were the high-flying notions which I took along to Fleet Street and presented to my editor. Donald sat back with the air of a tutor listening patiently to a student's stumbling essay. Then he said rather disarmingly, 'Well, go ahead then, Edwin.' I was

less surprised by his verdict than by his use of my first name. He was an old-fashioned man much given to friendliness but not usually to intimacies. I'd obviously passed some kind of test.

The next step was how to get in touch with Lipchitz. I guessed, rightly, that his agents were likely to be the most successful modern gallery in London, Marlborough Fine Art in Old Bond Street. I knew the two principal directors slightly – Harry Fischer and Frank Lloyd. The two men had been, like Lipchitz, Jewish refugees from Hitler's Europe. They had fled to England and became drafted into the British army during the war, where they served as privates in the Pioneer Corps carrying out the most menial of physical duties. It was here, over buckets and spades, that the two men met and where they planned to set up an art business together after demobilisation – which they duly founded just one year after the war. Within five years they had become phenomenally successful, selling works by many of the leading artists of the last hundred years from Monet and Van Gogh to Braque and Matisse. They were a formidable duet: Harry Fischer knew about art and Frank Lloyd knew how to sell it. They were greyhound and rottweiler. I arranged to go and see them.

It was an entirely new experience for me. Hitherto I had only met them at exhibition openings where they would smile as they handed you a glass of champagne in anticipation of a favourable review. They were always patronisingly polite. Now it was quite different. There were just the three of us in a private room above the gallery. I explained about the proposed memorial, that we had £50,000 to spend, and that we hoped Mr Lipchitz might accept the commission. There was no question of any more money; the sum was the contribution of our readers, none of whom had been allowed to give more than one pound.

I suppose I hoped for some expression of surprise and pleasure that fifty-thousand individuals should be underwriting such a commission; I didn't imagine Marlborough Fine Art often had that number of clients clamouring at their door. But I remember the reaction well: Harry Fischer said nothing and looked steadily at Frank Lloyd. The latter's face remained expressionless; yet never before or since have I been made so vividly aware of watching the silent operation of a cash machine. Eventually Lloyd nodded towards Harry Fischer and began to mutter what was clearly a list of potential venues in the United States where such a memorial might be welcome. After a moment of bewilderment I began to feel a surge of indignation. I hadn't imagined this meeting was going to be about an art dealer openly calculating how much money he could make out of a proposal to honour a dead American president. I blurted out that surely there should be an agreed limited number of bronze casts made of the portrait bust. The rottweiler

awarded me a glare that could have drawn blood. Nothing further was said, and a few minutes later the glacial meeting ended with the coolest of handshakes.

Harry drew me aside as I left. 'You're right of course,' he said in a low voice. 'Don't worry. I'll see to it. Ring me tomorrow.' I came away cautiously hopeful, conscious at the same time that a shiny piece of my innocence had fallen away.

Harry had already spoken to Lipchitz by the time I phoned the next morning. In principle he was happy to accept the commission. Harry sounded excited; the prospect of having an example of Lipchitz's on public display in this country was a cause for celebration, he said, and invited me to lunch at the Westbury Hotel. He explained that it often seemed as though the modern art movement had passed England by, as though we lived on a different planet. As for the Kennedy portrait, Lipchitz would like to meet me first, Harry added. Could I come over once the winter was over?

So, in the spring of 1964 I flew to New York. After a couple of days revisiting the museums and art galleries of so favourite a city I took the train upstate to Hastings-on-Hudson where Lipchitz had lived and worked since the 1950s.

Lipchitz had given me directions to his studio. As he opened the door I found myself in a place which had the proportions of a modest-sized aircraft hangar, littered with sketchpads, photographs, books piled here and there on the floor, and everywhere small plaster maquettes and bronzes set on rickety-looking trestle tables. Lipchitz welcomed me to what he called 'my workshop.' He himself was dressed like a workman, a hunched figure in a dark beret, a stained denim jacket and baggy jeans turned up at least six inches at the foot. We could have been back in Montparnasse. Thirty years on the Paris Left Bank had left its mark.

We lunched in a nearby restaurant that also had a touch of France, which clearly pleased Lipchitz, and over a *biftek* and a bottle of Mâcon we talked about Paris, of course, but mostly about Italy where he had begun to work for a period every summer in Pietrasanta, Tuscany, close to the marble quarries made famous by Michelangelo. I had brought my tape-recorder, but it felt too informal an occasion to use it; instead I placed a discreet notebook beside me on the table. It grew on me in the course of lunch that he didn't particularly want to talk about the Kennedy portrait, but as I'd come all this way at *The Telegraph's* expense I thought I'd better make sure he was happy to do it. He sounded quite surprised to be asked. 'Of course, yes!' he said. Then he added that he enjoyed doing portraits from time to time. It kept his feet on the ground, he explained. It was like using his skills and giving his imagination a rest.

He was obsessive about making sculpture, he went on. 'Working is my passion. I hardly do anything else. I often wonder why: perhaps it's warding off death; an act of defiance.' The fact that Kennedy had died so shockingly made him want to make something about him that would last. Then he told me how a few years earlier he had been diagnosed with stomach cancer. Before the operation he had said to the surgeon that if it became obvious that he'd never be able to work again 'please finish me off.' The surgeon had been furious; nonetheless when it was all over Lipchitz found a small phial had been left for him. 'Looking back I thought it would have been a pity to die because I had so much to do.' Then by 1959 I was working again. I didn't ask what happened to the phial.

We walked back to the aircraft hangar of a studio. He stood for a while with his hands deep in his pockets and gazed around him at the world which was his work in progress. And for a moment he looked almost perplexed, as if he hadn't expected it to be here. I remembered what he had said over lunch about art warding off death, and I imagined he was thinking that all of this might so easily not have existed. Then, as if a spell had been broken he turned to me and said with an air of finality, 'Yes, I've had a difficult but wonderful life.'

He agreed to start work on the Kennedy bust as soon as possible. It was difficult with someone so well-known but not actually there in front of you. He'd do his best, he assured me; and perhaps I'd like to come back later in the year to see what he had achieved. He'd like that, he said.

I rang Harry Fischer from New York to tell him the deal was 'on', and suggested he contact *The Sunday Telegraph* editor and draw up whatever contract was appropriate. I hoped the rottweiler could be persuaded to keep his hands off it, and diplomatically suggested as much to Harry, who gave a grunt down the phone which I took to be a 'Yes'. Back in London negotiations were already in progress over where the Kennedy Memorial should be placed, and which public building would be most suitable to be its custodian. Donald McLachlan was becoming exasperated by endless petty objections being raised by planning authorities and local functionaries, and at one particularly fruitless meeting was heard to suggest that in view of the Cuban missile crisis when Kennedy had called the bluff of the Russian leader Nikita Khrushchev, the Russian Embassy might be a suitable venue. Common sense eventually prevailed in the choice of a prime site on the Marylebone Road that would be incorporated into the new International Student's House now under construction.

That autumn I returned to New York and took the train to Hastings-on-Hudson as

I had done in the spring. This time I was accompanied by a photographer, Ugo Mulas, an engaging Italian now based in New York who specialised in working with artists and who knew Lipchitz well. *The Telegraph* was anxious to have publicity material on the forthcoming memorial and, as soon as we heard that the portrait was finished and ready to be cast in bronze, Donald told me to get moving and meet up with Mulas in New York. 'Tell him, Edwin, to make Lipchitz look as arty as possible.' Remembering the beret and the turned-up jeans I assured him this would not be a problem.

Ugo Mulas loved artists. He was particularly fond of Alexander Calder, whom he urged me to get to know. (Some years later I was visiting Calder in France when he showed me a book of photographs Mulas had taken of him at work. 'Great, aren't they?' Calder said. 'Shame he died.' Ugo had only been in his forties.)

We found Lipchitz in a low-key mood. He looked exactly the same, and I found myself wondering if he possessed a number of identical black berets and identical jeans each of them six inches too long. There, in the centre of the crowded studio, mounted on a heavy slab, was the life-size clay bust of Jack Kennedy. Ugo barely said hello before moving around the studio taking shots from all angles, sometimes catching Lipchitz unawares as he stood gazing elsewhere with an air of majesterial aloofness. This was clearly a duet he and Mulas had played together many times.

We took him to lunch at the same restaurant as before, with Ugo still snapping away with his Leica as we crossed the road; Lipchitz as oblivious as ever to the photographer's antics. Over lunch the sombre mood lifted as he began to explain the problems he'd experienced over the Kennedy bust. He had never met the late president, he explained, though of course like the rest of the world he was entirely familiar with his face. What was more, friends of Kennedy and members of his family kept offering advice: Pierre Salinger, the White House Press Secretary, sent him books and reams of photographs. But the more material Lipchitz gathered around him the less confident he had felt about the portrait. 'It sounds absurd, doesn't it?' he said with a grimace, 'but I came to believe I was the only person in the world who didn't know what Kennedy looked like.' The grimace softened and he gave a laugh. 'I suppose it's taught me something,' he added. 'I'll never do a posthumous portrait again.'

It had taught me something too. Ugo and I talked about the events of the day on the way back to New York on the train. I explained how we had come to choose Lipchitz in the first place; how I had thought it important to have the portrait bust done by one of the leading sculptors of our age and that it should be something London could be

proud of. Ugo looked at me knowingly. 'I'm afraid a portrait bust of a dead politician has got bugger-all to do with modern art,' he said with a laugh. Another shiny piece of my innocence had fallen away.

On the morning of May 15th the following year, 1965, the Kennedy memorial was unveiled by his brother Senator Robert Kennedy, who made a gracious speech thanking all those who had contributed. I overheard the proprietor of *The Telegraph,* Lord Hartwell, murmur to the editor, 'Not a bad likeness.' Lipchitz himself had declined to be present.

And that was the story I declined to tell Shireen Aga, Head of Alumni Relations at the

International Student's House, almost half a century later. She reiterated that she wished she could help me more and urged me to go and read the plaque attached to the wall behind the monument, though it had become quite hard to read after all this time, she added. I thanked her and assured her that I would do so. Returning to the Marylebone Road I stepped past the memorial to refresh my memory of the wording. After describing the unveiling by the late president's brother and attributing the work to 'the American sculptor Jacques Lipchitz' it concluded with the words: 'This memorial was subscribed for by over 50,000 readers of *The Sunday Telegraph* in amounts limited to £1.'

As I turned to leave I noticed a bunch of flowers had been laid at the base of the memorial.

Bernard Leach

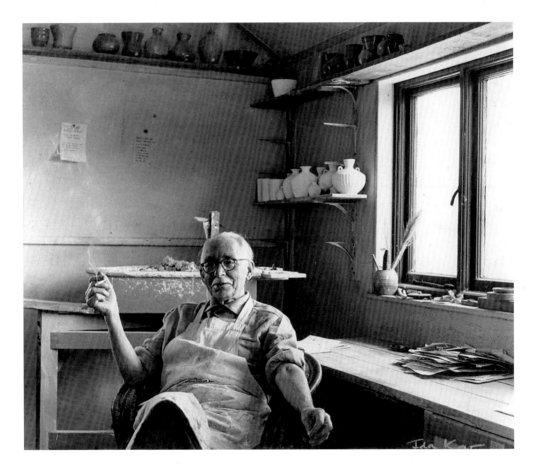

As a boy I remember being told that our soup bowls and coffee cups had come from the Leach Pottery in Cornwall, and that they were handmade. This impressed me deeply and I took great care not to drop them. But over the years these precious cups and bowls became

increasingly chipped and cracked, and as my mother Gwen's appetite for housework diminished to vanishing-point it became necessary to clear the spiders' webs and remnants of yesterday's cornflakes before sitting down to breakfast. Gwen was a potter herself as well as an expert weaver, and she explained to me that Bernard Leach would not have made our bowls and cups himself, though he would certainly have designed them.

So I was well aware of the doyen of studio pottery a good many years before I had the chance actually to meet him. This took place in 1961, when I was in my very first job as a journalist. This was as the most junior sub-editor on that hallowed British institution *The Illustrated London News,* or the *ILN* as we all knew it, the world's first illustrated weekly. The *ILN* had been founded in 1842 and was long famous for having acquired world rights to the coverage of the discovery of Tutankhamun's tomb in Egypt and for having commissioned the first war artists in the Crimean War. The editor who hired me was Sir Bruce Ingram, grandson of the paper's founder, a man now in his eighties who had been editor since the year 1900. Now and again he would decide to take me out to lunch at the Ivy, and over a bottle of excellent claret he would regale me with stories of those early days when illustrated journalism was in its infancy and he found himself having to arrange coverage of Queen Victoria's funeral. 'I was younger than you, dear boy,' he would declare lighting yet another cigarette.

Sir Bruce was a passionate art collector, particularly of Dutch 17th-century drawings. He would occasionally invite me to his Buckinghamshire mansion for the weekend and, after dinner and brandy, he would spread drawings all over the floor of his study and kneel among them peering closely at one after another, a cigarette between his lips. (Years later an expert at Christie's told me proudly that you could always tell an Ingram drawing when it came up for auction because of the burn-marks; they were like a certificate of merit and ensured a good price.)

He gave me a job on the *ILN* largely because I loved art and frequented the museums and galleries. As for becoming a journalist, Bruce just shrugged – 'You'll pick it up, my boy.' Actually I picked it up writing the weekly page of brief obituaries and 'Persons in the Public Eye.' This was the least favourite task on the paper, invariably a last-minute rush just before going to press on a Monday, and traditionally awarded to the most junior member of the editorial staff. On the other hand, my reward for loving art was to keep Sir Bruce informed of whatever was going on in the art world, chiefly in London but also in Paris and New York whenever there were major exhibitions or art auctions that needed to be covered. This involved a lot of time on the telephone, but more particularly a morning each

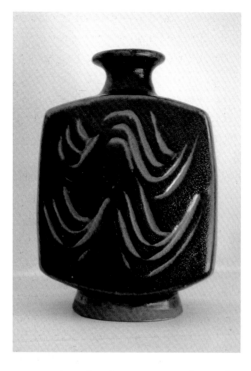

week patrolling Bond Street and St. James' getting to know the leading dealers and art auctioneers who would then supply me with photographs of works in forthcoming exhibitions and sale-rooms for Sir Bruce to choose and drop ash on later that day. And it was in the course of this weekly tour of galleries that I first met Bernard Leach.

The Arts Council at this time occupied a handsome building on the corner of St. James' Square. As I was crossing the square on my way to Christie's in King Street, two figures about to enter the Arts Council building caught my eye. I recognised from photographs the tall stooped figure of Bernard Leach, and the younger woman with him I took to be his American wife Janet. At that moment another woman appeared at the door to greet them. I recognised her as the Arts Council director of exhibitions, Joanna Drew, whose company I always enjoyed. As she ushered her guests inside she noticed me and beckoned me to join her. She then introduced me to Bernard and Janet. 'Edwin writes about art,' she said somewhat vaguely. Bernard nodded. 'Good! Then he should have a look round,' his wife added with a smile in a deep Texan drawl. 'Well, why not?' Joanna chipped in. 'The Private View's this evening, but you may as well have a sneak preview, Edwin.'

The exhibition was entitled *50 Years a Potter,* and it covered Leach's early years spent in Japan, but chiefly the work he had achieved since founding the Leach Pottery in St. Ives in 1920, including a rich display of recent pots made since Janet took over the day-to-day running of the pottery in the 1950s, freeing Bernard to concentrate on his own work. Bernard and Janet were led away by Joanna to her office upstairs, leaving me to my sneak preview. I felt privileged and rather excited to be wandering round the galleries entirely alone, surrounded by a man's life's work. After a while I found myself thinking, 'Could I possibly buy one of these?' I had never bought a work of art in my life. It was something only rich people did, I imagined. One piece I specially coveted was a handsome dark

bottle, tall with a narrow neck flattening into a broad rim that made me want to run my hands across it. On a nearby table I caught sight of a numbered price list. My piece was No. 52 and it was seventy-five pounds, roughly what I earned in a month. But I knew I was going to buy it. And I felt like Rockefeller.

I was so absorbed gazing at 'my' pot that I was quite unaware of Joanna standing behind me, with Bernard and Janet just a few yards away. I blurted out that I would like to acquire No. 52, please, and fumblingly produced my cheque book. Joanne laughed. 'This is the Arts Council, Edwin. I'm not allowed to take money,' and she turned to Leach. 'Your first customer, Bernard.' Leach bowed graciously, which made me feel even more awkward. 'Raku,' was all he said. Then he smiled and placed a hand on my shoulder. 'Good choice,' he added. 'Come and see me if you're ever in St. Ives.' That evening I looked up 'raku' and learnt that it was a style of pottery and glaze traditionally used for the Japanese tea ceremony, and introduced to this country by Leach himself at St. Ives in 1922.

My raku pot was to become something of a landmark because it sparked in me a love of studio pottery which has never faded. My small collection has moved with me from house to house, and today as I write this appreciation of Bernard fifty-three years after that first chance meeting, they still preside silently over my workroom above the clutter of books and papers, and the Gorgon's eye of my computer. In their wonderful variety of

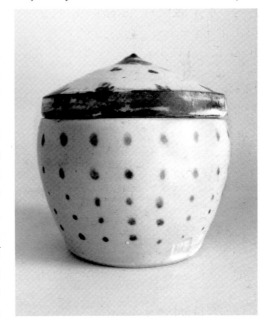

shapes and textures they have a life about them; they are so many still-lives in clay. It was sometimes levelled at Bernard that his work represented a hybrid culture, an uneasy cross-breeding of two artistic cultures, east and west, which were too far apart ever to be fused. I have always found the opposite to be true. Just as the paintings of the Post-Impressionists (Van Gogh in particular) were greatly enriched by the impact of Japanese prints arriving in Paris, so the earthy tradition of English slipware pottery was given a welcome lightness of touch by Leach, and those solid shapes of rustic cider jars and milk jugs became sophisticated objects decorated with

delicate images of flowers and fish often reduced to an almost abstract pattern dancing across the surface.

It was four years before I saw Bernard again. The invitation to visit him in St. Ives finally became a reality in 1965 when I spent several weeks in the town researching a book on the local fisherman-painter Alfred Wallis, whose work I loved. Wallis had died in 1942, but there were still quite a number of people in St. Ives who remembered him and had colourful tales to tell of this solitary old widower who fancied himself as a real painter just like the posh artists who came down from London every summer and set up their easels on the quayside in the sun. Among the few who had taken Wallis seriously were fellow-artists Ben Nicholson and his wife Barbara Hepworth. Bernard Leach was another. He had been in St. Ives for the whole period of time Wallis was painting there. Although he never got to know him, Bernard had always respected him for his lonely dedication to his art; and when Wallis died in the early years of the Second World War Bernard undertook to make his grave. Wallis had died in a poorhouse and would have been buried in a pauper's grave but for a few supporters who purchased a plot in Porthmeor Cemetery. It was here Bernard employed the limited wartime resources of the

Leach Pottery to create a grave made up of hand-painted tiles, with the dominant image of a lighthouse into which a tiny figure is shown entering.

Bernard took me there to look at it. I had spent much of the morning at the Leach Pottery – first being fascinated to watch Bernard at the potter's wheel, his long fingers seeming to do no more than caress the clay as it rose upwards at his touch, while Bernard himself grunted and sometimes whistled through his teeth. I then sipped tea with him and Janet in the Japanese style until Janet decided a whisky was more appropriate for the hour.

It was a short walk from the pottery to Porthmeor Cemetery, and soon we were looking down at the low grave. Bernard was looking pensive and said nothing for a while. Eventually he broke the silence. 'What seemed to me so very important was to capture something of the spirit of that little man,' he explained carefully, weighing every word. Bernard had a voice that could be rich and sharp at the same time and as he spoke he gestured with those long powerful hands as though they were still moulding clay. 'There's a lighthouse in so many of Wallis' paintings,' he went on. 'Of course there is! He was a mariner. Lighthouses guide you. They warn you. They would have been central to his life. That's why I wanted his grave to be like this, a tiny figure stepping into the dark in order to climb up into the light.'

I often recall those words of Bernard as we stood in the St. Ives graveyard in the spring sunlight looking out over the Atlantic and the Cornish coastline Wallis painted so often. There was such empathy – unexpected – between a semi-illiterate Cornish fisherman and this sophisticated man of the world. I found myself warming to Bernard even more, conscious of the profoundly thoughtful nature of the man and of the spiritual search in his make-up. Perhaps these were the qualities which made his pots so much more than mere pots to put things in. In Bernard's hands a simple object of domestic use could become a work of art.

Our next meeting, a year later, was in London. He invited me to an exhibition of his new work at Primavera, a unique crafts gallery run by the indomitable Henry Rothschild, the only poor Rothschild I ever met. Bernard was sharing the exhibition with Shoji Hamada, Japan's leading studio potter who had once been Leach's protégé in 1919 during the latter's years in Tokyo. Bernard introduced me to the small smiling figure of Hamada, a man shrouded in appealing modesty. Then he drew me aside to explain that due largely due to his friend's influence he had been awarded the Order of the Sacred Treasure in Japan – 'Second Class' Bernard added with a chuckle.

From the late-1960s I began to see Bernard more regularly. My wife Gillian and I

took to spend summer holidays in St. Ives with our young children. Sometimes Barbara Hepworth lent us one of the flats overlooking Porthmeor Beach which she used as studio for print-making. At other times we rented one of the other flats in the same block, Barnaloft. Bernard had separated from Janet by this time, though she still ran the pottery, and he was now living on his own in another of the Barnaloft flats. Bernard was now in his eighties. His sight was failing and he was spending more time writing his memoirs than making pots. This most outgoing of men was retreating within himself, and there was an air of spiritual solitude about him. I saw a good deal of him during those summers, often just sitting and talking on the beach, Bernard in totally inappropriate clothes as if he hadn't noticed it was summer, while our children built sand-castles close by, filling the moat with sea-water which Bernard would suddenly stir vigorously with his stick pretending to be an invading force.

Sometimes he would call round for a whisky in the evening after the children were in bed. Gillian, who loved him, decided to invite him to dinner. His passion, we knew, was for mussels; so she planned to serve him *moules marinières*. We had noticed where the richest mussel beds were and recruited the kids the following morning to help us gather them in quantity from the rocks. That evening Bernard tucked a napkin firmly under his chin and prepared to do serious battle with the mussels accompanied by appreciative noises. For half an hour the only other sound was the clink of shells being dropped into a large bowl in the centre of the table. Finally Bernard rose, spread out his arms wide, and pronounced 'Perfection.' We felt delighted and rather honoured to have been able to give him so much pleasure. The next morning we recounted our gastronomic triumph to a friend, Roger Slack, who was the local doctor. 'And where did you gather the mussels?' he enquired. We told him it was by the nearby headland known locally as The Island. There was a sharp intake of breath. 'That's exactly where the town sewage is piped into the sea,' Roger explained in a disturbingly soft voice.

We hurried back to Barnaloft in silence, expecting every minute to hear the wail of an ambulance. To make matters worse there was no response to Bernard's doorbell. Gillian and I hardly dared look at one another. Then, turning away we caught sight of the familiar tall moustached figure standing outside our own door. Seeing us, he waved his stick cheerfully. 'I came to thank you for a delicious dinner,' he announced. 'My favourite.' That evening we opened a good bottle of wine. Many weeks later Gillian admitted she was still haunted by the thought that she might have polished off one of Britain's leading artists.

In 1972 Bernard finally gave up making pots. We were in St. Ives that spring shortly before the birth of our third child. When I called on Bernard he was sitting in his chair going through a sheaf of correspondence with the aid of a magnifying glass. His assistant, the faithful Trudi, was hovering about making tea, plumping up cushions, adjusting his chair. He greeted me with his usual warmth and explained that he rarely went to the pottery any more. I found myself thinking sadly that he had been compelled to give up the place he had founded more than half a century before. We talked a great deal over the next few days, mostly about the books he was writing. This was where his energies now lay. What little remained of his eyesight still allowed him to write in a shaky longhand, to be transcribed by Trudi.

Over the next few years a regular sequence of books appeared, among them *The Unknown Craftsman, Drawings, Verse and Belief* and *Beyond East and West.* Bernard touchingly sent me copies. This concentration on writing also led to a flow of correspondence between us, his letters typed at his dictation by Trudi, then signed by Bernard, his once-beautiful calligraphic handwriting now reduced to a signature that grew increasingly wobbly as the years passed. In 1973 he wrote to inform me he had been made a Companion of Honour. When I rang to congratulate 'the Honourable Bernard' he chuckled, though there could be no concealing the pride he felt.

Then in 1976 Carol Hogben of the Victoria and Albert Museum in London was preparing a major retrospective of Bernard's work for the following year, as well as editing a companion book for which he asked me to contribute a chapter on Leach as a Writer, to be published by Faber and Faber. I had also been writing articles about Bernard in art magazines and for *The Daily Telegraph,* which prompted a letter from Bernard which surprised and delighted me. 'I have at last heard the full content of your article on me,' it began. I realised he could no longer read at all and relied on Trudi to read everything aloud to him. 'I have been much moved by it,' he went on, 'and it warmed up my tummy ready for supper.' I am puzzled to know what I can possibly have written, because the letter went on – 'occasionally I stopped Trudi at a sentence, sometimes in the laughter of appreciation.' This was followed a week later by another letter apologising for the nonsense he felt he had written before, while insisting that 'your subtleties delighted me and you missed nothing.' The letter ended with a lament that Japanese tea rooms in Tokyo were becoming whisky bars.

I look at these letters today – on yellowing paper – in Trudi's rather approximate typing and Bernard's signature becoming increasingly a battlefield of swirling shapes some-times disappearing off the page – and I feel a deep privilege at having been in the

thoughts of this remarkable man during the loneliness of his old age. It was a relationship that had begun with a chance meeting in St. James' Square almost two decades earlier.

Bernard was now nearing ninety. His virtual blindness sometimes brought out a brave sense of humour in him. In October 1977 he wrote to me about a television series I was presenting for the BBC. It was entitled *One Hundred Great Paintings,* each painting being the subject of a ten-minute film. Bernard explained that he had 'enjoyed listening to it' and got so excited trying to imagine what the painting looked like that he wondered if he would ever be able to get to sleep. Then, when the Faber book came out a few months later, Bernard wrote to say how much he appreciated my summary of his predicament as an artist divided between cultures so far apart. I had written of his endeavour to 'make the adjustment between East and West, between old and new, between the quiet values of the Japanese Tea Ceremony and the rowdy demands of the jet age.'

'What you wrote touched me very deeply,' he added.

It was the last letter I received from him. A year later, in 1979, Bernard died at the age of ninety-two. When a friend rang to tell me of his death I was working in my room. Facing me were the open shelves I had built to hold my small collection of studio pots which always kept me company. Standing among them was the tall *raku* bottle which had been my first-ever art purchase. And in my head I heard Bernard's quiet voice as I was buying it, 'Good choice. Come and see me if you're ever in St. Ives.'

Lucie Rie

In the 1991 honours list the studio potter Lucie Rie became *Dame* Lucie, DBE. The title could not have been bestowed on someone more deserving; yet when I heard the news I was struck by how unlikely a recipient of such an honour she would have seemed back in the 1960s when I first got to know her. All Lucie did, after all, was make pots! And in the rarified London art world of Abstract Expressionism, Action Painting and Hard-Edge, pots didn't figure much.

It was an invigorating time to be involved in the London art scene. From being something of a backwater to Paris and New York the city had become a major international art centre. This was to a large extent due to the financial drawing-power of the two rival art auctioneers, Christie's and Sotheby's – a success undiminished by Christie's still insisting on dealing in guineas while Sotheby's had boldly moved into the modern world and sold its Constables and Turners in pounds. Whatever the coinage, collectors now flocked to London to spend money. To feed their appetites new galleries began to spring up like mushrooms, run by a new race of polished young men in Armani suits keen to promote themselves as the heirs of Vollard and Duveen.

There was one conspicuous absentee in this fresh-faced company. Not a single gallery-owner among those I would visit regularly concerned themselves even remotely with the contemporary crafts. There were just a few isolated crafts galleries such as the Crafts Centre in Hay Hill and Primavera in Walton Street, both run on a shoestring by passionate devotees of the crafts; and I was virtually the only art critic who ever thought it worthwhile to visit them. I'd buy the occasional pot or rug because they caught my eye and because they were within my price range, unlike most of the paintings in Bond Street and Cork Street galleries. In art circles the crafts were generally considered to be little more than a hangover of the William Morris era best suited to Women's Institute stalls at county shows keeping company with homemade jams and a formidable lady in a poncho giving demonstrations of wool-spinning on a wheel. It was all a rustic contrast to the world of 'high art', as the fashionable American critic Clement Greenberg termed his favourite painters such as Frank Stella, Willem de Kooning, Robert Motherwell and Morris Louis. Everything else was 'low art' and not worth considering.

I had been raised in a quieter world. When I was a boy my mother, Gwen Mullins, was taught pottery and weaving at Farnham Art School in Surrey, and our house had been decorated with woven wall hangings by Peter Collingwood and pots by her teacher Henry Hammond, as well as others by Lucie Rie, Hans Coper, Michael Cardew and Bernard Leach. They all kept company with contemporary paintings by Ivon Hitchens and John Nash, forming a natural harmony of different creative skills, as it seemed to me. She also founded the Gwen Mullins' Trust to help struggling craftsmen, for which she was later awarded the OBE.

But now, in the bustling world of London art galleries, there was no such harmony between the arts and crafts. My contemporaries in art journalism and the gallery owners I knew well, if they had even heard of Bernard Leach and Hans Coper, regarded them

as inhabitants of some distant planet probably shared by Somerset basket-weavers and flower-arrangers of the school of Constance Spry. There was one unlikely exception. The Berkeley Gallery in Mayfair had been run since just after the Second World War by the collector and entrepreneur William Ohly, who had spent most of his life in Germany, fleeing to Britain with the rise of Hitler. Immediately after the war Ohly opened his art gallery in Mayfair and mounted the first commercial exhibitions of British studio pottery in London, including several devoted to the work of Lucie Rie, who had herself been a refugee from Nazi Europe.

Ohly had died in 1955, but the gallery continued to be run on similar lines by his son. I was a frequent visitor as I made my rounds of the galleries in the sixties, making the occasional purchase and forming a warm respect for the quietly-spoken manager Robert Melville, who was one of the most modest and shrewd of the London art dealers. It was Robert who pointed out to me that it took people imbued with the continental tradition of art schools, particularly the Bauhaus in Germany and the Wiener Werkstätte in Austria,

to understand the interdependence between the arts and crafts which English cultural snobbism ignored; hence people like Ohly, and of course Lucie Rie, he added.

The idea came to me that there were other traditions bringing the arts and crafts together which were equally ignored in the London art world. The English Arts and Crafts Movement of the early-20th century was one. Then there was the Japanese tradition of studio pottery made for the tea ceremony, which sounded far away from anything to do with drinking tea here in England. Yet, Bernard Leach had brought the practical skills and practice of the Japanese back to England from Japan where he had lived for so many years, and had established the St. Ives Pottery in Cornwall, combining that oriental vision and techniques with the English tradition of decorated slipware.

Since, for political and other reasons, all these strands of craftsmanship now flourished in this country, why not put on an exhibition of the very best contemporary pottery in Britain which reflected these various traditions? By doing this, I felt, it would bring together some of our most outstanding artistic talents largely ignored by commercial galleries. It seemed such an obviously good idea. But where?

Robert Melville relished the idea but considered the project to be beyond his brief as gallery manager. If Ohly had still been alive it might have been different. Then I remembered what Robert had said about people raised in the Germanic tradition of integrating the crafts with painting and sculpture. Nor far away, in South Molton Street, was a gallery I had often visited, run by a formidable lady I knew simply as Mrs Klein. She was Jewish and had fled to this country from Nazi Austria before the war, having been brought up and educated in Vienna.

Mrs Klein seemed like someone who might take my idea seriously and not politely show me to the door. So I went to see her at the Molton Gallery. She had a young assistant, Edmund Capon, who had just graduated from the Courtauld Institute of Art and was about to embark on a distinguished career as a museum director and an expert on Chinese ceramics. I sounded out Edmund first and he had a twinkle in his eye. 'What fun,' he said. 'Let's see.' And he knocked on the door of Mrs Klein's private office. 'Sorry to interrupt you,' he said in his most unctuous voice, 'but Mr Mullins from *The Sunday Telegraph* is here with an idea that I can't help thinking would be absolutely up your street.'

He was right. I launched into my speech about how in my view some of the finest talent in the visual arts in this country lay in the field of studio pottery. Edmund nodded eagerly in support. I went on to elaborate my thesis that this was due to an amalgam of different skills and traditions – native English domestic slipware, the imported tradition of the Bauhaus and other German and Austrian art schools, and on the other hand Japanese handmade pottery related to the tea ceremony introduced here by Bernard Leach at the St. Ives Pottery. Mrs Klein gazed at me impassively, adjusted her grey hair, and said 'So . . who?' I reeled off a list of about eight potters whose work I knew well, among them Michael Cardew, Gwyn Hansen, Ruth Duckworth, Hans Coper and Lucie Rie. At the mention of Lucie Rie Mrs Klein's face brightened and she nodded. 'Lucie . . . of course!' she exclaimed. They had come out of Austria at much the same time, she explained, in the late 1930s. She had not kept in touch, but she owned a few pieces which she treasured. 'Arrange it between the two of you, will you?' she said. Then she

turned to me with a smile – 'You'll find Edmund a good boy.' She thanked me briskly and returned to her papers.

'Looks as though we have a deal,' I said to Edmund. I felt bewildered by the simplicity of it all. I looked at my watch, it was 12.30. 'Let's go to the pub,' I suggested. Edmund nodded and over pints of draught bitter and a plate of sandwiches we laid plans for the first exhibition of British studio pottery to be held in a commercial art gallery. 'I'll trust you to choose the potters,' Edmund said. 'I'm good on the T'ang Dynasty, not this lot.' But he undertook to find suitable racks to display the pots and do all the paperwork and we set a provisional date for the following winter – December 1965. 'Good for Christmas gifts,' Edmund considered.

That summer and autumn I made a round of visits to potters' studios. Some were easy. Hans Coper lived in London. Bernard and Janet Leach were down in Cornwall, in St. Ives, where I was already spending some time researching for a book on the fisherman-painter Alfred Wallis with the help of Barbara Hepworth and Patrick Heron. Richard Batterham was not far away. Michael Cardew, Leach's first pupil, was just back from Nigeria where he held a government-sponsored job working with local potters in Abuja, and a lot of his huge cider jars and tall vases were stacked around his studio at Wenford Bridge in North Cornwall. Others, I made special excursions to visit and choose work, though generally I was happy to leave the selection to them.

The visit that gave me the greatest pleasure was just a short drive across London to a quiet cul-de-sac north of Hyde Park. I had known Lucie Rie's work since I was a teenager and had recently acquired a couple of small, exquisitely-delicate pots which had her characteristic drip-pattern glaze round the rim which made them look as though she had dipped them in chocolate at the last minute. They could not have been further away from the assertive tall bottles and square pots decorated with oriental images of flowers and foliage which I had been choosing in Bernard Leach's St. Ives Pottery the week before.

Robert Melville had given me her phone number, warning me to expect few words. I dialled and waited a little apprehensively. I was aware of a certain aura surrounding Lucie, simply from the way people talked abut her. After half a dozen rings a mellow voice answered in a soft Germanic accent, 'This is Lucie Rie.' It was a response that was to become reassuringly familiar over the next twenty years: gentle and modest, always the same, the simplest of announcements, *This is . . .*' I explained who I was and why I was phoning. There was silence. I listed the other potters I was approaching, ending with her former assistant and protegé Hans Coper. There was more silence, and I was growing

increasingly uneasy. Would she be prepared to participate? I asked. As I was preparing for yet another silence, she replied in that same gentle tone of voice, 'Of course!'

It turned out that she had known about the exhibition all along. 'Potters talk,' she explained. Hans had rung her. So had Bernard. 'You must come round,' she added. The soft voice sounded welcoming. We agreed a day and she suggested tea. 'Then you can tell me what you'd like me to do.' The remark surprised me. No artist I knew would expect a gallery owner to tell him what to paint for his next exhibition, though he might offer broad hints with pound signs prominent. More than this would have been to treat an artist like a tradesman. But this was a different world, where creative integrity was not punctured by the requirement to make things that were useful. Lucie had made a living producing domestic ware – cups and saucers, vases and soup bowls. Earlier she had survived by making ceramic buttons. Creating beautiful pots for collectors to display on a high shelf was the luxury end of an essentially utilitarian profession, and only now, in her sixties, could she afford to concentrate on making those wonderfully-shaped and decorated bowls and vases which were what pleased her most.

Lucie opened the door to me with the warmest of smiles. She was a small, neat woman, precise in every movement, with short grey hair swept back to reveal a face that was delicately moulded, with an unusual mouth slightly downturned, half-shy and half-smiling. 'Come in,' she said and led the way up a narrow staircase which opened into

a spacious room filling the entire upper floor of the tiny mews cottage. Tea cups were already laid on a low table, next to a plate of ginger rock cakes which, she explained, she had made that morning. Over the years those rock cakes were to become as regular an accompaniment to my visits to Lucie as our tour of the shelves to inspect her latest pots.

'So, what would you like for the exhibition?' she enquired as we finished tea. I told her I particularly admired her tall swan-necked bottles and the eggshell-thin bowls in brilliant yellow with a dark rim; also her more chunky pots with a heavy encrusted glaze like well-baked pastry. Lucie nodded. 'And how many?'

'About twenty-five,' I replied confidently, feeling entirely certain at that moment that we would sell every one of them (which we indeed did).

Lucie took me downstairs to her small workshop to show me her potter's wheel and, nearby, her kiln. This was an open-topped kind like a huge chest. She lifted the lid to reveal neatly-racked rows of bowls and tall bottles all looking naked and fragile in their unfired state. They were this week's work, she explained. There'd be a firing this weekend. (For years I retained a vivid picture of this tiny woman lifting the massive lid and leaning over to adjust a pot or two. More than twenty years later came an equally-vivid moment in a BBC television film presented by David Attenborough, a great admirer of Lucie's work. She was shown unloading a kiln when she looked up at Attenborough with the quiet words, 'David, you need to help me, I'm falling in!')

Albion Mews is a cobbled cul-de-sac lined with a terrace of small cottages that would once have been stables, made to feel even smaller by the block of thirties flats that tower over them. Lucie came across the mews in 1939, a few months after she and her husband Hans had fled Nazi Austria. It had been Hans' intention to use London as a stepping-stone to the United States. Lucie had other ideas. She wanted a workshop here in London, and she wanted an end to her marriage. One of the tiny properties in the mews was at that time used as a garage with a one-room flat above. It was owned by the Church Commissioners. With the help of an architect-friend Ernst Freud, a son of Sigmund Freud, she managed to rent the place for very little, convert the garage into a workspace soon to be equipped with a kiln, and to use the upper floor as her living area. And here Lucie remained throughout the war, even when a bomb fell nearby during the Blitz, blowing out her windows. And she had remained here ever since.

Having survived the war hand-to-mouth she proceeded to earn a living by turning her workshop into a small factory for making ceramic buttons. Then, one year after the war, a young man turned up on her doorstep unannounced, looking for work but possessing

no knowledge of ceramics. He too was a refugee from Nazi Germany and Lucie took him on as her assistant. He was Hans Coper. Lucie taught him to handle clay and make buttons, and very soon to operate a wheel and make pots. Before long it turned into the most important creative collaboration of her life. Coper's extraordinary gifts as a potter soon shone like a beacon in the contemporary crafts world, and in the 1950s Lucie and Hans shared several exhibitions in William Ohly's Berkeley Gallery.

Several of Coper's tall majestic pots occupied places of honour in Lucie's living-room. They seemed to offer a powerful masculine presence in Lucie's world. And looking at her pots next to his demonstrated how creatively the two artists influenced one another, and how their collaboration brought out the individuality of both of them. As for Coper I have never come across pottery that so strongly demands to be treated as sculpture, while remaining unequivocally a pot. Those dry unglazed surfaces, weathered as if by a desert sand-storm, decorate shapes that sometimes evoke the abstract forms of Brancusi and at other times the pared-down human forms of Greek Cycladic figures from 3000 BC. Like Lucie, Hans had lifted studio pottery into a new territory bridging functionality and art.

Lucie saw me gazing at Coper's pots while I tucked into her ginger rock cakes.

'Hans tells me you want lots of his tall pots so you can display more of them on the shelves,' she said, laughing. 'And why not?' I was beginning to feel I was becoming accepted in this rather exclusive milieu of the contemporary crafts. I was their man in the press – their 'mole'.

I saw Lucie a couple of times more before the exhibition at the Molton Gallery that December. She wanted to show me what pots she had earmarked for the show, and I wanted her to meet Edmund Capon who was arranging transport for all the pots. 'A nightmare,' he confessed. And I realised the extra hazard in being a dealer in ceramics rather than paintings. 'Supposing I drop one!' Edmund muttered. Lucie overhead him. 'Then I'll make you another one,' she said with a smile.

But there were no breakages. Edmund had organised display stands for the seven potters, and he and I spent the day before the opening arranging their work as best we could. We were handicapped now and again by the nature of the work we were arranging.

Michael Cardew's cider jars could have slaked the thirst of any West Country rugby team. Several of Dan Arbeid's pots showed a stubborn reluctance to stand up, while Janet Leach, Bernard's American wife, had been in a robust mood and created several ceramic bowls large enough to bathe a baby in. Nonetheless, some time that evening the task

was complete, and Edmund ceremonially opened a bottle of champagne, speculating on which of the works on show we should drink it from.

The following evening was the private view. I had got to know all the potters reasonably well by this time and it began to feel like a family gathering. The one I knew best was Bernard Leach, whom I had met several times in St. Ives. When Lucie appeared at the door of the gallery Bernard turned and looked at her from his great stooped height and flung his arms wide. 'Lucie!' was what he said.

They talked together all evening; or, rather, Bernard talked and Lucie smiled. They had known one another a long time: she had met Bernard in a London gallery before the war shortly after arriving from Austria and had become close friends with much to share. He became, with Hans Coper, the most important figure in Lucie's professional life. And yet they were so different – in personality, in way of life, and most of all in artistic heritage. Bernard with his roots in Japan where he had lived and worked for so long, Lucie with her European inheritance of the Vienna Secession and the art school in Vienna where most of the leading artists of the day came to teach, among them Kokoschka, also now a refugee in London.

The result had been a lively clash of minds. And the sparks still flew. In the weeks after the Molton Gallery show I saw Lucie several times. We'd have lunch at a small Italian restaurant nearby, or more often drink tea and munch ginger rock cakes in Albion Mews. And I asked her about her friendship with Bernard. She gave a wry laugh. 'Of course I already knew of him as Britain's leading studio potter,' she answered. 'So, soon after I met him I showed him some of my pots I'd brought from Vienna. I had them all in a suitcase, so it was easy to go and see him.' At this point she made a slight grimace. 'No, Bernard never liked them. They were all too much of this, too little of that. All the same I learnt a lot from him, perhaps most of all that making pots was a very serious business – that things made by hand for everyday use possess something essential of the human spirit about them'.

Those conversations with Lucie greatly helped me understand the appeal of studio pottery, and why I love the work of potters like Lucie, Hans Coper and Bernard Leach, even if they just sit on a shelf too valuable and fragile to be used. It is the simple reality that they are beautiful vessels in themselves, yet created by the human hand to satisfy two of our basic needs and pleasures – eating and drinking.

The Molton Gallery exhibition virtually sold out in a week. A lot of pots must have been Christmas presents in 1965 and I wondered who got given the ones that wouldn't

stand up or were large enough for a baby to bathe in. None of my critical colleagues in the national press gave it even a mention; but then, what would an art critic – even one trained at the Courtauld – have to say about a mere pot? On the other hand the crafts fraternity welcomed the event enthusiastically and were eager for more. But it was a one-off. Mrs Klein enjoyed the show's success but thought enough was enough. As for Edmund Capon, very soon he got the job he had been hoping for at the Victoria and Albert Museum.

Perhaps because the show was over, I saw Lucie only rarely after those celebratory lunches and teas in Albion Mews. I phoned occasionally, and called in, always receiving the same gentle welcome. My few Lucie Rie pots continued to preside over my workroom at home in south London over the coming years, as I wrote my books and documentary film-scripts for the BBC. My children were warned never to touch 'Daddy's pots' and occasionally asked what they were doing there.

Then dramas broke out. In 1982 Gillian, my wife, died of cancer. Suddenly I had three children to look after on my own, and visiting artists' studios was low on the agenda. Then Anne came into my life, and the sun came out again. One day on impulse I phoned Lucie and said I would dearly love to bring my new wife round to meet her.

'Of course,' she replied in that familiar soft tone of voice. I remembered how nothing ever seemed to surprise Lucie. I could have said, 'Can I bring the American president?' and she would have said, ' Of course.' A few days later I took Anne round to Albion Mews. It was as if nothing had changed. There was the same gracious welcome. The same tea cups and ginger rock cakes. Anne was thrilled. Lucie silently showed us the shelves of her recent work, and Anne gazed for a long time at one particular vase; tall with a slender neck rising to a wide rim dipped in a gold glaze that created a pattern which looked liquid and edible.

'You can pick it up,' Lucie said, smiling. Anne shook her head. 'I wouldn't dare,' she said. 'But could I possibly buy it?' Lucie shook her head. It was already sold, she explained. Then, noticing Anne's disappointment she added, 'I could make you another, if you like.'

A thought came to me. 'Then I could give it to Anne as a wedding present,' I said. Anne's face brightened. 'In that case I shall do my best,' was Lucie's response. 'But I warn you, my best is not always very good.'

Anne plucked up the courage to make one more request before we left. Might Lucie be prepared to give her the recipe for those delicious ginger rock cakes? There was another, 'Of course,' and Lucie carefully wrote out a list of ingredients and instructions. Anne thanked her effusively and we left Albion Mews in high spirits.

Several weeks later the phone rang. 'Edwin,' came Lucie's quiet voice. 'Your wife's wedding present is ready. Come round.' We drove there straight away. Anne's face was ecstatic as Lucie handed her the tall vase which was exactly like the one she had been too frightened to handle before. Anne had brought her an orchid as a thank you – a scented purple Miltonia which Lucie admired and set on her window sill.

'So beautiful,' she exclaimed. 'All I can offer you are my ginger rock cakes.' I caught the quizzical look on Anne's face.

'You know, Lucie, I followed your recipe very carefully,' she said, 'but I'm afraid they were a disaster. They were ginger pancakes!' Lucie looked dismayed.

'I'm so sorry,' she said. 'My memory is terrible. I must have left something out. I'll write it out for you again.' And so, armed with the treasured vase and the new recipe, Anne thanked Lucie warmly and we left. Back at home Anne was determined to get the rock cakes right this time, and next day our kitchen became out of bounds to anything not in the service of baking ginger rock cakes.

I went to see Lucie a month later and Anne decided to come with me. She wanted to say how much she loved the vase Lucie had made specially for her. I suspected there was another reason; the new recipe for ginger rock cakes had proved no more successful than the first. As usual Lucie produced her own cakes that were light and crisp. Anne couldn't help laughing, and told her of the latest pancake disaster. Lucie made an effort to appear distressed – 'My memory . . . my memory!' she exclaimed. 'I am so sorry.' Anne and I exchanged a smile, which I am sure Lucie noticed.

The subject of ginger rock cakes was never raised again. As we left Albion Mews I found myself thinking of those women fleeing Nazi Germany for America in 1939, taking with them their precious sour-dour wrapped in muslin so that the secret of bread-making should not be lost in the new life.

I know that if, years later, I had enquired of Lucie, 'Is your memory as poor as ever?' she would have replied with that downturned smile, 'Of course!'

Barbara Hepworth

Barbara Hepworth became one of the artists I loved most. I have greatly admired her sculpture and enjoyed writing about it. I saw a good deal of her during the last ten years of her life (she died in 1975). This was partly because my first wife and I took to spending Cornish summer holidays in St. Ives where she lived, and where she would ply our children with ice-cream and cakes while they played in and out of her sculptures in the garden, as she insisted they should. That was what sculpture was for, she insisted, not just something to look at.

Our friendship had an unlikely start: it was founded on a shared interest in a Cornish fisherman and rag-and-bone merchant who had become a painter in his widowhood and old age. Alfred Wallis had already been dead for more than twenty years by the time I came across his work in an exhibition of his so-called 'primitive' paintings of ships and Cornish harbours at the Waddington Gallery in London during the winter of 1964/65. The show was a landmark for me because I recognised immediately that here was an artist I wanted to write a book about – if I could manage to find a publisher prepared to take the idea seriously. I had my doubts. An unknown eccentric who had mostly painted on scraps of wood and old packing cases was hardly the ideal vehicle in which to launch my literary career.

Fortunately Wallis had distinguished admirers in the art world, and one of them was Barbara Hepworth. Her former husband, Ben Nicholson, along with the painter Christopher Wood, had been the first to 'discover' Wallis painting in his tiny fisherman's cottage in St. Ives back in 1928. And when she and Ben went to live in St. Ives at the outbreak of the Second World War, Barbara took to visiting Wallis and buying his work. Now, a quarter of a century later, Wood was long dead and Nicholson had remarried and was living in Switzerland. But Barbara had stayed on in St. Ives; hence she was a key surviving link to Wallis and his long-lost world of the Transatlantic fishing fleet in Cornwall. She was someone I was keen to meet. And as it turned out this proved to be delightfully easy. I had recently written an article in *The Sunday Telegraph* enthusing about her 19-foot Winged Figure that had been mounted on the John Lewis building in Oxford Street. Her friend and London dealer, Charles Gimpel, told me she had been touched by what I'd written and he suggested I join them for a 'pub lunch' the next time Barbara came to London.

A pub lunch seemed a pedestrian venue for one of the *grandes dames* of British art. Nonetheless, I duly turned up at the saloon bar of the pub close to the Gimpel Fils Gallery in South Molton Street feeling a little apprehensive. Charles Gimpel's wife Kay was there, and straightaway she introduced me to a diminutive woman half-buried within a shawl seated at a low table in a corner of the bar. She looked up as I approached then the drawn and rather tense face broke into the most engaging smile. And she held out her hand.

As she did so I found myself amazed that so small and fragile a hand should have been responsible for carving those massive hollowed sculptures in wood and marble which were Barbara Hepworth's special hallmark, or modelling and chiselling huge areas of plaster in preparation for the monumental sculptures I had been writing about, or the 21-foot Single Figure recently commissioned by the United Nations in New York in memory of the late Secretary-General Dag Hammarskjöld, whom Barbara had known and admired.

As the three of us sat there with our beer and sandwiches I raised the subject of Alfred Wallis, and the book I was planning to write on him. Barbara's eyes lit up; she would love to talk to me about him, she said, and promptly invited me to visit her in St. Ives. She had a number of his paintings, though many of them seemed to have disappeared when her marriage to Ben Nicholson broke up. She lived in a state of clutter these days, she added with a laugh. With so much work on hand there was never time to sort things out. Then she admitted that she actually rather enjoyed knowing there were lots of

'treasures' close at hand but you didn't know precisely where they were. It made life a bit of a treasure-hunt. So everything remained in packing-cases or tottering piles. Except her studio, I felt sure. As she sat composed and quiet in the corner of the bar that morning fingering her beer glass and gazing intently ahead to wherever her thoughts lay, I got my first impression of this small dynamo of a woman whose every glance and gesture suggested a pulse of energy waiting to break out. One wouldn't enjoy being in the line of fire, I imagined.

As we returned to the gallery she paused at the door and said very touchingly that she very much hoped I would come and see her. She would love to show me her new work, and she'd also have 'a jolly good look' for the missing Wallis paintings.

'You've made a friend there,' Kay Gimpel said after Barbara had gone inside. 'I know Barbara very well. I can tell.' As I made my way home on the underground I tried to tell myself I wasn't feeling deeply flattered; and I failed.

During the months following that first meeting with Barbara in a London pub I made

several visits to Cornwall – seeking out people who had known Alfred Wallis and who still owned his paintings. And each time I would gravitate with the greatest pleasure to St. Ives, and in particular to Trewyn Studio in the heart of the town where Barbara lived. And each time the routine was the same, as it was to remain over the years to come. I would be let in by Barbara's housekeeper who would nod – 'Barbara is expecting you.' And I would climb the narrow stairs to her sitting-room on the first floor. She had not exaggerated about the clutter she lived in. I would pick my way between a veritable Scilla and Charybdis of books and packing-cases to where Barbara was seated at the far end of the room by the fireplace where there was just space enough for a second chair, a table with a bottle of whisky and two glasses on it.

'Wonderful to see you,' she would say. 'And now tell me.' And I would recount my day.

At first we would talk about Wallis and her memories of going to see him in his cottage in Back Road West, and how he would read out passages from an ancient Bible to her, then instruct her gravely to be careful what company she kept. It was all invaluable material for my book. Then the conversation would turn to her own work. She was preparing for a large open-air exhibition to be held in the park of the Kroller-Müller Museum in Holland, to which I promised to go. As art critic of *The Sunday Telegraph* I was more or less free to go where I chose, thanks to my indulgent editor who was rare among his breed at that time in finding art glamorous even if he didn't always understand it.

Conversation about Barbara's new work stretched over many evenings. I invariably enjoyed listening to artists talk about their own work. Some, like Lowry, have been delightfully entertaining. At the other extreme Victor Pasmore invariably did his best to reduce even his most lyrical compositions to an arid cerebral exercise. Salvador Dalí delivered wild speeches to the world from some dark throne. Henry Moore preferred weighty words of one syllable. Barbara, however, invited you to share her innermost thoughts and concerns. She talked with refreshing openness about how her career had unfolded.

'I am first and foremost a carver,' she said. 'I learnt that from spending two years in Italy in my early twenties. I wanted to make sculpture that was uninhibited by what had been drummed into me at art school, and was a rejection of portraiture.'

She talked just as openly of the rewards of international fame – the money, the freedom, the acclaim – but also the dilemmas that came with it. We were walking in her delightful enclosed garden where her recent large sculptures were not of wood or stone, but bronze. A carving was by definition a 'one-off,' she explained. Now world-wide fame had brought increasing demands for her work, creating a need for limited editions, and this required

her to model an armature in plaster before it could be cast in bronze or aluminium. She admitted that at first this promised to be a betrayal of her first love of carving. But then she came up with a solution: she would build up the required shape of a sculpture in plaster, allow it to dry thoroughly, and carve it like stone or wood. In this gracious garden, with her sculptures all around her, she looked serenely proud of what she had achieved. Then, before I left that evening she gave me a reminder of less affluent days. She often thought of the days during the war, she said, when she was bringing up triplets at the time when her husband, Ben Nicholson, was making white reliefs! She managed a wry smile.

A while later I arranged to meet her at the Kroller-Müller opening in Holland where she was being royally fêted. The Dutch always loved her work, the stylistic links with Mondrian being partly responsible. Shortly afterwards she wrote thanking me effusively for my review of the exhibition in *The Telegraph*. She was still hunting for the missing Wallis paintings for me, she assured me. I replied that I now had a publisher and she wrote back immediately suggesting I take time off to write the book here in St. Ives. 'That would be a wonderful idea. Bring the family. You can have my studio in Barnaloft. It's very easy to run and beautifully warm.' I was deeply touched, and gladly took up her offer for the following spring.

Barbara's letters were arriving regularly now, full of warmth and enthusiasm, describing her new work as well as her battles with the local telephone authorities. I noticed her letterhead now read 'Dame Barbara Hepworth', though she never mentioned the honour she had just been awarded, instead, 'I have planted 300 bulbs in the garden and got quite a few new sculptures in position,' she wrote just after Christmas. She would very much enjoy the chance of talking to me about them, she added.

So began an annual family migration to St. Ives for a few weeks every spring or summer. The Barnaloft studio overlooked Porthmeor Beach and the headland known as 'The Island' which delighted me as it features in many of Alfred Wallis' paintings. After that first spring we took to renting a flat nearby that was large enough for our two (and eventually three) children. St. Ives was then in its heyday as an art colony, and I came to know a number of leading painters and sculptors who lived in the town or in the surrounding area, among them Patrick Heron, Brian Wynter, Johnny Wells, Denis Mitchell, the potter Bernard Leach and – inevitably – the irrepressible Roger Hilton who bearded me early one morning waving a whisky bottle and pronouncing that he had just been released from jail having been arrested the evening before for being drunk in charge of Penzance railway station. And strangely, presiding over this mixed band of brothers, hovered the ghost of Alfred Wallis, about whom even the locals, who had ridiculed

his claim to be an artist in his lifetime, now spoke of him with bemused respect. I was actually writing a *book* about him! What next?

Barbara had become the much-revered *doyenne* of this diverse company, which she regarded with a certain matriarchal pride. I saw her regularly. Each time we arrived I would phone her and be invited round. It was always whisky hour whatever the time, and my visit would be concluded by an invitation to bring the family for ice-cream in the garden. And my elder daughter would treat the place as an adventure playground, clambering among the sculptures as though they were rocks on the beach. A letter from Barbara one winter ended 'P.S. My walk-through sculpture nearly finished. Your children will enjoy it. I so look forward to seeing you all again.'

Our conversations in St. Ives during those summer visits often turned to how much she liked people to feel able to touch her work and relate to it physically. Sculpture could be an expression of a body's poise and rhythm, she insisted. This was something she had learnt from dancing, she explained. When she was a student at the Royal College in London it was the era of Diaghilev's Russian Ballet, and she would go round and watch the dancers limbering up. It gave her an insight into what she wanted to achieve as a sculptor. One evening I was walking with her along Porthmeor Beach. The sea was rough, and suddenly she stopped and said, 'You know, if you were a fisherman wrestling with a rope and a net in a high sea, that is a marvellous kind of dance too.' Then she added, 'I identify with things like that. If I see a woman walking down the road pregnant, I feel pregnant.'

Honours were pouring in on Barbara during those years. She had acquired a powerful new agent, Marlborough Fine Art, who arranged exhibitions for her all over the world. The key event was her large-scale retrospective in London at the Tate Gallery in the spring of 1968. I put together an extended feature in the *Telegraph Magazine*, including photographs of her at work in St. Ives taken by my friend and work colleague Adam Woolfitt – which she loved. 'They were so excellent and *true*,' she wrote. There was an endearing touch of vanity in her love of being photographed, and she sometimes sent me sheaves of approved photos of herself should *The Telegraph,* or any other publication I worked for, require one. Yet while she bathed in the fame and widespread adoration that was surrounding her, she was becoming exhausted and her health was suffering. I organised a small open-air exhibition of her sculpture in the beautiful gardens of Syon Park in West London that summer. Barbara came to a celebratory lunch in a wheelchair as she had fallen and injured her leg. As I helped her to her taxi she told me almost

casually that she was being treated for cancer. Later she wrote that she had pulled out of St. Ives to get a rest as well as an overhaul, she said. 'I don't know where I'll be,' she added. 'But keep in touch with me dear Edwin. My secretary will track me down with personal letters.'

A year later Barbara asked if I would write the catalogue introduction for the first exhibition of her work to be held in Japan, in 1970 at the Hakone Museum in Tokyo. I was delighted but not at all sure what would be appropriate to write. Books and articles about Barbara's place in contemporary art were available everywhere, and I found it hard to imagine the Japanese public being uplifted by yet another dissertation on how her work related to that of Brancusi, Arp, Mondrian or Naum Gabo. Besides I was not an art historian but a journalist who loved her work. So I suggested to Barbara that I bring a tape-recorder and she talk to me about the principal themes that had run through her sculpture from the beginning. She liked the idea a lot, she wrote back, adding, 'it would be marvellous fun to see what comes out of our discussion.'

She lent me her studio overlooking a deserted Porthmeor Beach for some blustery winter days early in 1970. Every morning I made my way along the back streets of St. Ives to the familiar cluttered room and set up my tape recorder on the table between us. At first she clearly felt inhibited by this little object silently stealing her every word, but before long she relaxed and forgot it was there. I had a good deal of experience in conducting radio interviews and, as so often, it was just a matter of finding the question that opened a door to the private garden of her thoughts. That moment came when I suggested that she had harnessed the traditional English love of landscape to a medium which had never before accommodated it. She looked pleased and quite surprised; then the thoughts began to flow. Coming to live here in Cornwall awakened something, she said. The rocks and hills of her native Yorkshire had always touched her imagination. Now there was an extra element, the sea. She talked of the sensuous association between sea and sky which she strove to evoke in her work – the tides, the winds, rock forms, sea caves and the little Cornish harbours folded into the land. Hence there was a spiritual relationship between humans and their natural environment; it was a theme which irrigated so much of English art, poetry, music and architecture. It was a tradition she felt she belonged to. 'As a sculptor I am the landscape,' she added.

This self-identification with landscape led the conversation to her debt to Greece and the Aegean islands. Barbara had visited Greece in the early 1950s, though she had never returned as if anxious to preserve the almost mystical impact which the country

had made on her. Its primordial landscape, the ever-presence of the sea, its temples and classical sculpture, its intense light and, in particular, to have witnessed Greek drama being performed in ancient theatres carved out of the rocky hillside and where the masked actors seemed like living sculptures in this landscape of stone. The experience still remained vivid in her mind so many years later and there were times when the light and the contours of Cornwall made her believe she was back on the shores of the Aegean. 'Greece strengthened me,' she said. 'It made me understand a lot about the dignity of man in his natural setting.'

There was a strongly idealistic streak in Barbara which her recollections of Greece brought out. She described to me how a great deal of her work was a song of praise to the human spirit, translated into wood, stone and bronze. 'My sculpture has often seemed like offering a prayer at moments of great unhappiness,' she said to me one evening as we walked round her garden where she had set up some of her latest works. 'When there has been a threat to life, like the atomic bomb dropped on Hiroshima, my reaction has been to swallow despair and to make something that rises up. In the age of cathedral building I would simply have made carvings for a cathedral.'

This wonderfully mediaeval perception of her role as an artist would have perplexed those who still regarded Barbara as carrying the banner of modernism. I felt I understood exactly what she meant; hers was a conviction that sculpture must relate to the most important human concerns. It felt entirely appropriate that when I next saw her the following summer she had begun working on an ambitious project to create a group of large bronze sculptures on the all-embracing theme of The Family of Man. It was to be her final statement of the humanist values that lay at the core of her art. 'My group of figures are growing,' she wrote that autumn. She would ring me, she said, as soon as she got some 'weight and form on them.' A month later came a scrawled note: 'Just had a marvellous day's work and have put some flesh on the Bride.'

She was out of touch most of that winter. Then in the following spring, 1971, she rang excitedly one evening: 'I now have eight figures in bronze in the garden, and only one more to be completed. I'd love to show you.' A postcard arrived soon afterwards: 'Edwin, could you perhaps come down for a couple of days? I'd love you to see the *family*.'

I'd already thought of bringing my own family down to St. Ives for part of the Easter holidays. So I booked one of the handsome new flats overlooking Porthmeor Beach for a week and drove down a day ahead with Gillian and the children taking the overnight train to Penzance. As usual I phoned Barbara on arrival at the flat and she insisted I come round straight away. She was seated in the customary corner of the cluttered room with

her whisky. Only this time a bunch of keys lay on the table in front of her. 'Edwin, I want you to go over to the dance hall and choose something you might like,' she announced. The former St. Ives dance hall was a large building close by which Barbara had acquired as a storage place for her sculpture. I was taken aback by this extraordinary offer right out of the blue, and managed to blurt out a few words of thanks as I took the bunch of keys. I made my way to the large building a short distance away and unlocked the large heavy door, feeling excited and thoroughly bemused. I had often dreamed of owning one of Barbara's small slate carvings or perhaps a bronze table sculpture; but knew I could almost certainly never afford it. Now maybe it could become a reality. I opened the door and stepped inside.

I am not sure how long I was there. Perhaps half an hour. It was growing dark and the place was chilly. As I gazed around the large gaunt building I began to feel smaller and smaller by the minute. Every bronze, every carving in wood and stone was enormous, it would have required a crane to shift any of them. I was Gulliver in the land of giants. I examined every dark corner of the building in the hope of coming across something modest in size, maybe a hidden cupboard or a secret drawer contained a piece I could actually handle. But no! I tried to work out what I should do. What did Barbara have in mind, I wondered? She was elderly and tired, maybe she had forgotten that all her small pieces had been removed for some exhibition. A nightmare scenario came to me: supposing I was to go back and say, 'I'd really love that 6-foot bronze called Divided Circle'. And her face would tell me immediately 'That's not what I meant at all.'

All these years later and I still wonder, and speculate, what would have been the right thing to do? Now it seems relatively simple: I ought to have come clean with my predicament, and given her a chance to find me something small. But then maybe she really *did* mean it, and imagined that since I hadn't ask for her 6-foot Divided Circle it was because I didn't like her work all that much after all. The thought pains me. But I shall never know. As it was I procrastinated. I was overwhelmed, I said, and would like to think about it. Barbara nodded, and said nothing. The next day came. I returned to Trewyn Studio with Gillian and the children. Barbara produced ice-cream and biscuits in the garden just as she often did. She played with the children. We talked about the Tate Gallery, about Vietnam, about President Kennedy, about De Gaulle's veto of Britain's entry into Europe – just about everything except the St. Ives dance hall. And each time I edged the conversation in that direction she deflected it elsewhere. It was as if yesterday had never existed, or had been airbrushed away.

And so it continued. Today it seems absurd that I should never have felt able to break the silence and remind Barbara of her offer on that first evening, and explain why I had been so reluctant to accept it. Nonetheless, that is the way it was; the subject became forbidden territory. I remind myself that I was a young man in my thirties somewhat overawed at finding himself the confidant of one of the most celebrated artists in the world. As it is I shall never know the truth.

Barbara's letters and phone calls continued just as warm as before. The following spring she invited Gillian and me to a party and 'candlelit dinner' she was holding in London where she always stayed, in the hotel at Paddington station, conveniently straight off the train from Cornwall. I discovered that we shared a love of trains, and I took to writing her an account of the more exotic journeys I'd been taking as a journalist, in Russia and most recently in Egypt. 'I always love your descriptions,' she wrote. She had never been to Egypt, but she always found romance enough at Paddington 'with the shades of Brunel and the thrill of going west.'

January 1973 was her seventieth birthday. I sent her an orchid, which pleased her. 'The orchid is in marvellous condition,' she wrote, adding, 'If I had another life I would like to grow orchids.' Gillian was nursing our third child and we never got to Cornwall that summer. I saw her briefly once or twice in London when as a trustee of the Tate Gallery she came up for meetings. She looked frail and strained, and much of her former energy had drained away. There was an air of gritty determination to carry on. She had so much still to do, she said. 'My new work,' she wrote, 'not one but three, although please keep this dark.' She was indomitable.

We arranged to spend another summer holiday in Cornwall the following summer, 1974. Barbara announced that she was not going anywhere. 'So please ring me when you reach St. Ives. I would dearly love to see you. With my love. Ever, Barbara.' She seemed weary but otherwise much the same as ever when I called round. The clutter was still in place. The missing Wallis paintings were still buried there somewhere, she felt sure. She asked me to pour us both a whisky. Then, as she sipped it and lit a cigarette she reminded me how since her treatment for cancer she could no longer taste anything. She smiled as I poured her another glass. 'Bring the family tomorrow, won't you?' she said as I left. 'You'll need to bring your own ice-cream.'

The last image I have of Barbara in my mental photograph album is of her watching intently as my young family played hide-and-seek among her Family of Man sculptures. Her quiet smile seemed to suggest 'that's just how it should be.' Nine months later the

Edwin's daughter Frances with Barbara Hepworth and in her garden amongst the sculptures, 1966

cluttered room where I had visited her so often over the last ten years went up in flames after she had fallen asleep there.

Today, apart from my memories of those ten years that remain in my mental photograph album, I possess an expansive sheaf of her letters, a number of books on her art and her life inscribed to me, and just one work of art which I treasure. It was a gift long after her death from her son-in-law Sir Alan Bowness, a former Director of the Tate Gallery. It is a small lithograph delicately drawn and representing an idea for one of her stone carvings; a rectangular form with a perforation like a window. It bears no title, though my young son, Jason, gazed at it solemnly for a while and then asked politely if it represented a washing machine. I sometimes think I hear Barbara's laugh.

Mervyn Peake

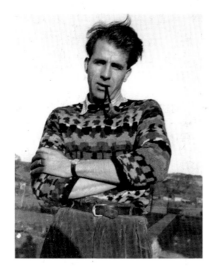

For my discovery of Mervyn Peake I owe a great deal to the parsimony of *The Illustrated London News*. Uniquely among newspapers and magazines in my experience it was the editorial policy of the *ILN* during the four years I was on the staff to insist that reviewers return books to the office rather than keep them or sell them. Sub-editors like myself were then allowed to take our pick. In this way, at some time during 1959, my eye fell on a new novel with a strangely alluring cover depicting a boy wandering through a misty landscape of rocks.

The book was called *Titus Alone,* and its author was Mervyn Peake. The name faintly rang a bell, though I was unclear why. The story of a boy lost in an alien world intrigued me so much that I immediately went on to read the two novels that had preceded it, *Titus Groan* and *Gormenghast.* These I found even more absorbing as I became plunged into a grotesque world of gothic castes inhabited by deranged characters with names like Steerpike, Flay and Irma Prunesquallor. And, because the books were illustrated by Peake himself, I realised that I recognised the vivid, exaggerated style of drawing from other books I had read as a child.

During the Second World War our family lived in south London in the mainstream of the German bombing offensive. I remember my father lifting me to the window one night to watch the flickering red glow of the London docks burning. Throughout the Blitz and later the flying bombs (Doodlebugs) and the V2 rockets, I spent my nights in a makeshift air-raid shelter which my parents had constructed with massive oak beams and iron girders within the house. I would retire to bed with my books. While Hitler did

his worst outside, my imagination got to work in my bunk-bed with the aid of a torch.

Memories are fleeting and fragile, yet in sharp focus are the images of wild and rather quirky figures illustrating a collection of nursery rhymes which I had been given. The Mervyn Peake impact had begun. Even more vivid in my mind are the drawings accompanying Lewis Carroll's *Hunting of the Snark* and Coleridge's epic poem *The Rime of the Ancient Mariner,* both *of* which came out during the war and have been more or less tattooed on my brain ever since. Looking again at the cover of *Titus Alone,* I began to see the boy wandering through the mists and the rocks as myself reading by torchlight as the sirens wailed and German bombers growled overhead.

It was with all these memories and associations in my head that I decided to write to Mervyn Peake. In my spare time I had become the London editor of a small literary magazine with greater pretensions than sales. We desperately needed contributors happy to waive their fee for the honour of being published, even in a little tinpot journal. This effectively meant hoping for some unwanted scrap edited out of a book or rescued from a writer's wastepaper basket. I was frequently surprised by the courtesy of their refusals, though once in a while we struck gold. Mervyn Peake was one of those who offered to deliver.

Having posted my suitably humble request via his publisher, I tried to imagine what kind of man could be the author of the Titus books and the creator of a place like Gormenghast. Where, I wondered, would such a person live? The answer turned out to be Wallington, deep in the Surrey commuter belt. Peake's letter sounded like a note of apology. He had been ill over the past two years, he explained, but if I was in no great hurry he would be pleased to write something specially for me. I could scarcely believe my luck. The author of *Gormenghast* was going to write something specially for me!

It was more than a year later that I was to learn that the letter had not been written by Mervyn at all, but by his wife Maeve. She was covering up for him. Mervyn's hand now shook so much that he was virtually unable to write. All I knew at that time was that he had been ill for the past two years. The reality of his condition only gradually became clear. Two weeks after the first letter came, a second one in the same hand, stating that he was now working on something new. He never explained what – a poem, a short story, a novel? – though he did ask if I would like some illustrations to go with it. I was more thrilled than ever, seeing before me those unforgettable illustrations for *The Ancient Marimner, Grimm's Fairy Tales* and *Treasure Island.* I replied as calmly as I could that I would be delighted to have illustrations for whatever it was he was working on. Barely a

week later a third letter arrived informing me that he and his family were shortly moving to London: what was more he noticed it was just round the corner from where I lived. Would I care to call?

I had recently married, and we had moved into a first-floor flat in Redcliffe Square in south-west London. The house in Drayton Gardens, where the Peake family was now installed, was scarcely more than a five-minute walk down the Old Brompton Road. Taking up the invitation I phoned somewhat nervously and was relieved that it was Mervyn's wife who answered the phone. She immediately invited us for a drink that very evening.

Maeve greeted us at the door, a shy and beautiful woman with the most warming of smiles. She led us upstairs to the first floor sitting room The staircase was flanked by dozens of framed drawings, several of which I recognised from the illustrated books I had read as a child. In the sitting room itself hung illustrations for *The Ancient Mariner* and several large canvases of children I assumed to be the Peake family. But still there was no Mervyn. Maeve had the quiet air of someone very much in charge. 'If you'll wait a minute,' she said, 'I'll go and call him.'

She was away some time. After a while I heard slow footsteps on the stairs and the sound of Maeve's voice quietly repeating our names and why we were here. Then Mervyn shuffled into the room. He was stooped and lean, with greying hair somewhat dishevelled, and a look of bewilderment as he gazed about him for something he might recognise. Then in a mechanical gesture he held out a hand in my direction, muttering something I could not catch. Maeve led him gently to a chair, keeping up a patter of conversation all the time as if to draw him in. Mervyn continued to say nothing, merely staring about him with a puzzled look. Gillian and I felt increasingly awkward at being here at all, and could only wait for something – or nothing – to happen.

What *did* happen was entirely unexpected. Mervyn suddenly cleared his throat as though about to make an announcement and began to recite a robust limerick about the habits of a young curate from Kent, followed by a guffaw of laughter. Maeve pretended to look embarrassed, then out of sheer relief we all burst out laughing. Mervyn's crumpled face immediately broke into a surprised smile. He seemed to give some sort of signal to Maeve, who reached over to the desk and grasped a slender folder, handing it to me without a word. I opened it a little warily, and inside were a few pages of hesitant handwriting, mostly notes and isolated phrases, interspersed with surprisingly sharp drawings. The piece was headed *Footfruit*. Maeve explained that it was the outline of an illustrated short story about a man in the desert with his dog.

This was what Mervyn was proposing to offer me for our magazine. I handed Maeve back the slender folder and thanked Mervyn profusely, bewildered by the thought that *Two Cities* might before long be publishing an original work by the renowned author of the *Titus* trilogy. This young sub-editor on the *Illustrated London News* floated back to Redcliffe Square in a dream.

I never saw *Footfruit* again, and as far as I know he never completed it. But we did see a lot more of Mervyn and his family over the course of the next few years. We became regular visitors to Drayton Gardens, and just as regularly Maeve would bring Mervyn round to our flat for a drink or for dinner. It was a distance he could just about manage. Maeve would ring the doorbell down below and between the two of us we would steer him up the long flight of stone stairs to the first floor. There was no doubt his physical state was deteriorating, though strangely his cheerfulness and sense of humour seemed to improve, especially as he got to know us well. The impish smile and stifled laugh were never far away. Sometimes we would invite people who admired his work to come and meet him. On one occasion an actor-friend brought his beautiful half-Indian wife. The transformation in Mervyn was remarkable. He seemed to throw off his illness like an unwanted garment, becoming charming and flirtatious. Not only did his hands stop shaking, they found the woman's sari possessed irresistible folds to explore as they sat on the sofa after dinner. Maeve leaned over towards me, 'Mervyn hasn't entirely lost his touch, Edwin, has he?' she said in a low voice. I think she was happy to be reminded of the handsome, irresistible young man she had married, even though, as she told me once, 'I think he made love to every woman we met, but I knew I was the one he loved.'

The shaking hands had been why Maeve disguised herself as Mervyn when she wrote to me. She was doing everything in her power to make it possible for him to work. In the first year I knew the Folio Society published Balzac's *Droll Stories* with Mervyn's wonderfully wry illustrations. As Maeve presented us with a signed copy she explained how she would read the stories to him until a particular passage caught his imagination, and he would reach for his sketchpad and rapidly begin to create figures and faces with a hand suddenly no longer shaking.

Mervyn was now spending lengthy periods of time in hospital having tests of one kind or another, being passed from one specialist to another, each coming up with a different analysis of his illness and a different proposed treatment. Maeve was being pulled in all directions and in a cauldron of uncertainty. Sometimes while Mervyn was away she would invite us round just to talk and to share her dilemma. I learnt so much about

their lives and about Mervyn's past during those evenings in Drayton Gardens. She often talked about the island of Sark in the Channel Islands, where Mervyn had lived for a while during the 1930s in an artists' colony, and where he and the family had returned to create an idyllic life for themselves after the Second World War.

She talked also about the war itself. Mervyn's application to become an official war artist had been rejected, and he found himself conscripted into the army, first in the Royal Artillery and subsequently in the Royal Engineers. Maeve's account of Mervyn's unsuitability for military life would have made a hilarious Peter Cook sketch. Mervyn in fact suffered a nervous breakdown in 1942 and was eventually invalided out of the army, though not before he had put his service to king and country to good use by writing the first of the Titus trilogy, *Titus Groan*.

Immediately after the war, a magazine commissioned him to visit France and Germany and record some of the dramatic legacies of the war. As a result Mervyn became one of the first visitors to the notorious German concentration camp of Belsen. Most of the survivors had already been taken to allied hospitals. Those remaining were dying of starvation and malnutrition, too ill to be moved. Mervyn made a number of drawings of these living corpses before revulsion set in and he withdrew in a state of shock. It was hardly surprising, after the horrors of Belsen, that as soon as possible he escaped with Maeve and their young children to the sanctuary of Sark.

In the early-1950s they returned to live in England, and Mervyn took a part-time teaching post at the Central School of Art in London. He was still putting in an appearance at the Central when I got to know him, though ill-health was about to bring it to a close. The students loved him, Maeve said, but he had little idea who they were or what he was supposed to teach them. So he just told them stories. His physical state was making it hard for him to be out in public. His daughter Claire, who I remember as a delightful and loving child, recently recorded a painful train journey she made with him to Box Hill in Surrey when she was about twelve. A group of boys got into the same carriage and began imitating his shaking body and slurred speech, giggling to each other and blowing paper pellets in his direction.

One evening when Maeve invited us round she was on the verge of tears. She had been persuaded by the latest specialist to allow Mervyn to undergo electric shock treatment. She had visited him in hospital that afternoon and he had been too heavily sedated even to recognise her. It terrified her that the last threads of affection which bound them would have snapped and he would return home to a house of strangers, not recognising

her or their children, Claire and the two elder boys, Sebby and Fabian.

In fact there was no apparent change in him, she said on the phone a few days later. If anything Mervyn seemed rather more jolly and had even made a few drawings. We invited them both for a dink, and Mervyn did seem more alert than I had seen him for quite a while. Gillian always made sure there was a sketchpad and felt-pens at hand when he came to the flat in case Mervyn had a sudden urge to draw, which happened every so often. That evening Maeve was beckoning him to leave when Mervyn reached over for the sketchpad and a pen. The three of us stood watching him as he looked down at the blank sheet of paper for a short while. Suddenly his face broke into the impish smile I remembered from our first encounter, and in a few swift strokes of the pen a skittish prancing horse with a flowing tail appeared on the sheet of paper. There was a brief pause while he peered at the drawing critically with his head on one side, then he picked it up and handed it to Gillian.

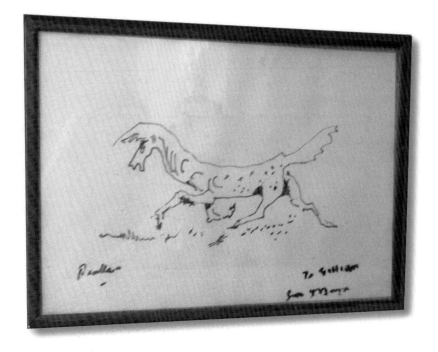

'You must sign it, darling,' Maeve said. Mervyn took the sheet of paper back and signed it at the bottom left 'Peake.'

'No, Mervyn,' she interrupted, 'it's for a friend. You gave it to Gillian.' And she placed

the drawing back in front of him and restored the pen to his swollen fingers. Mervyn looled puzzled for a moment, then gave a laugh. 'Of course,' he said, and added, 'For Gillian from Mervyn' at the bottom right.

(Today the drawing occupies a small space in a narrow room in our house that I think of as Memory Lane.)

In the months that followed Mervyn's health became a matter of ever-increasing concern. One day Maeve rang and told us she had been persuaded that Mervyn would greatly benefit from a new form of brain surgery which had been successfully pioneered here and in the United States. The operation was known as a Frontal Lobotomy and consisted – as far as she understood – of a surgical scraping away of part of the front lobes of the brain, thereby greatly reducing the patient's fears and anxieties. Only much later Gillian and I became aware that the operation was regarded in many medical circles with deep suspicion, and very soon went out of fashion.

We never saw Mervyn for the best part of a year. Maeve seemed to have withdrawn and we kept a discreet distance. Then one day I visited a small London gallery where I knew she sometimes exhibited her own paintings, and there she was. We had a pub lunch together, and we talked about everything but Mervyn. I had become art critic for *The Sunday Telegraph* by this time and Maeve was keen that I should know of an exhibition of her new work planned for a couple of months ahead. After years of being merely a support to her husband, in her gentle and modest way she was anxious to remind me that she was an artist in her own right. It seemed an indication, too, that she had finally given up hope of Mervyn's recovery, and was looking to a future without him.

When we did talk about him she made it clear that the brain surgery had brought no improvement; if anything Mervyn was more confused than ever. And he had drawn and painted nothing for months. I hesitated to ask if he might still like to come to dinner with us. To my surprise Maeve sounded enthusiastic; she was sure he would enjoy it, although now they would need to take a taxi. He could no longer walk even that short distance.

We had not seen Mervyn for a long while and were uncertain what to expect. Then, when the doorbell rang, and we helped him up the flight of stone stairs and into our living room he seemed much the same as ever. As we sat round our gas fire he was with us in flashes, though often those flashes passed before we had grasped what he had said, or could respond. Most of the time he sat silently, head down, his hands shaking as Maeve guided his fingers round a wine-glass.

The evening progressed slowly, with Mervyn nodding in the background while the

three of us kept up contrived bursts of conversation about art exhibitions we had seen, or how their children were doing. After dinner Mervyn sat slumped on the sofa as before. But suddenly he made a gesture to Maeve with his hand and when she leaned over to him I heard him murmur something about 'paper'. Maeve nodded to Gillian who hurried over to the desk to find the sketchpad and pens she always used to keep for him. She placed them on a tray in front of him and we watched.

He sat upright and gazed about him as if to ascertain where he was. Then he reached forward and grasped a felt-pen in a hand that was no longer shaking. For perhaps half an hour Mervyn seemed to throw off his illness and became the artist who had once illustrated *Treasure Island, The Ancient Mariner* and his own novels and books of poetry. In that long, silent half-hour he covered sheet after sheet with images of his zoomorphic world of fantasy beasts and humanoid creatures which had escaped from his brain. Mervyn seemed quite unaware of our presence as we stood quite still a short distance from him, having given up any pretence at conversation. As he finished each drawing, sheet after sheet of rapid sketches were strewn around him on the sofa as he peeled them off the sketchpad.

Then the spell broke. He put down the felt-pen and the hand began to shake. His body slumped. Yet his face remained radiant and there was a tired smile on his face. Maeve stepped forward and gathered up the litter of sketches from around him, placing them in Mervyn's hand and closing his fingers around them. Then he rose to his feet, steadied himself and without a word presented the sheaf of sketches to Gillian, giving her a kiss on the cheek as he did so.

As we all stood around the door-bell rang and the taxi was announced. Maeve took Mervyn's arm and we escorted the two of them carefully down the stairs. Gillian kissed him goodbye on the doorstep.

It was the last time I saw Mervyn. Not long afterwards he was moved to the Priory nursing home in Roehampton, and later to a home further afield. About that time we moved house, and in the ensuing shambles the sheaf of drawings he had presented to Gillian disappeared. Maeve never said as much on the occasions when we managed to see her in the months to come, but I have a feeling they had been the last things Mervyn ever did.

Mervyn Peake died in 1968.

L. S. Lowry

The idea came to me that it would be fascinating to have Lowry revisit some of the industrial sites made famous by his paintings, and to record him talking about what they had meant to him. It was something BBC Television should have thought of, considering Lowry was England's most popular painter, but they never had. So I wrote to him offering my services as chauffeur, suggesting that if he liked the idea I could pick him up at his house in Mottram, near Manchester, and drive him wherever he wished. I had my motive. This was 1965, and the Arts Council had asked me if I would write the catalogue introduction for the Lowry retrospective exhibition to be mounted at the Tate Gallery in London the following year. Since catalogue introductions are generally an anaesthetic rather than a stimulant I was keen to write something that visitors to the exhibition might actually enjoy reading.

I had met Lowry a number of times, first in Newcastle where my friend Mick Marshall of the Stone Gallery had put on an exhibition of the artist's recent works, and subsequently a number of times when Lowry visited London. Here I'd collect him from his hotel near Russell Square and we'd go off in search of a café where he could enjoy his favourite tea and cakes. Alternatively we'd take a tour round the British Museum, which was close by, and where Lowry would enjoy making unpredictable comments on the more exotic examples of Indian or Inca sculpture which he pretended not to understand. He was always a delight to be with, endearing and witty, which was why I felt sure that his commentary on the industrial landscape to which he had devoted his life would make engaging and illuminating reading.

He replied to my letter promptly, 'What you suggest will suit me very well.' When I enquired where it might be convenient to stay, his response was equally prompt, 'There is nothing at all in Mottram. It's a dreadful place and I spend a lot of my time wondering why I ever came to live in it.' He recommended a hotel in the centre of Manchester, adding, 'I hope you are keeping as well as can be, and I am looking forward to seeing you again.'

I turned up at the appointed hour with several days entirely free to go wherever Lowry wished. He had described his house as 'grey', which was an understatement. Amid the general clutter of books, papers and half-finished canvases there were multiple ticking sounds from innumerable clocks all over the house which he explained had been his mother's collection. 'They all keep different times,' he assured me, 'but you get used to it. You have to be thankful they go at all at their age, don't you?'

We talked over mugs of coffee about where he would like me to drive him. He thought the best idea would be to start in Salford where his interest in the industrial environment was first awakened. It was one of those late-winter mornings that made me understand why the sun never seems to rise over Lowry's townscapes, with their smoky horizons spiked with chimneys and church spires. As we drove off he settled into the passenger seat looking comfortable and contented, dressed in the familiar long raincoat and trilby hat that had seen better days. He talked disparagingly, but with a laugh, about this awful place where he had chosen to live. Then in a while we stopped at a café he knew, and here he began to delve into poignant moments of his past as we tucked into midmorning cakes and tea.

He explained how when he was twenty-two his parents and he had moved from a residential district of Manchester to Pendlebury, which was a suburb of Salford 'and as industrial as could be. At first I didn't like it at all,' he went on. 'It took me six years. Then I began to get interested. I wanted to depict it. And I couldn't recall that anyone had ever done it before. Finally I became obsessed. And I did nothing else for thirty years.' He explained how between the two world wars he even made a point of visiting every industrial town in the north of England, spending a couple of nights in each, and always gravitating to the poorest part of town. His only ambition, he insisted, had been to prove that the industrial landscape was as worthy a subject to paint as any other.

'As I went around I did a lot of studies of little figures, drawing them as well as I could. I didn't know they had big feet until people told me; I was just recording everything as I saw it. So I'd come back with all these little drawings. Then it was a question of what to

do with them.' He leaned forward across the café table with an impish look on his face as if about to tell me something I oughtn't to know. 'You see, I really liked to do imaginary compositions back in my room, collecting it all together in my head. I used to start in the morning in front of a big white canvas, and I'd say, "I don't know what I'm going to do with you, but by the evening I'll have something on you".'

There was a streak of mischief in Lowry, combined often with self-mockery, and he liked mixing the two. As we drove on towards Salford he warmed to the theme of his childhood days, relishing the account of himself as an amiable misfit, and enjoying the look on my face as I listened. 'It was suggested I went in for art as I was fit for nothing else,' he assured me. 'An aunt remembered that I'd drawn little ships when I was eight years old. So that was it. It was any port in a storm.' He went on to describe how he went to the Manchester School of Art in 1905, and stayed there for about ten years without ever taking an exam. 'And in the holidays I started painting landscapes that nobody wanted, and portraits that nobody wanted. Eventually they suggested at school that I leave. So I did, and they tried not to look happy.' He then told me how he once painted a man's portrait specially to please him, 'I thought it was sweet, but his wife said she wouldn't have it in the place.' It was put in the attic for forty-three years until they were both dead – 'never once down.' Lowry shook his head and laughed. 'But then his son didn't like it either, so I got it back and gave it to the Salford Art Gallery. It's very sad, you know.'

Listening to Lowry being witty and entertaining about his catastrophic early failings placed the huge success of his later years ironically in perspective. Here was an artist who has kept going for decade after decade on the strength of selling one painting a year if he was lucky. He described a rare moment of hope when he was already in his forties. A dealer wrote out of the blue explaining that he had come across some of Lowry's work and felt he might be able to sell it. 'He said he was going away for a few weeks, then he'd be in touch. But he never did. Then many years later I asked a gentleman who I thought might know him. And he replied, "Very sad, wasn't it? Oh, didn't you know?" The man had been going in for an operation when he wrote to me and he died a week later … I've never judged a man for not answering letters since.'

The bleak and bustling industrial landscapes by Lowry were in my mind's eye as we drove through the region that had inspired them, now greatly changed. So much of the mood and humour of his early life as he recounted it to me was reflected in those familiar paintings in which the urban scene has become a human anthill. Lowry himself was a solitary figure who loved crowds. He was the sharp-eyed observer. His grey figures stride

purposefully through the streets of industrial England, wearing shoes like boxing-gloves and wearing hats rammed down over their ears, their clothes draped over gangling limbs that seem to possess no bones or muscles. They pour out of a cotton-mill after work, they pace railway platforms, congregate round a street fight, swarm into a football ground, form a procession of pram-pushers in the park accompanied by absurd dogs looking like animated pipe-cleaners. Lowry loves them all; they are his 'real people,' he explained, and this industrial wilderness we were now driving through was their heartland. They are figures as unmistakable as Charlie Chaplin's bowler-hatted tramp, to which they bear strong similarities. They are sad, funny and vulnerable. There is something of the silent movie about Lowry's canvases; they are narratives without words.

We'd arrived in Salford, his former home town. Lowry was keen to take me to the Salford Art Gallery which possessed the largest public collection of his work. The attendants barely raised their eyes at the old man in a shabby raincoat, until one of them suddenly did a double-take and nudged his colleague sharply. Within seconds it was as if the king had arrived unexpectedly at his court. Doors opened, and there was much bobbing of heads and fluttering of hands. One of them must have alerted the gallery director, who emerged at the head of a flight of stairs. Lowry introduced me with a chuckle as his 'young biographer who's getting me to tell the sad story of my life.' The director invited us to join him for a salad lunch in his office, and this was brought in by a minion breathless at finding herself serving the great man. Lowry himself talked of his forthcoming retrospective in London, for which, he explained with the hint of a smile, my 'biography' was apparently to be the catalogue introduction.

After the long description in the car of his unending failures as a younger painter it was a touching contrast to be seeing Lowry in his pride. He talked to the gallery director about his prestigious exhibition to come and about the prices his pictures now commanded at auction. He spoke with exactly the same tone of self-deprecating humour as when he had talked to me about the barren decades when he had sold virtually nothing.

Lowry wanted to walk round Salford for a while after we left the art gallery. He felt a mixture of nostalgia and sadness, he said. 'What is that line of Sheridan's? "There's nothing so noble as a man of sentiment",' he said. He gazed around him in a circumspect way as we walked, and I half-expected to see tears in his eyes. Then he found yet another café he remembered and we sat over cups of tea while he talked about how things changed in his life. There was a sudden change of tone in his voice. 'It was in 1938,' he explained. A London art dealer, Alexander Reid, founder of the distinguished Reid and

Lefevre Gallery in Bruton Street, had seen some of Lowry's work on the floor of a framer's workshop. The owner had told him there were plenty more upstairs, mostly returned from exhibitions where they'd been unsold. 'Reid told the man to send them all round to his gallery. 'And that was how I got my first exhibition the following year,' Lowry explained in a matter-of-fact voice. 'I was fifty-two years old, you know. I sold about sixteen pictures,' he went on. His face brightened. And he laughed. 'My God, it gave us apoplexy at home; our brains almost weren't powerful enough.' (Lowry was still living in his parents' home, though this was the year his mother died.) 'You know,' he added, and there was a surge of pride in his voice, 'I got more pleasure out of that first show than anything in my life, before or since.'

Lowry had another reason for bringing me to Salford. 'There were special places I liked to draw here,' he explained. 'And my favourites were houses that had been built round factories. There was a particular feel about them, being surrounded by chimneys and working places. I thought they'd all been pulled down, but then I heard that there was one still there.' We headed off, with Lowry striding along purposefully. And there it was, the one that was left – a grim tenement block, black and scaly with fire-escapes. One end of the building was strangely curved like the stern of a ship, and the streets around it were narrow and cobbled. It felt like a leftover from the Industrial Revolution.

'Well, here we are. Ordsall Lane Dwellings.' And he gazed at it admiringly. 'I first came here in 1927,' he said. 'I remember standing here for hours on this very spot where we are now.' He turned to me with that mischievous smile I'd come to recognise. 'And scores of kids who hadn't had a wash for weeks came and stood round me. There was quite a niff, I can tell you.'

Lowry's painting of the Dwellings I knew well; it had been bought by the Tate Gallery, dirt-cheap, from that first exhibition at the Reid and Lefevre Gallery in London. I could see the painting clearly in my head. The artist had certainly not flattered the place, if anything he had glorified its grimness, its lugubrious greyness and smoking chimneys making it look as much a factory as a human dwelling. Yet there in the streets around the building Lowry had included the same unwashed kids who had swarmed round him while he made his drawing of it.

We were standing exactly where he had made that first sketch almost forty years earlier. And as we gazed up at this grim relic of industrial England we might have been admiring Chartres cathedral or the Taj Mahal. I was reminded of how Lowry had been drawn almost magnetically to the village of Mottram which he professed to hate, and to the

soulless house where he chose to live in the company of his mother's collection of clocks that all told different times. I was reminded, too, of his story about working in London, which he rarely did except for one location in particular, St. Luke's church in Old Street. 'I'd been told it had the ugliest spire in the world. So naturally I had to go and look at it.'

Why should he have felt the need to see the ugliest church spire in the land, I wondered? What exactly was the appeal of ugliness? As we made our way back to the car I wanted to ask him, but he had such a contented air. 'I'm pleased to have seen that place again,' he said. 'I imagine they'll be pulling it down soon, just like all the others.' He was silent for a while as we drove off. I got the feeling he was quietly saying goodbye to a disappearing world he had grown to love. All of a sudden he said, 'I'm attracted to decay, I suppose. I'm not sure why. It's the way I see things.' It was a remark that gave me a clue to what it was about ugliness that attracted him. There were no ideals in Lowry's world – no perfections; it was always on the verge of falling apart, damaged beyond repair, like so many of the people in it. He felt a burning need to paint life as it really was, warts and all. That was the world as it truly was, and often it was the warts that made it more real – like that ugly spire reaching up to heaven, bloody-minded and undaunted, as if it was pronouncing, 'Here I am, this is me, make of me what you will.' In a similar fetid world are the damaged human beings he loved to paint: people who had seen better days, hanging on to life, decaying, but invariably with an air of heroic defiance. This was what gave them pathos and character or Lowry.

He was looking thoughtful after the visit to Salford. 'If I hadn't been a lonely man,' he said suddenly, 'I might not have seen things the way I did.' Then his face brightened, and he glanced across at me with his mischievous look. 'You know, I've never robbed a bank, or shot someone. I've never been married. I've never had a girl in fact; and now I'm nearly eighty I think it's too late to start, don't you?'

He wanted to stop in Manchester before I drove him back to Mottram. I got the impression he was putting off the evil hour when he had to return to Mottram and the house of the clocks. It was becoming increasingly clear to me that the dedicated 'solitary,' as he described himself, 'immensely enjoyed human company, and in particular the chance to talk about his life, carefully polishing each well-chosen phrase.' As we reached Manchester he guided me on a detour of some of the more dilapidated back streets which he wanted to make sure were still there, giving a nod of approval every now and then. Finally we headed for the city centre and, at his suggestion, I parked the car on the edge of Piccadilly Gardens – one of his favourite haunts, he assured me.

There was a bench on the edge of the gardens. Lowry seated himself and began looking around him, his eyes scanning the passers-by and groups of figures standing around, playing ball-games, chatting, pushing prams, or just sitting in the evening sunshine. Suddenly it was like looking at a Lowry painting. And I remembered him telling me that for the last ten years he had more or less given up painting crowded mill scenes and industrial landscapes in favour of studies of individuals – people who had caught his eye; usually they were doing something odd and it intrigued him to know what it was and what they were about. Lowry had a quizzical look on his face. He was people-watching, as if mentally photographing the scene for future use. After a while he broke the silence: 'People think crowds are all the same; but they're not, you know. Everyone's different. Look!' And he leaned forward and began to point out some of the figures dotted around the gardens. 'D'you see? That man's got a twitch. He's got a limp. He's had too much beer. That woman, she's angry with her child. Those two have had a row … It's wonderful, isn't it? The battle of life. That's what it is: the battle of life.'

It was a favourite phrase of Lowry's, 'the battle of life.' He used it several times during the course of that day. It was a quality he had found absent in the French Impressionists ('too sweet'), but admired in their contemporary Daumier, and particularly in the 17th-century Dutch and Flemish painters Brueghel and Avercamp.

Lowry's world was a battleground where most of the survivors seemed to be the wounded. As we sat there in the quiet of the evening I was reminded of the subject matters of some of his recent paintings. They made a bizarre list: Man lying on a wall; Cripples; Man looking through a hole in the fence; Woman with a beard; The fight; and – a typically Lowry touch of humour – the same woman coming back. I broke the silence and asked him what it was that appealed to him so strongly about the people he chose to paint. There was a pause, then he said, 'They're misfits, but they're real people, sad people, something's gone wrong in their lives and I feel I need to record them. I'm attracted to sadness, I suppose. But there's also a mystery about them and that intrigues me. They all have a secret and I find myself wondering what it is.'

I found myself thinking of Lowry as a collector, stalking the human race with his butterfly net. Yet the description did him less than justice. The people he selects are never rare specimens pinned to his canvas as if he was creating some kind of freak show. His portraits, however quirky, are imbued with pathos, and with a certain affection that comes close to mockery without ever becoming so. They are the creations of a man projecting his own solitude on other solitary figures, just as he projects those same

intense feelings of solitude on his stark landscapes, and his vast seascapes empty except perhaps for a tiny sail.

I drove him back to Mottram that evening. He had politely refused my invitation to dinner at any restaurant of his choice. I suspected that after a day 'on show' he preferred the solitude of his own company, though God knows what he would find to eat in that bleak house. I knew also that he often worked at night, wrapped in his isolation. And I remembered his remark earlier in the day, that had he not been a lonely man he would never have seen what he did.

I saw him again the next day. He welcomed me cheerfully as his 'biographer', and showed me other sites in the region which he had enjoyed painting and which had yet to be demolished as he feared they soon would. But that first day was what remains most vividly in my mind. In his delightful and idiosyncratic way Lowry had given me the privilege of sharing for a few hours the private world of a deeply private man. I have never looked at a Lowry painting in the same way since that day I spent with him nearly fifty years ago. He sent me a Christmas card with a painting of one of his human misfits printed on the back. 'A Happy Christmas,' he wrote, 'and thank you very much. Yours sincerely L. S. Lowry.' There followed a printed quotation from D. H. Lawrence: 'Everything can go but this stark, bare, rocky directness of statement. This alone makes poetry today.' For 'poetry' read 'painting'. It could be Lowry's epitaph.

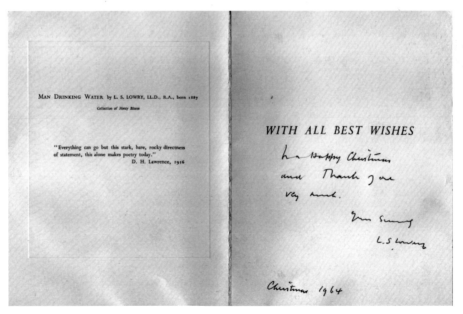

Graham Sutherland

Of the many artists I came to know and work with Graham Sutherland was the most charmingly accessible, and at the same time the most unfathomable. Over the course of ten years or so I never managed to reconcile the glamour and outgoing warmth of the man himself with the secretive and disturbing art that came out of him. I once found the courage to ask him about this apparent contradiction. Characteristically, he was unfazed by my question, and laughed, 'Edwin, sometimes I think I see better in the dark,' was all he said. And of course what he saw 'in the dark' was the essence of his art, his inner self – whether it was nature's hidden world of twisted roots and spiky forms, the rage of caged beasts, or the sagging flesh of some distinguished figure brave enough to sit for his portrait. Sutherland saw things in nature and in people that no one else saw; and they were generally uncomfortable things.

In the early-1960s he was at the height of his fame. He seemed a figure of unassailable grandeur. This was partly because he never fitted into any of the fashionable art movements of the day; besides there were so many facets of him. I had always loved his early Pembrokeshire landscapes – moody and mysterious, with their roots in the visionary landscapes of Samuel Palmer. But those were long past. Now there were those uncompromising portraits of Somerset Maugham, Helena Rubinstein and more recently Winston Churchill; then bafflingly stranger paintings – piles of chains on a dark forest

floor, trapped beasts unknown to science, and thorn bushes that suggest the Crown of Thorns without actually saying so.

And now there was the most unexpected and remarkable achievement of all – the huge tapestry of Christ in Glory which had just been installed behind the high altar of the new Coventry cathedral after ten years in the making. The city's Gothic cathedral had been destroyed by German bombs during the war, and now a new one had been built to a design by the most fashionable architect of the day, Basil Spence. In the Renaissance tradition he had commissioned a number of leading artists to contribute to the building. Epstein's dramatic bronze of St. Michael trampling the Devil had been set up on the outer wall close to the entrance. John Piper had designed an acreage of stained glass. Finally there was Graham Sutherland's tapestry. This was 1962, and the new cathedral was at last complete.

I had been appointed critic of *The Sunday Telegraph* only a month or so earlier when a cryptic note arrived from the editor, Donald McLachlan. It was a Friday afternoon and I was correcting a galley-proof of my weekly article in the main editorial room. 'I'm sending you to Coventry,' the note read. ' Come and see me.' A little nervously I knocked at Donald's door. 'Well now,' he announced as I entered. 'Coventry. The new cathedral. It's being called God's Art Gallery. That's your line of country, Mullins. Write me something next week.'

I drove up to Coventry the following Monday. Like many people I found the shell of the bombed cathedral with its Charred Cross in place of the high altar more moving than its replacement – a sharp reminder that the legacy of history wins out over current affairs every time. John Piper's windows filtered the sunlight, drawing the eye towards Sutherland's enormous tapestry dominating the centre of the building.

I stood gazing at it for a long time in some amazement. How could one not be amazed at a work of art so huge, so elaborate a composition, on a theme that lay at the very centre of the Christian faith, and over which the artist had agonised for ten years? Yet the longer I looked I found myself being nagged by a simple question: what is it? With its image of the Risen Christ enclosed within its cocoon-like mandorla this was clearly an echo of those powerful carvings that confronted God-fearing mediaeval worshippers as they entered great pilgrim churches like Conques and Vézelay: images of magestic authority as moving today as they would have been in the 12th century. Yet this was the 20th century, and a Protestant cathedral, with the artist (himself a Catholic convert) striving to re-create a visual message from a far-distant time and culture. It had the look

of being elaborately contrived – of being designed by committee, with each member of the cathedral council determined to add his tuppence-worth of theological correctness. And amid all this where was the spirituality? Where was the awe-inspiring grandeur of Christ in Glory?

Standing in front of Sutherland's huge tapestry that morning I became strongly aware of the enigma of endeavouring to create religious art when the traditional visual language of the Christian faith has been either sentimentalised or lost. Could there be a religious art appropriate for our day? And what form might it take? I remembered then that the architect of the cathedral, Basil Spence, had chosen Sutherland chiefly on the strength of a painting of the Crucifixion which the artist had undertaken towards the end of the war for a parish in Northampton, St. Matthews, commissioned by the then vicar, Walter Hussey. It had been Sutherland's first important commission, and his first religious painting.

I knew the painting still hung in the Northampton church; so I made a diversion on my way back from Coventry to look at it. I located the church in a residential suburb of the city. It was open. Not a soul was around. And there behind the altar hung Sutherland's Crucifixion. As I stood gazing at it the contrast with the Coventry tapestry was startling. This was not God's art gallery. There was no hint of a committee voice, no elaborate theological correctness which the artist was required to respect; only an uncensored account of the agony and pathos of Christ's agony on the Cross. It was powerful and deeply moving. As for the visual language, Sutherland had used as his model Grünewald's great altarpiece in Colmar, Alsace, one of the most brutally realistic interpretations of Christ's crucifixion in western art. Perhaps because this was wartime Britain, and Sutherland had been working as an official war artist, Grünewald's shocking image of pain and physical violence had struck a powerful chord in him. Now I saw how religious art could be profoundly traditional and the same time vibrantly modern. In its directness the painting was as modern as a Picasso, and in the way paint can take on the feel and even the odour of flesh and blood it was as modern as a Francis Bacon.

In this disturbingly powerful painting I felt I had discovered a Sutherland I hadn't known to exist. And it drove me to explore further. The vicar of St. Matthew's church who had commissioned Sutherland's Crucifixion back in 1944, Walter Hussey, was now the dean at Chichester cathedral in West Sussex. This was close to where my parents lived, and one day I telephoned the deanery and asked if Dean Hussey would be prepared to talk to me. He invited me over that very afternoon and gave me an enthusiastic tour

of the cathedral to show me the works of art he had commissioned, which included another smaller Sutherland altarpiece. John Piper was in the process of making a large tapestry to be hung behind the choir, and Marc Chagall had agreed to design a stained-glass window. Hussey sounded deeply proud. Then, when I asked what he felt was so important about having works of art in a church he looked at me fiercely and said, 'Bad art is blasphemy!'

It was over glasses of wine, surrounded by his substantial private collection of modern paintings, and with a Henry Moore bronze reclining on the deanery lawn beyond the open window, that we got to talking of Graham Sutherland. And I mentioned my admiration for the Crucifixion I had recently seen in Northampton. Walter lowered his glass and looked at me. 'Then you should meet him,' he said. 'Graham would like you. He enjoys people who ask questions.'

The idea of doing an extended interview with Sutherland remained dormant in my mind for some time. Like every project in Fleet Street this one needed a peg, and 'Sutherland on religious art' fell flat on its face when I proposed it to my editor, Donald McLachlan. Then a door opened. Donald summoned *The Sunday Telegraph* critics to a meeting in his office and made the announcement which I have quoted elsewhere, to the effect that we all of us knew distinguished figures in our field who might be expected to die soon. We should attempt to obtain in-depth interviews with such celebrities which he could then publish as obituaries, or earlier if an appropriate moment arrived. I proposed several names, among them Oskar Kokoschka. Then, some months later, after the Kokoschka interview had been well received, I suggested a similar piece on Graham Sutherland – to which Donald replied with his thin-lipped smile, 'I suppose you want a free trip to the Riviera. It had better be good, Mullins.'

Sutherland had bought a house in the south of France in the 1950s. Harry Fischer, his London dealer at Marlborough Fine Art, gave me the address and phone-number, having already spoken to Sutherland and obtained his agreement to see me. 'Graham liked your piece on Kokoschka,' Harry assured me. 'He thought you were very perceptive. Have a great time. And whatever you do, don't ask him about the Churchill portrait. He's very touchy on the subject.' Unfortunately this removed one of the key topics I had wanted to ask Sutherland about. Churchill had died the year before, and it was strongly rumoured that Sutherland's portrait of him, commissioned in 1954 by the House of Commons, had been destroyed by Lady Churchill because she detested it so much, though it was not entirely clear why.

This was now the autumn of 1966. I booked a flight to Nice, and a small hire-car. Sutherland's wife Kathleen had answered the phone when I rang. The road from Menton up to Castellar was winding and precipitous, she explained. 'You can't miss La Villa Blanche,' she added. 'It looks like a white ship. That's us. Graham's looking forward to meeting you. Do you have any food fads?'... Good!'

It was exhilarating to be driving up into the mountains from Menton, the sea receding further and further below, and the shadowy silhouette of Corsica in the far distance. I had known the Maritime Alps since school days, with holidays spent in 'perched' hilltop villages encircled in wildflowers and eagles circling above. Castellar was one such village, lower than most, still within the olive line, and embraced by vineyards and cherry orchards. There was no mistaking Kathleen's 'white ship'. And clambering up the 'gangway' to reach the terrace I was greeted by the smiling debonair figure of Sutherland himself. He greeted me with an easy warmth as though I had known him for years, the handsome bronzed face and greying hair smoothed back bearing the look of a quintessentially English

gentleman perhaps of the kind who used to winter out here in Menton, returning to the Home Counties to avoid the oppressive heat of the Riviera summer. This was my first impression of Sutherland, and it was entirely delightful to be here, sipping cool wine before lunch looking out over a steep hillside of rough stone terraces with scrub and olive trees, and then Kathleen calling out from the kitchen 'Graham, stop talking. Isn't it time you introduced me to our guest? Lunch is nearly ready.'

That afternoon, after a good Latin siesta in the shaded garden, Graham and I talked for hours in his studio. To my surprise one of the first topics he raised was that of the Churchill portrait. Far from being 'touchy' on the subject, as Harry Fischer had maintained, Sutherland seemed keen to share his thoughts. A note of conspiracy entered his voice as he explained why he believed Lady Churchill had destroyed the portrait. 'I suspect she believed I'd detected in Winston's face that he'd suffered a minor stroke, which no one was supposed to know about.' Sutherland gave a half-smile, 'Actually I didn't know; I just painted what I saw, an old man's face beginning to fall apart.' It struck me as he said it that this was a remark which identified one of Sutherland's most abiding and disturbing gifts as a painter – his fascination for things that are falling apart, in a state of decay – whether it be the human form, a shattered building, a gnarled tree that continues to defy old age, or (the image came before my eyes from that visit to the church in Northampton) Christ bleeding on the Cross. His was a gimlet eye which drew blood.

From the destroyed portrait of Churchill he talked of the role portraiture played in his work. 'I need to keep it as a sideline,' he insisted; though he admitted it was an agreeably lucrative sideline. It had begun by chance, he explained. He and Kathleen were staying on the French Riviera a few years after the war and had an introduction to visit Somerset Maugham at his villa on Cap Ferrat. After they left, Graham made some remark abut Maugham's extraordinary craggy face, and if he had been a portrait painter that was the kind of subject he would choose. Through various circuitous routes that casual remark led to the reality of Sutherland's first portrait – which aroused instant acclaim in the art world, seeming to inject an almost shocking honesty and psychological insight into a moribund art form fit only for an officers' mess or a corporate boardroom.

'I learnt to wait and watch the sitters for some facial expression or pose which revealed their character,' Sutherland explained. 'That was what interested me most.' It was also what sometimes disturbed his sitters most, I suggested. He smiled and gave a shrug as if to say 'What else could I do?'

Portraiture took Sutherland by surprise. But then, as we touched on different aspects

of his long career that afternoon I became struck by how much of his whole professional life had been driven by chance. His first apprenticeship had been in engineering with Midland Railways in Derby. Then at art school in London he learnt engraving, and for nearly a decade that followed he earned a living making etchings of brooding landscape subjects in the manner of Samuel Palmer in the early-19th century. Only when the print market collapsed during the Depression did he take up painting, discovering an area of south Wales which moved him to paint landscapes with strangely dreamlike overtones. The war put an end to all that, wrenching him back to a very different kind of reality. He became an official war artist, producing dramatic images of devastation caused by the Blitz. Then came Walter Hussey's surprise commission for a Crucifixion, followed after the war by the move to France and the quest for quasi-religious imagery in nature – thorn bushes, tortured and disfigured shapes of trees, menacing creatures, sunless caves and forests. And finally the diversion into commissioned portraiture. It was as though each step into the unknown opened up a fresh field for his imagination to explore. His had been a life of surprises and rediscovery.

There was to be one more surprise for me that day. As we left the studio early in the evening and strolled back towards the house Sutherland paused and shook my hand as if to say goodbye. Then without a word he blew Kathleen a kiss, and departed. Kathleen and I were left standing on the terrace. A moment or so later there was the sound of a powerful engine and a large Jaguar accelerated fast down the road. Kathleen was smiling. 'You can tell Graham's had a good day. He enjoys talking to people who can contribute. It gives him something new to think about. Now he needs a break. His little flutter.' And she explained that every now and then he would take himself off to Monte Carlo and spend an hour at the casino. 'He enjoys the drama of it,' she explained.

Back in London I wrote and thanked him for his courtesy and the time he had given me. Then I wrote to him with an idea: would he consider my accompanying him on his walks in the Maritime Alps to see him recording the details in the landscape which were inspirations for his paintings? I would bring a first-rate photographer, I added. I had recently begun writing features for the new *Telegraph Magazine* and had already put the idea to the editor, John Anstey, who always loved articles about glamorous figures. To my relief Sutherland replied on November 25th, 'what an excellent idea.' He suggested a visit in the spring. In January it was all confirmed and I wrote to him that the photographer was one of the best, Anthony Howarth. On January 27th he wrote back: 'We were both greatly happy to receive your letter. I found our meeting last autumn immensely agreeable

and interesting, I look forward to your visit. With best wishes from us both, Graham.'

The planned spring visit to explore his French landscape got postponed. A telegram arrived: 'Weather ghastly outside work impossible.' Meanwhile a major retrospective of Sutherland's paintings was being mounted in Munich – the largest exhibition of his work so far held. I flew over and wrote about it as *The Sunday Telegraph's* art critic. On June 17th I received a letter from Graham thanking me for having gone to Munich. Apparently I was the only critic of a national English newspaper to have troubled to do so. He was quite used to this by now. Graham wrote, 'Only ballet and Henry Moore get any attention,' he added sourly. I felt hurt for Graham. Until now I had never taken in how out of favour critically Sutherland had recently become. Much of this cold-shoulder treatment was inverse snobbery – a hangover of the romantic notion that artists should be happy to live in creative poverty rather than be paid a fortune to paint world leaders and Nobel Prize-winners. It was also being put about by influential voices in the art world that Sutherland had 'lost his way' by going to live among the fleshpots in France; as if somehow the English climate would have kept his inspiration fresh. Graham found it significant that the Munich exhibition was due to travel to Cologne and The Hague, but not to Britain.

The visit in search of Sutherland's Mediterranean landscape eventually took place early in that autumn of 1967. It was almost a year since my first visit to La Villa Blanche, and the welcome was even warmer than before. Graham had clearly been deeply hurt by being 'side-lined' – as he saw it – by the British art establishment. He made only a passing reference to the Munich exhibition which had meant so much to him; instead he was keen to show me some of the special places in the hills that had inspired some of his recent paintings. As I had noticed previously when Graham had decided to share a secret, there was a slight air of conspiracy as we set off along a rough path behind the house; Graham's rudimentary painting gear already prepared in his rucksack. We were making our way up the last valley in France; the long spine of mountains stretching down to the sea far below us was the Italian border. I realised as we climbed, that Graham was relishing being photographed 'in action'. Anthony Howarth caught the spirit of the occasion and snapped away as his subject led the way along narrow tracks through the scrub and the shale, cheerfully brandishing his stick from time to time. He so obviously loved this wild region. And I suspected he loved it the more because, out of sight only a few miles down the valley, lay the rich spread of the Riviera and the glossy aspect of Graham's life. Up here was his private world.

At one point he stopped suddenly. 'That's the sort of thing I like,' he said abruptly. And

he pointed his stick in the direction of a particularly battered and gnarled fig-tree beside the track. Its whole structure bore the scars of struggle. Graham took out his sketchpad and began to create a miniature studio around him, with brushes, paints and a pot of water. The sketch took barely ten minutes, with the artist totally absorbed; then we moved on. A short distance further on he paused again and the stick pointed out another tree, half-dead and carbuncled with warts. In the heart of the tree a knot of wood had fallen out, and through the hole in the ancient trunk a young sprig had thrust its way into the light. Graham set up his outdoor studio a second time.

And so it went on. As we walked back towards the end of the morning he explained, 'The older I get the more strongly I see these extraordinary correspondences in things. Nature is so full of paraphrases.' I realised how central in Graham's vision of the world were these hard, embattled shapes in nature – all of them dark metaphors of the human condition in his eyes. To my surprise I found myself reminded of a remark made to me recently by a very different artist, L. S. Lowry, about what he most loved to paint – 'It's the battle of life; that's what it is – the battle of life.' Their two battlegrounds could hardly have been more different: Lowry's matchstick figures striding to a football match; Sutherland's tortured trees and cruel thorn-bushes.

'There were things I saw this morning that hadn't struck me before; so I have to thank you for coming,' Graham said graciously after we got back to the house and were sitting in the garden. He looked around him thoughtfully, then he added: 'The things we've been looking at have – how shall I put it – a kind of force of nature in their shapes; a mystery too which responds to one's state of mind at the time, and the need of the nerves.' It was the nearest I ever got to understanding how Graham's creative instincts worked.

I sent him my account of our trek in the Maritime Alps when it was published in the *Telegraph Magazine* that November with Anthony Howarth's outstanding photographs of Graham at work in his own landscape. I got a handwritten reply: 'My dear Edwin, I like the article very much indeed,' and he very much hoped he would be able to work with me again. He went on to explain that as a result of the article he had received a great many letters including one from Kenneth Clark. Also, 'This morning the most abusive and mad letter I have ever received – from a woman, a self-styled psychologist.' Graham went on to paraphrase its contents for my enlightenment. His obsession with warts and ugly growths in plants, she informed him, was the consequence of his mother having hit him for urinating in the garden when he was five, since when he has been unable to pee properly.

I felt pleased and flattered that Graham should want to work with me again. My thoughts returned to our long conversations in France. And I remembered how, after our walk in the hills, Graham had talked about religious painting and how the *Crucifixion* he had painted for Walter Hussey in Northampton had come out of his experience as a war artist, and the scenes of misery and desolation he had witnessed and recorded in the London Blitz. That afternoon I took myself to the Imperial War Museum and asked to see some of the drawings and paintings Sutherland had done during the Second World War. As a large folder was laid in front of me, and I turned over leaf after leaf of Graham's wartime sketches and watercolours, I was astonished at the power and drama of these eye-witness accounts of shattered buildings and scenes of figures in makeshift shelters. It came to me that Henry Moore's wartime sketchbooks of people sleeping in the London Underground during the Blitz were famous, yet Sutherland's work on similar themes had remained unknown. Nor had he ever talked about his experiences as a war artist, as far as I knew.

So I wrote to Graham and asked him if he would consider this as another possible project we might do together. The reply came that it was certainly an interesting idea, and could we perhaps see how it went? I wondered about the note of caution, but took up his suggestion that I come out to France with a tape-recorder in early spring. I proposed the idea to the *Telegraph Magazine* and the editor smiled, '*Telegraph* readers love anything to do with the war,' he exclaimed. 'Most of them are old enough to have fought in it!' Then he summoned one of his busty secretaries to pour me a vodka-and-tonic.

In March I made my third visit to La Villa Blanche. This time there was snow on the mountains and clusters of early-spring flowers filled secluded spaces in the Sutherlands' garden. I arrived early, having spent the night in my Menton hotel overlooking the Mediterranean, then driving up the familiar road zigzagging up to Castellar. Graham greeted me as warmly as ever, and we spent most of the morning in his well-heated studio where Kathleen brought us coffee accompanied by snippets of local gossip which we could do with, she said, if we were going to talk about the war all morning. With the tape-recorder running Graham spoke carefully and precisely. He had clearly been rehearsing, and again I was aware of the note of reserve in his voice.

That evening the three of us dined in a favourite restaurant of his in Menton, and Graham became his normal delightful self, outgoing and amusing; Kathleen sometimes teasing him about some portrait he was painting and all the appalling things he daren't say to the sitter about his halitosis and terrible skin. We drank excellent wine from the

maître d's own vineyard in the Var and which he produced specially for Graham. Then, as we parted, I promised to send him a transcript of the long interview he had given me that morning.

Back home I listened to the tape carefully. And as I listened the thought grew on me that I had in my hands a remarkable and unique document. Graham's account of his experiences as a war artist during the bombing of London I found deeply moving. I was also astonished how his descriptions of the Blitz matched so vividly his drawings and watercolours I had been shown at the Imperial War Museum. The two came together perfectly. 'It had all begun,' Graham explained, 'with Kenneth Clark, Director of the National Gallery.' Clark had conceived the idea of a body of war artists just as there had been in the First World War.

'On a typical day,' Graham went on, 'I would arrive with very sparse paraphernalia – a sketch-book, black ink, two of three coloured chalks, a pencil.' Then he would look around. 'I will never forget those extraordinary first encounters: the silence, the absolute dead silence, except every now and then the tinkle of falling glass.' He described going to the area round St. Paul's cathedral which had been almost completely flattened by the bombing – all except St. Paul's itself, miraculously, it seemed. And he would 'make perfunctory drawings here and there: a lift-shaft, all that remained of a tall building: 'in the way it had fallen it was like a wounded animal.' One shaft in particular, from the way it had fallen, 'suggested a wounded tiger in a painting by Delacroix.' Then there were machines, 'their entrails hanging through the floor … And always the terrible sour stench of burning.'

When he moved on to the East End the atmosphere became more tragic. Now the destruction was of people's homes and lives. 'Even a mattress that had been blown out of a house into the middle of the street looked more like a body than a mattress.' From butchers' shops that had been hit, meat was spewed out over the road, and Sutherland remembered 'feeling quite sick … because I thought here was a body which hadn't been picked up.' Then there were the East End houses themselves, long terraces of destroyed buildings that seemed to 'recede into infinity, and the windowless blocks were like bind eyes.'

Graham had talked to me about the requirement for a war artist to be a 'pictorial journalist' Perhaps as a fellow-journalist I found myself responding as much to these naked accounts of the London Blitz as I had to the drawings of the same themes which I had seen in the Imperial War Museum. They also helped me understand Graham's

fascination for what he had described as 'paraphrases' in nature and the world around us: the way the destructiveness of war led him to see wrecked machines as possessing entrails, and meat from a butcher's shop as a human body. The war provided him with so many images which he saw as metaphors for human decay. And I found myself thinking that these 'paraphrases' born of the war possessed a dramatic urgency and a vigour which his more recent work, employing similar metaphors, somehow lacked. Perhaps, I wondered, Sutherland needed the immediacy of real human drama to give his work life.

These thoughts left me wishing I could do more with this remarkable material than tidy it up for publication in a colour supplement. It deserved a longer life.

Nonetheless, I transcribed the tape and set to work editing it. I then posted the resulting piece to Graham. He replied immediately, thanking me but saying nothing more. A few weeks later he wrote again asking if he could listen to the original tape – though I would need to let him have my tape-recorder too, plus spare batteries. I managed to arrange through *The Telegraph's* wide network for all of this to be delivered to him in Castellar. In July he thanked me again but said he had no time at present to listen to it. Our project was clearly being stalled and I had no idea why.

The whole matter grew even more cloudy when Graham suddenly wrote that he would prefer to adapt his words on the tapes as answers to questions he would like me to put to him – if I would be so good as to send appropriate questions to him. Feeling more and more puzzled, I complied with the artifice and sent him a list of questions to which of course I already knew the answers. This seemed to be becoming an elaborate game, and I was unsure of the rules. Graham replied that he was delighted I had gone along with his idea, adding cheerfully, 'Castellar is giving us a very fine autumn as usual and I wish you could get out here.' So did I, if only to get my hands on the promised answers to my questions. By now a whole summer had drifted by.

In fact two more summers then drifted by, during which time I decided to forget about the whole enterprise. Then, early in 1971, I glimpsed what I believed might be the reason for the delay. Graham wrote out of the blue, warmly as ever, to explain that there was to be a book on his war drawings by none other than Kenneth Clark. It had been Clark, when Director of the National Gallery, who had invited Graham to be a war artist more than thirty years ago. He had been Graham's mentor. Apart from the prestige of having a book on his work by the great man himself, Graham would not have wanted anything to come out in print in his own name that had not received Clark's nod of approval. And I imagined this had now been given, and that Clark might wish to make use of

some of Graham's answers in his book. In the event, on May 27th I received a breezy letter from Graham announcing that he was about to finish his answers, 'Otherwise I shall get into trouble with you!' He was true to his word and later that year the *Telegraph Magazine* duly published the piece with my introductory article entitled *Images Wrought From Destruction,* followed by Graham's long 'letter' beginning: 'Dear Edwin, You ask me questions about my war paintings and I will try to answer.'

There followed more or less the original edited version of my tape which I had sent to Graham three years earlier. And to my knowledge no publication by Kenneth Clark on the war drawings ever appeared. Maybe he was too busy being 'Lord Clark of Civilisation' as he was now widely known as a result of his immensely successful television series of that name.

Graham wrote on October 5th thanking me for seeing the project through finally. 'I liked your accompanying article very much,' he added. 'And I hope we meet in the not too distant future.'

There had been another change of direction in Graham's life – again more by chance than by choice. Several of his letters had alluded to a film being made about him by an Italian television company. It was Kathleen who had told me on my last visit to Castellar that the film director was particularly interested in the years Sutherland had spent working in South Wales during the 1930s. Graham had agreed to return to Wales to be filmed in the places where he had painted thirty years ago. The effect on Graham had been dramatic. The appeal of Wales was re-ignited and since then he had taken to returning regularly to Pembrokeshire to work in the creeks and valleys that had caught his imagination before the Second World War intervened.

No further letters arrived from Graham and I imagined that 'I hope we meet in the not too distant future' had been a fond farewell. Then, a while later, I ran into Kathleen at some art function in London and she invited me for a drink at Claridge's where she had rented an entire suite. Graham was working in Wales, she explained, as two large martinis were placed between us. There was silence for a few moments, then much to my surprise she said, 'Why don't you go down there? He'd love to see you, I know. He so often talks about his pleasure at working with you.'

I felt deeply touched. I had forgotten how very fond I had been of him. I would drive down whenever it was convenient for him, I told Kathleen. The journalist in me was already envisaging another project on the lines of 'Sutherland returns home.' Then Kathleen said, 'I need to tell you one thing. Graham has cancer, and there's not a great

deal that can be done about it. Your visit would be a tonic for him.'

I forgot about journalism and drove down to Pembrokeshire a few days later after I had received a message via Kathleen that I was most welcome. She had told me Graham always stayed in Milford Haven at the Lord Nelson Hotel, where he was given a spare room as a studio. When I phoned from where I was staying we agreed that I would collect him at nine the following morning. He sounded remarkably cheerful and was looking forward to showing me around, he said, but 'not at all like the Maritime Alps, though,' he added with a laugh.

And yet it *was* so very like the day we had spent in the hills above Castellar almost ten years before. Even Graham's rucksack with his painting gear looked the same. There were two river estuaries he wanted to go to – Sandy Haven where he had worked thirty years earlier, and (especially favourite) a wooded stretch of the River Cheddau at Picton. It was here he wanted to visit first; there was something he particularly wanted to draw. We arrived at a narrow stretch of the river heavily overhung with trees. Graham seated himself on a rock by the water's edge and pulled out his sketchpad and drawing materials. In front of him, half-collapsed on the shingle, lay a huge misshapen tree-trunk, its living branches thrusting upwards to create a dense canopy. 'That's what I love,' Graham said. At that moment I clearly remembered him saying much the same thing as he pointed to a knotted and gnarled fig-tree in the Maritime Alps. I remembered, too, his remark some time later about finding 'paraphrases' in nature for the human condition.

I had always felt uncomfortable, even alienated, by Graham's obsession with images of struggle and decay; it seemed such a dark and joyless vision of life. And I had looked in vain for glimpses of a brighter world, one which reflected the warmth and humanity of the man I had come to know and to value. But now, as I watched Graham, old and ill, deep in concentration as he recorded an aged leviathan of a tree straining for life, all those recurring images of menace and decay felt like a prophesy being fulfilled before my eyes.

This is my last enduring picture of Graham. Though as I drove him back to his hotel later that day another picture came into my head. He suddenly talked about cars, and the ones he had most enjoyed driving, and driving fast. At that moment an image flashed before me of Graham waving vigorously as he sped off in his Jaguar down a perilous mountain road heading for the casino at Monte Carlo. That was a side of Sutherland which never reached his paintings. But I am glad I saw it.

L'Ultima Dogaressa

Peggy Guggenheim was a legendary figure in the art world. But by including her in a portrait gallery of artists I need to stretch the definition of 'art.' Peggy's own art was that of an 'art addict' as she described herself in her autobiography. In Venice, where she lived for over thirty years, she was called 'the Last Doge.' It was a title which managed to express the deep respect and affection the Venetians felt for her, as well as a certain bewilderment at the presence of this exotic creature in their midst who did not seem to belong to our mundane era, but rather to the city's audacious and glorious past.

In the winter of 1964/65 her personal collection of modern art formed a highly popular exhibition at the Tate Gallery in London. It was the first time the British public had seen many of the American *avant-garde* painters whose work she collected. Peggy was then in her mid-sixties. A glamorous banquet was held in her honour in one of the main galleries of the Tate, hosted by the new director, Norman Reid, who made no secret of his hope that the Guggenheim collection might eventually find a permanent home here in London.

A short while after the banquet, he held a small drinks party in the Tate in order that Peggy might meet members of the press who had written effusively about her collection and, as art critic of *The Sunday Telegraph,* I was among the guests. Norman Reid, always

a kindly man, decided to introduce me as a friend of her son-in-law in Paris, the painter Jean Hélion. Perhaps Norman didn't know that a while earlier the couple had been through a messy divorce and her daughter was now married to someone else. Nonetheless, Peggy appeared undeterred, and we soon found more fertile common ground in a shared acquaintance in the United States who bred Lhasa Apso dogs; Peggy's favourite breed. Of such irrelevant coincidences are friendships made. Suddenly the tense air of reserve that had enclosed her instantly dispersed, and by the time the party ended, I had received an invitation to visit her whenever I was next in Venice

In spite of her awkward and rather shy manner there was an unmistakable glamour about Peggy. As the niece and heiress of Solomon R. Guggenheim, the American mining billionaire, she possessed great wealth allied to precise ideas of how to spend it. At the outbreak of the Second World War, a time when no one in their right minds was thinking of buying avant-garde art, she toured the studios of leading European artists and purchased their work by the cartload, shipping them back to the United States in the nick of time. Her 'war babies' she called them. While still in France, as a Jewess she escaped being arrested and sent to Auschwitz by the skin of her teeth. She then smuggled her lover, the German painter Max Ernst, out of Europe and married him (briefly) back in the United States. In New York she established her gallery, Art of This Century, in which she showed the work of her 'discovery', Jackson Pollock, and gave first exhibitions to many of the rising young American artists of the day. Her marriages were dramatic and ill-starred, and her extensive love life was legendary. Her wide circle of friends embraced some of the most eminent figures in contemporary art, literature and cinema. And as if this was not enough, she also lived in a palace on the Grand Canal in Venice.

How could anyone not be in awe of such a woman?

A year after that first meeting, in the summer of 1966, I was in Venice for the Biennale. Somewhat nervously I phoned Peggy from my hotel and reminded her of the invitation she had given me, imagining that her response might well be 'Who on earth are you?' To my relief she remembered me and our conversation about her Lhasa dogs, and suggested I come round the following morning. I'd done my homework by this time, having read the American edition of her autobiography, *Out of This Century*. Peggy, I knew, had come to live in Venice when her entire art collection was shipped here by the Italian authorities in 1948 to be exhibited at the Biennale that year. Her wish to keep the collection here permanently and make her own home in Venice became fulfilled when the following year when a local grandee found her a palace for sale on the Grand Canal. The Palazzo

Venier had been started in the 18th century, but never completed. It remained a single storey building ('the only bungalow on the Grand Canal' as Peggy later described it to me). Yet it possessed a wider frontage than any other palace on the canal, and with one of the largest gardens in Venice. Signor Venier, who built it, was from a distinguished Venetian family, and was said to have kept lions in the garden, hence the full title, Palazzo Venier dei Leoni. True or not, the front of the palace displays eighteen carved stone lions. And lions soon became Peggy's personal symbol.

The entrance to the Guggenheim palace is from a modest alley between high walls and a forbidding wrought-iron gate. At the appointed hour I pressed the bell and the gate clicked open. Two small fluffy animals, I assumed to be Peggy's Lhasa dogs, greeted me and proceeded to escort me, one on either side, across the shaded garden onto the marble porch. And here, in an ankle-length silver robe and standing in front of a large Picasso panel in Surrealist style of two girls playing on a beach, was Peggy. She greeted me with that slightly awkward warmth that I remembered from London, and led me through the house and out onto an open terrace overlooking the Grand Canal.

Small-talk was not Peggy's style, and for a while we exchanged brief comments relating to her Tate exhibition, the Biennale, which she hated, and about Italian television which she hated even more. Suddenly, quite unexpectedly, there was a feeling of ice being

broken. Gazing out over the Canal she said, 'Good that you came in June. The best month. It always makes me understand why I'm here.' Then, without any alteration in her tone of voice, she added, 'You're a married man, aren't you? So at least you won't be having your honeymoon in Venice. Too many people do. Big mistake. They fall in love with the city, then out of love with one another.' (Many years later I came across precisely the same comment in her updated autobiography published in England after her death.)

A maid brought out coffee, and we moved over to where a bronze statue of a horse and rider was set on the open terrace overlooking the canal. I recognised it as a characteristic piece by the Italian sculptor Marino Marini who had won the main sculpture prize at the Biennale here some years earlier. The horseman had flung his arms outwards in a gesture of ecstasy and his face wore an expression of joy, which was startlingly matched by his naked penis in full erection.

I have no idea what expression was on my face, but Peggy didn't appear to notice. She put her coffee cup down close by, then in a matter-of-fact voice explained that she had bought the statue from Marini when she'd seen it in his studio in Milan. It had been in plaster, so he agreed to cast it in bronze for her, suggesting that he cast the penis separately. 'That was thoughtful of him,' she went on in the same soft drawl, 'because he insisted on setting it here in full view of the Grand Canal. So, when the Patriarch of Venice passes by in his state barge, or a party of young nuns are on their way to be blessed in San Marco, I can remove it.' Whereupon she reached over and deftly unscrewed the bronze phallus. 'I keep it in a drawer,' she added. 'I feel I have to do the same when some ladies' group want to view the collection; though sometimes I forget. Their reactions always amuse me,' she went on. 'Not at all what you might expect. The Sisters of the Immaculate Conception are the worst.' I had a suspicion that no such body existed. But I was beginning to grasp that Peggy had an endearing habit of being outrageous while pretending not to be so.

There was a rumour in Venice, she explained in the same flat tone of voice, that Marini had made the phallus in different sizes for different occasions. I was plucking up courage to ask if it was true when the maid reappeared to collect the coffee cups. At that point Peggy asked if I'd like a tour of the collection. 'There are a few things you won't have seen,' she said. 'Not just the Marini.' She gave a rare smile. 'Norman didn't think visitors to the Tate would appreciate it. D'you think he was right?' She clearly didn't expect an answer and changed the subject. 'That's the city Prefettura over there,' she said, pointing out the palace directly opposite across the Grand Canal. 'I think Marino had that in mind when he placed it here and called it *The Angel of the Citadel.*'

Some years later a long-time friend of Peggy told me a story which put her comment about Marini and the Prefettura in context. It concerned the fact that her art collection had originally been brought to Venice on a temporary permit. Then, when she decided to keep it here and offer it to Venice, the authorities decided to impose a large import duty. Peggy's response had been to drive the bulk of her collection to the Swiss border, where she phoned the authorities and announced that she was about to find a home for the Guggenheim collection in Switzerland. The response of the Prefettura was instant. And so, I suspect, had been Marini's response when Peggy told him this story. His joyful horseman was not facing the Prefettura for nothing.

Peggy followed the maid indoors, then led me on the promised tour of the palace – the Pollock rooms, the Picassos and Braques, the Giacometti sculptures, Mondrian, Klee, Duchamp, Brancusi, Arp, Kandinsky, and so on through the list of major figures of 20th century art, her 'war babies' as well as those she had supported and collected since. Though I knew most of the paintings from the Tate exhibition the year before, it was a very special experience to be shown them again by the person who had personally acquired them from the artists themselves. As Peggy led me from room to room I found myself imagining her visiting studio after studio as the German panzer divisions advanced around her, sweeping up works of art as she went. She said almost nothing the whole time, as if she was merely the caretaker going through the motions of being a tour guide. At the same time her very silence managed to suggest a profoundly private connection between her and whatever we were looking at – a powerful emotional bond. It made me understand that her love affair with art was a passion for whatever challenged the conventions of taste and opened up unexplored territories of human experience. It was a passion that extended to everything that was *avant-garde,* but which found its most intense point of focus in Surrealism. It was as if Surrealism had been invented specially for her.

Towards the end of our tour Peggy opened a door and chuckled. 'I don't bring everyone here,' she said. On the far side of the room was a huge bed-head in wild shapes of twisted silver wire, with images of fish, birds and plants. It had been made for her, she explained, by the American sculptor Alexander Calder during her New York years just after the war, and which she had brought to Venice when she moved here. (Some years later I got to know Calder when he lived in France, and one day I asked him about the Guggenheim bed-head. He rummaged in a drawer and produced a photograph of Peggy and himself sitting demurely on the bed in front of it. Then, with one of his laconic grins he put the photograph away again without a word.)

The tour was over, and we moved out into the garden where we were joined by her two Lhasa dogs. She proudly showed me the handsome Byzantine marble 'throne' which I'd seen in photographs and in which she loved to be photographed in her majesty. Finally she was keen to show me a handsomely-carved wooden piece, elegantly shaped and mounted, standing about a metre high. Peggy looked at me quizzically as if to enquire who I thought might have created it. She then took pity on me. 'People come up with all sorts of fashionable names. And I teased Norman, telling him he could have it for the Tate. It's actually the oar-rest for my gondola.'

I took my leave and thanked Peggy warmly. The two Lhasa dogs seemed to understand the cue and escorted me purposefully to the gate. 'Next time,' Peggy called out. That was all.

'Next time' turned out to be a year later. Again it was June, and this time I was there to prepare a feature for the *Telegraph Magazine*. The editor, John Anstey, had decided that his readers would enjoy profiles of people who had managed to create their own exotic lifestyle. One of this chosen band was Peggy; and since John was aware that I knew her he asked me to write it. Peggy seemed happy with the idea, though she was rather less happy with the photographer chosen to portray her for the magazine. He was Terence Donovan, a fashion photographer principally associated with crowd-stopping images of the beautiful model he had discovered, Celia Hammond. I arrived at the Palazzo Venier just after the photo-shoot. Terence was packing up his cameras and I sensed a certain frost in the air. 'How did it go, Peggy?' I enquired once Terence had departed. 'A thug!' she replied. That evening I asked Terence about the photo session. Looking thoroughly bored he said, 'Oh, I told her we'd do one standing up and one sitting down. That was it,' and he sighed. I think he must have imagined an expenses-paid trip to Venice to photograph some Celia Hammond lookalike reclining provocatively in a godola.

This was the golden age of colour supplements, and an equally golden era for writers and photo-journalists with an eye for a good story that would also make striking pictures. John Anstey, my editor, had an eye for glamour, both in his choice of a bevy of secretaries and for stories he was happy to commission. Since I was going to be in Venice for him anyway, he was happy to buy the idea of a feature on the Venetian lagoon, two hundred square miles of it with scores of islands, from glorious Torcello where the Venetian Republic was born, to Murano with its glass, San Lazzaro with its memories of Lord Byron, and Sant'Arianna made entirely of human bones carried from the overcrowded cemetery of San Michele. Terence had departed sulkily by now, and the photographer appointed to

work with me was Adam Woolfitt, anything but a fashion photographer, and who was to become my close friend and working colleague for more than a decade to come.

Peggy suggested we both come for a drink in the evening after our first full day exploring the lagoon in the small motorboat which the local tourist office had lent us along with a guide who knew the channels and the shoals. It was barely a year since I'd last seen her, yet she looked old and weary, and a veil of sadness seemed to shroud her. It was hard to imagine her as the woman who had made ribald comments about nuns and an erect penis. She asked why we were in Venice; and when I explained that we were visiting all the islands of the lagoon she gave me a wistful look. 'Will you find me one, Edwin?' she asked.

Adam and I looked at one another. Was this something to be taken seriously, we asked ourselves later? Was this a serious commission? And why on earth would she want an island? The following day we toured the northern stretch of the lagoon, and there – with its own handsome mansion and small private harbour – was an island which our guide and pilot assured us was for sale. What was more, he said, it possessed its own natural gas. 'Perfect for your friend.'

Peggy had invited us to dinner that evening. She had dressed herself like the queen of the Nile in a flowing silk robe, her wrists jangling with jewels, all of which took me by surprise after the gloom of yesterday. Yet, as we had drinks on her terrace she still seemed as far away as before. Finally I raised the matter of the island, and told her we'd found her one. I waited for a response, but nothing came. It was as if she hadn't heard. Shortly afterwards two visitors arrived unexpectedly, one of them an American art scholar who was spending a year in Venice. Peggy introduced him as an old friend whose taste in painting unfortunately ended with Canaletto. Shortly afterwards we found ourselves together gazing out at the evening light on the Canal, and I told him about the island Peggy had asked us to find and her negative response this evening. 'Yeah, that figures,' he said. He then told me that her daughter Pegeen had committed suicide in Paris just a few months earlier. 'The only person she really loved,' he added. 'There are some things you just can't escape from.'

The unexpected guests stayed for dinner, though Peggy's cook was evidently not told, and two extra places were hurriedly laid. She then brought in a single roasted wild duck which looked at that moment about the size of a sparrow. To make matters worse Peggy announced, 'Edwin, you'll carve, won't you!' Carving is not my strong suit, least of all when the victim is an anorexic mallard. The cook came to my rescue, and with a certain

sleight of hand, slivers of emaciated duck were laid as elegantly as possible across the Guggenheim family Sèvres.

The next year, 1968, was another Biennale. This time I was summoned to lunch, which took place in the cool of her garden under the trees. Mercifully there was no carving to be done. There were seven or eight people present including the Tate Gallery director Norman Reid (by now Sir Norman), who was charmingly attentive to Peggy throughout lunch, doubtless in the hope that his hostess's pictures might yet find a last resting-place beside the Thames. Peggy herself looked resplendent in one of her Queen-of-the-Nile outfits, jewellery clattering everywhere and seated on her marble Byzantine throne. She should have worn at least a tiara, I felt. Never one for making introductions, she left it to her guests to discover who was who, while Peggy presided contentedly at the head of the table, bathed in compliments but saying little. That was her style, I was coming to understand. She struck me as a woman who shied away from an intimacy which she found difficult, and who was most relaxed and at home in company which made no demands on her, and of course in the company of her pictures. But then suddenly there would be a private touch of mischief. One of her guests was an Italian museum director who had been obsequiously attentive to her all through lunch. As everyone was departing, and the Italian had kissed her hand for the fourth time, Peggy turned to me, and in a flat undertone said, 'Lack of balls there, wouldn't you agree?'

I saw Peggy a number of times in the 1970s. Besides the alternate Biennale years this was also the era of Venice in Peril, brainchild of the admirable John Julius Norwich. Floodwaters swamped the city more deeply year by year. Palaces peeled and crumbled. Pollution from nearby oil refineries was damaging ancient fabric and threatening wildlife on the lagoon. The Italian authorities repeatedly gave a Latin shrug, pocketed the bribes, and did nothing. On the other hand Venice might be in peril, but it still looked the most beautiful city in the world, and television and newspapers were happy to give plenty of opportunities for journalists like me to cover the story of its plight. The daily arts programme on Radio 4, *Kaleidoscope*, of which I was one of the presenters, devoted an entire programme to the subject, and I spent several absorbing days armed with a tape-recorder interviewing restorers, politicians and museum directors.

I always gave Peggy advance notice of when I'd be in Venice, then I'd phone her on arrival. The response was invariably the same, 'Come over,' uttered in an almost offhand way. She was never a woman of many words if just two would do. I'd sometimes bring her Stilton from London and malt whisky for her visitors. Peggy was now well into her

seventies and getting frail. Her social life seemed to have shrunk considerably, and I got the impression she now enjoyed single company rather than the crowds she used to assemble round her. We'd go to Harry's Bar where she was treated like royalty, and we'd eat smoked salmon and drink Bellinis while she talked of the friends who'd visited her recently – Truman Capote, whom she loved, the film director Joseph Losey, Maria Callas, Gore Vidal, Samuel Beckett whom she also loved. It was always a five-star list. For someone close to being monosyllabic Peggy had the gift of magnetising some of the most articulate figures of our time. People loved her, as I realised I did too.

One autumn I went to say goodbye to Peggy the day before flying back to London. 'What are you taking for your kids?' she asked. I had three children by this time, but hadn't found time to go shopping for them. 'Then I'll take you. I know where you should go,' she said. She rang a hand-bell beside her chair. A maid appeared and Peggy gave a rapid instruction to summon 'Giovanni'. (I'm not sure if that was really the name of her gondolier, but it will do.) While we waited Peggy explained that she used to have two gondoliers, but now she got about less and only needed one.

In a short while Giovanni appeared, dressed in his black gondolier's uniform. Peggy greeted him and we both followed him out onto the terrace to the quayside where I could see Peggy's private gondola was already moored. In all the years I had been coming to Venice I had never set foot in a gondola, least of all a private one. Giovanni helped Peggy in, and she settled herself with great dignity on a spread of scarlet tasselled cushions, her arms draped elegantly on either side. Feeling proud and foolish at the same time, I seated myself facing her, noticing as I did so that behind me the prow of the gondola was carved with the majestic golden figure of a lion.

Peggy gave a brief order to Giovanni, who began to manoeuvre the gondola out into the Grand Canal, steering it skilfully among the motor launches and water-buses. He then made for one of the side-canals, and after ducking under several bridges, eased his vessel to the base of a flight of stone steps. Peggy gave a nod. 'This is what you need,' she announced. 'The best toy shop in Venice. I'll wait here. Take your time.'

I have no recollection of what I bought that morning. I only remember making a hasty tour of shelves laden with fluffy animals and plastic toys, seizing whatever could be easily carried and rapidly paid for, conscious that one of the world's most celebrated heiresses was waiting in her private gondola outside. This was not a moment to ponder on whether a two-year-old girl would prefer a pink bunny rabbit or a blue one. Laden with whatever I had managed to acquire, I clambered back into the waiting gondola.

I had plenty of time to reflect on Peggy's gesture of kindness and generosity. More than ever I was aware of the unexpected in her nature, and how much of her appeal perhaps lay in that ability to surprise and wrongfoot people. She was a genius at doing the unexpected. More than a year passed after our shopping expedition before I saw her again. This time I was in Venice preparing a feature for the *Telegraph Magazine* for the four-hundredth anniversary of Titian's death which would fall in the following year, 1976. I was working with an outstanding French photo-journalist, Robert Freson, whom I knew from eleven years ago when I was interviewing Salvador Dalí in Spain. This seemed likely to be a more solemn occasion, recording the place associated with Titian in his native Venice, including the paintings still in the places for which they were commissioned, like the majestic *Assunta* in the church of San Rocco.

Peggy looked grateful that Robert made no request to photograph her, a gratitude possibly matched by Robert's own gratitude that she didn't expect it. Peggy was in a poor state. She was only recently out of hospital, having fallen and broken eight ribs. She felt as old as Titian, she said. Her mood was sour. She was far from the woman who had taken such gracious pleasure in taking me shopping in her gondola a year before. She railed against the quality of the paintings in the Biennale ('they get worse and worse'). Even the artists she had 'discovered' and first promoted in her New York days were now producing inferior work. Money had replaced vision, she said. 'I dislike modern art now,' she assured me. It struck me as a sad remark from someone who had once been so bold and in the forefront of creative ideas. It was as though everything had gone downhill in her eyes since the death of her great protégé Jackson Pollock in a car crash in 1956. Her life seemed to be becoming a darkening sunset.

Not long afterwards I was given the chance by BBC Television to plan a series of one hundred ten-minute films, each to concentrate on a single picture, supported by others related to it. The series was to be called quite simply *One Hundred Great Paintings*. And I could choose whatever I wanted in the world. It was like being given the keys of the kingdom, and it became one of the most exciting projects I've ever undertaken. I was determined to include a painting from Peggy's collection. The obvious choice would have been one of her twenty-three Jackson Pollocks, but much as I admire Pollock, I found it hard to imagine talking to camera in front of a 20-foot canvas that was all splashes and squiggles without sounding as though I'd stepped straight out of Pseuds Corner. Instead I opted for a particular favourite of mine, Magritte's eerie visual paradox, *An Empire of Lights*.

I was anxious to ask Peggy personally for her permission to film it. I had been working in Italy, and took the train from Florence specially to see her. This was 1978, and I knew she had recently suffered a heart attack. She looked very worn and fragile and couldn't even rise from her chair. I told her why I was here and the painting I had chosen. There was silence for a moment, and I wondered if she was disappointed. But then she nodded. 'Yes! Good! I wouldn't have trusted you with my Jackson Pollocks.' She gave me one of her rare smiles. 'And you'll write it yourself, won't you?'

'Of course,' I said.

She accompanied me to the door with a stick. 'Don't make it too long, Edwin,' she said. A single Lhasa Apso escorted me to the gate. I waved goodbye and she raised her stick. It was the last time I saw her. Early the following year, shortly before we were due to film her Magritte, my first wife was diagnosed with cancer. I gave up work for a while and became housebound. Scripting and presenting the Magritte film was offered to a man who was passionate about Surrealist art, the writer and jazz-musician George Melly, who I also knew was just the kind of overblown figure Peggy would enjoy. George returned with warm greetings and a message of hope and goodwill for my wife. I rang Peggy to thank her and give her my apologies for not being there. Her voice was even lower-keyed than usual as she told me the Venetian top brass were giving her a party for her eightieth birthday in a month or two. 'I hope I make it,' she said.

The party was held later that year amid the splendour of the Gritti Palace, with battalions of the great and the good in attendance. I would certainly not have qualified for an invitation even if circumstances had been different. Joseph Losey, who had once cast Peggy in his wonderful Venetian film, *Eve,* gave a speech of welcome. The huge birthday cake ceremonially presented to her was a model of her own Palazzo Venier. And as she cut the first slice, a large banner was unfurled embroidered with the legend '*L'Ultima Dogaressa*'. At that moment all the church bells in Venice began to ring out – by the happy coincidence of an announcement just made by the Vatican that the Patriarch of Venice had been elected Pope John Paul I.

I felt sure Marino Marini's horseman would have risen to the occasion.

Then, within a few months Peggy was dead.

F. N. Souza

I have kept the first to the last. Francis Newton Souza was the first artist I came to know well. We became close friends over a number of years, and I wrote my first book about him. It sits in front of me as I write this, open at the handwritten inscription from Francis – 'To the author, with much love and gratitude, but by golly the thing has come to life, hasn't it?'

It began with a casual encounter. One of my weekly tasks as a sub-editor on *The Illustrated London News* was to keep a check on the London art galleries and bring back visual material on forthcoming exhibitions for my editor to pore over with the inevitable cigarette in the corner of his mouth as he grunted his approval or disgust. ('Edwin, what on earth did you bring me this for?' 'It's a Picasso, Sir Bruce.')

One morning early in 1959, I wandered into a tiny art gallery tucked away in Soho which I knew slightly, run by a mild-mannered eccentric called Victor Musgrave. He was unwrapping a pile of canvases to be framed for an exhibition the following month, he explained. 'You might like them,' he said, 'though your editor certainly wouldn't.' He tore the wrapping off one of the canvases to reveal a painting of a sinuous dancer entirely naked except for a string of beads above her buttocks. Victor was right, this was not one to show Sir Bruce Ingram.

'He's Indian in case you hadn't guessed,' Victor said. 'Very successful. The High Commissioner has bought that one already. Do come to the opening.'

At the Private View a few weeks later every inch of wall space was occupied by some of

the most disturbing paintings I'd ever come across. They hit you in the eye. It was as if the artist was saying, 'You may not like this, but you're never going to forget it.' There were sleek nudes, erotic without being in the least pornographic. There were cityscapes where the buildings tilted and wobbled as if struck by an earthquake. There were hideously-elongated male heads with multiple eyes and teeth like a steel trap. Then, dominating the room, was a bloodstained Crucifixion, full-length and with weeping attendant figures. It was a brutal study of naked pain and anguish which spoke to me immediately of that most dramatic of Renaissance Crucifixions, Grünewald's Isenheim Altarpiece in Colmar, Alsace. I stood gazing at the 6-foot canvas puzzled by how a painter from Hindu India came to paint an image that lay at the heart of the Christian story. Victor seemed to read my mind and came over to me. 'Francis comes from Goa,' he explained, 'and you can't get more hard-line Catholic than that. Come and meet him.'

He led me towards where a group of visitors (none of them Indian) were gathered round a small dark-haired figure who seemed to be regaling them with some story, because at that moment he gave out an infectious laugh which seemed to rise up from his stomach like a geyser and spill over the audience around him. I collect laughs, and this was my introduction to one that I was to enjoy for years to come. Like his paintings, it was a laugh designed to surprise and shock as much as to express delight.

Victor intervened and drew Souza away. 'Francis,' he said steering him towards me, 'this is Edwin who works for a magazine that would never review your paintings in a million years, but you might like him.' I could see Souza sizing me up with those intense dark eyes set in a face that had a powerful yet battered look about it. I broke the ice by asking him straightaway about the Crucifixion and whether he knew the Grünewad altarpiece. He looked surprised and then pleased. 'I love art that isn't beautiful,' he said in a matter-of-fact voice. It was such a provocative remark and I started to realise that I wanted to know this man better, and to know his work better. Soon we found ourselves talking animatedly about all sort of things that we liked and disliked in a way that surprised me. Art, sex, travel, politics; everything seemed to get thrown into the ring. He seemed to be enjoying it, and when Victor tried to drag him away to meet a client, Souza scrawled his phone number on the exhibition catalogue, adding, 'Do call and come round. It would be fun.'

I followed up the invitation and went to see him. It was the first of what was to be many such occasions . They proved to be a great deal of 'fun' and much else besides – because one thing I learnt quickly was never to anticipate what Souza wanted to talk

about, or suggest that we do. It might be an invitation to join him for lunch at the House of Commons with one of his collectors who happened to be a junior minister; a proposal that we both go to Paris for the day to see the latest Picassos at Kahnweiler's gallery; or a wish to regale me with the story about his teetotal father on his wedding day who had the toast wine poured over his head.

We used to meet mostly at his flat in north London, where I met his German wife and two young daughters, all of them welcoming and delightful. I would spend much of the time going through paintings which were stacked all over the placed, as well as sheaves of drawings – portrait sketches, landscapes, nudes (some of them erotic), often accompanied by a fruity commentary by the artist on how they came about, with the familiar caustic laugh. It was richly entertaining and fairly scurrilous. Souza clearly loved having a new young audience whom he enjoyed trying to shock, but with whom he could also share serious thoughts about painting.

I picked up a lot about his background, which was unusual and idiosyncratic. He was born in 1924 in the Portuguese colonial enclave of Goa on the west coast of what was then British India. Goa had been colonised by Portugal 350 years before Britain took full control of India, and from which it was still at that time separated politically. For all those long centuries under Portuguese rule, Goa had been a Roman Catholic community and many Goanese families had taken Portuguese names. Souza had been given the first name of Newton because his father had an English godfather. The name Francis was added later by his mother in thanks to Goa's patron saint, St. Francis Xavier, for her son having recovered from smallpox.

Souza's upbringing was strictly Catholic, and it was the Roman Catholic church in Goa which provided him with the first powerful images to paint. On my early visits to the Souza flat we scarcely touched on his religious imagery, but one morning as I left he invited me to dinner the following week. 'Come early and we can talk some more.' I had become intrigued by his work and wanted to know more about what struck me as an extraordinary and unlikely marriage of mediaeval Christian imagery and Indian eroticism art. How could he reconcile those two?

'I can't!' Francis answered when I put that question to him, and gave out one of his enigmatic laughs. This was after dinner while his wife was putting the children to bed and we were sitting round a fire sipping wine. His face had a crumpled look as if memories of his religious upbringing tasted unpleasant. As a child in Goa, Francis assured me, 'God seemed a fearful person, and as his servants we went around in dread of him.' The

church in which he was brought up was still the church of the early Christian martyrs. He was fascinated by the statues of saints with staring eyes, by the grandeur of the churches themselves, and by the stories his grandmother would recount to him of the tortures endured by the saints. 'It all created the artist in me,' he said shaking his head as though to say, 'What else could I do?'

Very soon a quite different source of inspiration appeared. On his travels within India he came across the sinuous South Indian bronze figures of dancers, and in particular the erotic stone carvings on the Khajuraho temples, of 'girls wearing nothing but their smiles that are more enigmatic than even the Mona Lisa could manage.' Souza had discovered classical Indian art, and it taught him the value of the definitive line tracing the twist and movement of the human body. From now on his tortured saints had seductive rivals.

Then in 1949, at the age of twenty-five, he came to England. During one of our discussions he explained why. As far as he was concerned England still ruled the world. It stood for civilisation – 'not only culture but power and glory.' The reality came as a shock; no one seemed to care about painting and food was still rationed. Yet there were compensations. For the first time he saw paintings by the Old Masters, which previously he had only known from black-and-white reproductions in books. There was the Rembrandt Room at the National Gallery. There were the Impressionists and Post-Impressionists. Then the great loan exhibitions from the continent, his first experience of the 'moderns', and having to come to terms with Matisse, Picasso, Brancusi, Rouault, Dalí and Miro. 'It was like a relay race, one after the other,' Francis explained. He was introduced first hand to the long unbroken tradition of European art. 'It was bewildering, being clobbered on all sides. Sometimes I thought I'd go mad. I used to feel like one of my tortured saints.'

By the end of 1959 I had been seeing Francis from time to time for more than six months. I was beginning to feel almost like a member of the family. Our friendship was warm, full of discussion and laughter. I introduced him to Gillian, who I was about to marry, and Francis enjoyed himself speculating on what he might give us as a wedding present. On one occasion the three of us went to Paris. In my spare time I'd become the London editor of a hopelessly-unsalable literary magazine in two languages called *Two Cities* to which Francis contributed a short story together with an illustration. I introduced him to the editor, the poet Jean Fanchette, who came from Mauritius. This brought them into a deep discussion over lunch about Indian Ocean politics, which only lightened up when Jean noticed Francis had been making an obscene drawing on his paper napkin

purporting to be a portrait of General de Gaulle, and which he then signed 'Souza' with a bold flourish and left with the bill in lieu of a tip. I began to sense that this trip to Paris could end up in the Bastille or wherever today's equivalent might be.

'To take your mind off your wedding, Edwin,' Francis declared once we were safely back in London, 'I think you should meet Anthony. He has a suggestion to put to you.' We were again having dinner in the Souza flat, and Francis explained that Anthony was someone who owned several of his paintings and had recently commissioned him to paint a portrait of a friend. At that point he got up from the table and disappeared into his studio. A few moments later he re-emerged bearing a medium-sized canvas wrapped in a linen sheet. He propped the canvas on a chair in front of us and removed the sheet. The painting was of a young woman with long hair, entirely naked and holding a baby to her breast.

Francis said nothing for a moment, enjoying the expressions on our faces. 'It's not Anthony's wife,' he said finally. 'But it is his son.' By now Francis clearly thought he had kept us in suspense long enough. 'He's Anthony Blond,' he explained, 'an enterprising publisher who wants to bring out a book on me. He asked me who should write it, so I said "you". Would you like to?'

I had never thought of writing a book before, except in my daydreams. It was something only *real* authors did, and I was simply a young journalist who happened to love art and who enjoyed talking to artists. All the same I was deeply intrigued. I might be heading in a quite new direction it occurred to me.

So I rang Blond and arranged to meet him. He greeted me warmly in his crammed London office. 'There's no money in publishing of course,' he declared cheerfully. 'If you want to make a fortune you need to be the lady downstairs. She edits a magazine called *Pins and Needles*. That's where the money is, in knitting.' He couldn't pay me anything, he explained, but he'd make a very handsome book. Francis and I could choose the illustrations together, and we'd have a great party to launch it.

It was while I was working on the book with Francis that Gillian and I got married. Francis was a most welcome guest, and his wedding gift has become the frontispiece of this book. Hidden at the back of the drawing is his wry inscription – 'King Edwin playing the lute to his bride.' While my mother-in-law might have been proud that her daughter had chosen a man eminent enough to be cast as King David I was less confident that she would appreciate her being depicted as a voluptuous *houri*.

A few months after the book was published in 1962 I was appointed art critic for *The*

Sunday Telegraph. Francis was thrilled for me, he said, and I suspect he attributed my elevation chiefly to our creative partnership about which he talked constantly. By the same measure I felt he now regarded me as his attendant publicist who would always put him top of the list. A one-man show of his recent work coincided with a magnificent display of Goya's paintings at the Royal Academy as well as with a major Delacroix exhibition in Paris. As a result I could only find room for two short paragraphs on the new Souza canvases, which was two more than he received from other critics. Lack of space was one factor, but there were others. My own taste was changing. I was now writing a book on the Cornish fisherman-painter Alfred Wallis. There could hardly be a greater contrast between Wallis' windswept accounts of sailing ships and Souza's agonised saints and sensual dancing girls.

Besides, I now had a family life with a young daughter. Francis' own family life was breaking apart. We saw less and less of him now and the freshness and sense of fun had evaporated. Then, one evening he invited himself to dinner and introduced us to his 'new wife', announcing that they were moving to New York. That was where his future lay, he assured me. It was where everything was happening on the art scene.

It was the last time I saw Francis. Occasionally mutual acquaintances dropped me titbits of news, making it clear that New York had not exactly welcomed Souza with open arms. The Promised Land was turning out to be the land of broken promises. Increasingly he was being drawn back to India for acclaim, and to receive the patronage of a new generation of wealthy Indian collectors who now regarded him as the founding father of modern Indian painting – the nation's very own Picasso and Matisse.

I read his obituary in *The Times* with great sadness. We had grown together and grown apart. But the sound of his laughter remains fresh. I shall never forget the moment he informed a very serious actor in the Royal Shakespeare Company that his favourite character in Shakespeare was Yorick; nor the look on the Parisian waiter's face when he looked down for the tip and saw Francis' obscene caricature of General de Gaulle. There has only ever been one Francis Newton Souza.

Brief Encounters

1 There was a time when the people I was with on some assignment or other were forever rushing off to see **Picasso.** Roland Penrose, his biographer, had to cut short some filming with me in Spain in order to catch a plane to Nice where a car would be waiting to take him 'to dinner with Pablo in Mougins.' His Paris dealer and long-time friend, Daniel Kahnweiler, apologised for postponing an interview because he needed to make a long phone call to Pablo about his next exhibition. The art historian Douglas Cooper glanced at his watch over lunch in Antibes, then shot off down the road towards Mougins leaving his coffee untouched. The French photographer Lucien Clergue, whom I got to know in Arles, would have loved to take me round his beloved Camargue to see the flamingos had he not been summoned by Pablo to take pictures of his latest sculpture.

And so it went on. All roads seemed to lead to Picasso. For all that, I never had the chance to meet him. Yet I did see him once. On my first summer vacation at university two friends and I toured France and Italy optimistically in my pre-war Ford 8. The engine boiled on every hill, and we pitched our tent and lit our butane-gas stove where we could. This was in the days before camp sites were obligatory, and driving back along the Riviera we found a secluded spot among rocks and pine trees only a short distance from Cannes. The beach was right there, and among a scattering of sunbathers in the early evening, was an elderly, bald headed gentleman standing by the shore with his hands shielding his eyes as he gazed out to sea. Curiosity led me to look for what had attracted his attention. There were bathers everywhere, some of them snorkeling, others floating on inflatable rafts, some introducing their toddlers to the sea. But one group in particular had clearly caught the old gentleman's eye: five or six young men and women were passing a beach ball rapidly between them, to and fro, trying to catch each other out, leaping, tumbling in the water, splashing one another amid gales of laughter. It was only when I glanced back at the onlooker, still peering intently at the frolic, that I realised it was Picasso.

This was the summer of 1955. Twelve years later, on June 9th 1967, I went to the Press View of a large exhibition of Picasso's sculpture at the Tate Gallery in London. And there, dominating the main gallery, was a group of six bronze figures, highly stylised as mere slabs but with appendages here and there, unmistakeable as human arms akimbo or limbs flailing. I flicked through the Tate exhibition catalogue which I had just picked up, and there the group of figures was – No. 324, *The Bathers,* 1956, Cannes. Picasso had made the original figures in wood, probably driftwood from the shore, then had them cast in bronze a year later.

I resisted announcing to my fellow-critics busy scribbling notes, 'I was there! I was there!'

2 In July 1967 I was standing on the balcony of a town hall in central France gazing down on an unlikely scene. Below me was an open square fringed by a crowd of intrigued onlookers. Next to me on the balcony stood the photographer who had been appointed by the *Telegraph Magazine* to work with me on the story which had just been unfurled below us. This was a giant tapestry which the two of us had persuaded the mayor to lay out in the centre of his town so that we might obtain a striking photograph of it from above. The tapestry, which had been woven in the town, was destined for an English cathedral, and was on the theme of the Trinity, accompanied by the symbols of the Four Evangelists and of the Four Elements, Air, Earth, Fire and Water. And standing next to me on the other side stood the artist who had designed it: the tall angular figure of **John Piper.**

He turned to me with a smile. 'Looks pretty good down there, doesn't it? Perhaps they should keep it'. And we went down into the square where John was to be presented to various local dignitaries..

The photographer, John and I had travelled from England to this small French town of Felletin, near Aubusson, where the tapestry had just been completed ready for transportation to England. Its destination was Chichester Cathedral in West Sussex, for which it had been commissioned by its remarkable dean, Walter Hussey, who had said to me when I asked him about his choice of John Piper. 'He's simply the best!' And I was reminded of a remark Walter had made to me on an earlier occasion as we walked round his cathedral, 'Bad art is blasphemy!'

Piper had welcomed the idea of a newspaper feature on his tapestry, and some months before we left for France had invited me to his elegant house tucked away in the Chiltern Hills beyond Henley-on-Thames. It was the first time I had met him and it seemed appropriate that such a quintessentially English artist should live in such an idyllic stretch of Engish landscape. He greeted me heartily as I got out of the car and proceeded to talk enthusiastically about the tapestry over cups of coffee, until he suddenly suggested we go for a walk before lunch. It was a soft morning in mid-May and the beeches of the Chiltern Hills were at their spring best. I noticed that Piper was carrying a large plastic bag as he strode vigorously along the woodland path behind

his house, talking all the while about the need to find just the right colours for the Four Elements in the tapestry – until suddenly he stopped, bent down and picked up something from beside the path. 'Morels,' he exclaimed. 'The right time of year, after rain. D'you like mushrooms? And there's another. That's supper.'

That was my first mental snapshot of John Piper – striding along the wooded slopes of the Chilterns like an animated stick insect, eyes scouring the ground left and right, occasionally dropping a morel into the plastic bag swinging from his arm. It was an image that came back to me those few months later as we stood on the balcony of a French town hall gazing down at the great tapestry he had discussed with me at such length.

I saw John only occasionally during the following years. Then, in the spring of 1984, I was writing and presenting a television series on English art called *A Love Affair with Nature*. John is my man, I thought, he will have a great deal to say. And I rang him. He warmly invited me to lunch with my wife, Anne. The greeting was just as before, except that instead of suggesting we go mushroom-hunting he invited me to inspect his capacious wine cellar. And here was my third snapshot of John, reaching down to select a bottle for lunch with long careful fingers just as he had reached down to pick a morel. There were sounds of laughter from the kitchen as we returned. And I have a happy picture in my mind of Anne in lively conversation with John's wife Myfanwy Piper while she acted as her *sous-chef* in the making and tossing of pancakes.

My last snapshot of John is of him in London in the late 1980s. He was seated by the window of one of the art galleries in Cork Street. Beside him lay a pile of screenprints of English parish churches, which had become his trademark in recent years. A gallery assistant was handing him sheets of them one by one for John to sign in a limited edition. His head was bowed in concentration, and I didn't want to disturb him. But before I walked on I noticed the print he was signing. It was of Hauttebois church in Norfolk, dramatically moonlit and with its strange mediaeval watchtower in the background.

This is a print which now hangs on the wall beside me as I write. Many years after John died Anne came across one of his signed copies and gave it to me for my birthday. As I settle down to work I am daily reminded of morels and pancakes, of the most handsome wine-cellar in England, and of that view down into the town square of Felletin with John's tapestry laid out like a royal carpet. And John remarking 'Looks pretty good down there there, doesn't it!'

3 **Michael Ayrton**'s obsession with the Greek myth of Daedalus was a recurring phenomenon of the London art scene during the 1960s and 70s. Having turned from painting to sculpture, Ayrton was now producing large agonised figures in bronze which seemed to represent various aspects of Daedalus himself and of the Minotaur, half-human and half-bull, for whom Daedalus had constructed the celebrated labyrinth as the creature's prison on the orders of King Midas of Crete. The Minotaur was the offspring of Midas' wife Pasiphae, who had lusted after a white bull which had been a gift from the god Poseidon.

What puzzled and intrigued me was not Michael's choice of such a richly imaginative Greek myth, but that he seemed to identify with both Daedalus and the Minotaur. Michael was not a man given to setting boundaries on his own talents as an artist, and I perfectly understood the appeal to him of Daedalus, first mentioned by Homer, then subsequently cast by Ovid and Pliny the Younger as the ultimate artistic inventor. The innumerable achievements attributed to Daedalus tested Michael' s own inventiveness in several fields, culminating in his 1967 novel *The Maze Maker*, purporting to be Daedalus' own account of his life. But if Daedalus represented the loftiest peaks of Michael's ambition, then the Minotaur was his darker incarnation – a creature trapped, haunted by unfulfilled hopes, and enduring the pain of physical deformity. Michael himself was inflicted with continual suffering from his back. My wife and I stayed with him one weekend at his house in Essex, Bradfields, and he took me into his studio to show me a figure of the Minotaur he was working on. It was hunch-backed, brooding, and with a look of pent-up rage. 'That's me,' Michael muttered, one hand reaching painfully to the nape of his neck.

More often Michael's frustrations were lightened by an acerbic sense of humour. One evening when we invited him to dinner he turned up at our house in Putney clutching a small book, which he presented to me without a word. It was the paperback edition of *The Maze Maker*, which I already possessed, except this copy displayed quite a different cover. I turned it over. On the reverse was an Ayrton drawing of a bellowing Minotaur, on whose abdomen had been written the following text:

'The author of this book, finding the jacket imposed on it by the publisher of this edition unacceptable in that it represents a Balinese lady reclining on a stuffed moose, has here replaced it with a drawing of his own in which the Maze Maker holds the totem of the publisher symbolically. Fifty copies in this form, each signed by the author, will be distributed as gifts to his friends and others. Those tempted to seek the lady and the moose will sacrifice to their present curiosity a future bibliographical rarity of which this copy is No. 31.'

I would not have enjoyed being the editor at Penguin Books who had commissioned the cover with the Balinese lady.

Much as I relished Michael's company and admired his passion for the classical worlds I harboured a nagging guilt that I really did not like his sculpture. So, when the editor of the *Telegraph Magazine* asked me to invite eminent figures in the art world to write about their favourite museums it gave me huge pleasure to nominate Michael as one of them. And, not surprisingly, he chose the new Parthenon Museum in Athens, delighted also that he would enjoy First Class air travel on account of his back. On his return he wrote me a euphoric letter about the joys of the Hellenic world, ending 'Do let us meet soon. I shall be in London around the 14th of February for a few days.' He added that there was something he particularly wanted to show me.

I invited him to dinner and when I answered the doorbell on a bitter winter evening, Michael was standing on the doorstep hunched like his Minotaur and holding a small package, which he pressed into my hand as I took his coat. 'That might interest you,' he said. I poured him a drink, then opened the package. Inside was what seemed to be a honeycomb, except that it was metal and yellowish in colour. I must have looked puzzled because Michael laughed, then took a long sip of his wine. It had taken him many years to work it out, he explained. How did Daedalus create a honeycomb in gold? 'Suddenly it came to me. What's a honeycomb made of? Wax! Simple. Any sculptor knows about casting molten metal. The lost-wax principle. And there it is!'

My wife had overheard the conversation and appeared with a bottle of champagne at this moment. We had a great evening, toasting Daedalus and Michael liberally.

This was February 1975. Nine months later I was shocked to hear that Michael had died. He was fifty-four.

4 When British television burst into colour during the 1960s it was the moment for the BBC's controllers to discover 'art'. And cultural journalists like me were fortunate enough to be around to take advantage of it. For an art critic the chief bonus of working in colour was that you could now treat the camera as the human eye, exploring a work of art in detail or from afar, as you chose. It was more intimate and incisive than any guided tour.

I was asked if I would like to script and present a short film for BBC2 on an artist of my choice. I decided on the Italian-Swiss sculptor **Alberto Giacometti,** an artist I had met once shortly before his death in 1966, and his skeletal figures in bronze prancing vigorously across the landscape fascinated me. As far as television was concerned I was a total innocent. This was my first film. But somehow I had grasped that the confines of a TV screen would allow me to make an object large or small depending on how it was displayed. This, I thought, would suit Giacometti's sculpture perfectly, with its teasing ambiguity of scale, as well as demonstrating the strange, disquieting nature of his work which seemed at times to hark back to his association with the Surrealist Movement in Paris before the Second World War.

His London dealer kindly lent me (with a gun in my back) a tiny bronze figure some eight inches high. This I arranged to be filmed against a wide horizon and a vast sky while I spoke with my tongue in my cheek of the artist's fantasy of human giants striding across the earth. Then, without a further word, I placed my hand behind the miniature figure and picked it up.

My primitive attempt at illusionism was the product of an invitation I had received at *The Sunday Telegraph* two years earlier to the opening of the Fondation Maeght at St.-Paul-de-Vence in the South of France. I unhesitatingly nominate this place, set in the pine woods north of Nice, as one of the most exhilarating venues for displaying modern art in the world – the brainchild of the Paris art dealers Marguerite and Aimé Maeght. You need to imagine a safari park inhabited by sculpture – some of it alarmingly like science-fiction beasts. Zoomorphic creatures by Miró stand against the Provençal sky. A Calder mobile spins around you. Is that a bird or a beast that spouts water from a wall? And here and there, striding purposefully through the garden as if they were guardians of the place, long-legged bronze figures by Giacometti point and peer in different directions, each of them taller even than the figure I later tried to enlarge in front of the TV camera.

One of the directors of the Galerie Maeght noticed the intrigued look on my face, and joined me as I gazed at one of these pipe-cleaner giants. She introduced herself simply as Marie; then she explained how Giacometti said that he saw people that way, huge or minute depending on where they were. These tall elongated figures, she said, were originally intended for the new Chase Manhattan Bank building in New York. They were his response to the idea of seeing people in the context of a skyscraper – which he himself had never seen. 'But he didn't like the setting when he went there. So we've got them,' Marie went on. 'Then of course he got the grand prize for sculpture at the Venice

Biennale. And now the world's at his feet.'

Before we parted Marie offered to take me to Giacometti's studio if I was going to be in Paris. 'It's an amazing workshop, and you'd find it fascinating watching him at work. He rather enjoys an audience. And what he has to say about his sculpture is always fascinating.' The journalist in me was not going to miss out on an interview with the current Venice supreme prize-winner, and I straight away arranged to break my return flight to London to take up her offer.

In Paris I phoned her from my hotel, and she said Alberto would be happy to meet 'the young English journalist' and we could go tomorrow morning. The next day we drove out to Montparnasse, and I was led into a richly-overgrown courtyard which half-hid Giacometti's studio in a grey side street lined with peeling walls. He had seen us coming and was waiting at the door – a tousled figure with a face as deeply-furrowed as a ploughed field, which, as we approached, re-shaped itself into an enigmatic smile. His fingers were too smeared with clay to shake hands, but he thrust out a bare arm in greeting before explaining that he was in the process of modelling a figure if I didn't mind just being an observer for a while.

Artists do not generally like to be watched while they work. Giacometti appeared to enjoy it, as though I was a useful witness to a silent dialogue he seemed to be conducting with the figure his fingers were shaping – adding a slab of clay here and there, shaping it to the features of a face or limbs, then reducing it – forever reducing it – until the figure itself became thinner and smaller. I could understand how it was said that sometimes it could end up fitting into a matchbox. I was riveted watching those powerful agile fingers at work and I longed to know what thought processes were dictating those persistent changes in the shape he was creating. There were so many questions I was longing to ask. What determined the size of a figure? Was it always a particular person? His brother Diego perhaps? How did he know when a figure was finished?

Eventually there was a pause, and he turned to greet me as though he had forgotten I was there. This was my moment, I thought. I had my note-pad ready. The questions were piling up in my head. I started with a simple one to get things going – 'How do you begin a piece? What sets you going?'

He looked at me for a moment, then gave a shrug. '*Il faut savoir le truc!*' ('You need to get the knack of it!') was all he said. And he turned back to the figure he was modelling, humming to himself as his fingers continued to mould and mash the clay on a face which was suddenly looking remarkably like his own.

I still vividly recall the briefest interview I have ever conducted. The lesson it taught me was that artists, like bakers, often prefer to keep their secrets to themselves.

5 A bizarre fashion of the 1960s and 70s was 'Op Art' – abstract paintings which tantalised the eye with optical illusions of depth and colour. Just a few artists rose above the banality of these kinetic games to explore more subtle areas of human perception; in England Bridget Riley in particular.

But the supreme monarch of Op Art was the Hungarian-born Frenchman **Victor Vasarely**, who had risen through the ranks of advertising and graphic design, and was responsible for the logo on Renault cars using the optical trick of 'the impossible square'. Every time I was in Paris there seemed to be an exhibition of Vasarely's latest eye-dazzlers, which I began to find mesmerisingly beautiful, often playing with the changing effect of a single colour – gold, deep purple or livid green – when placed in different contexts of shape and colour. Then in 1977 I learnt that there was to be a permanent collection of his work set in a Renaissance palace in Aix-en-Provence, not far from the artist's home near Gordes. Known as the Fondation Vasarely, it was to be formally opened by the French President, Georges Pompidou, a great admirer of the artist's work.

My editor on the *Telegraph Magazine* liked the idea of an artist who had designed the logo for a car, and gave me the nod. With a photographer I flew out to Marseille and drove up to the rocky plateau of the Luberon and the picturesque hill-village of Gordes. Vasarely's Paris dealer had organised our visit and given me instructions on how to find the house. We were invited to lunch, but were requested to arrive mid-morning to allow time for a photo session. After lunch, I was informed, Monsieur Vasarely would be happy to answer any questions I chose to put to him. It all sounded alarmingly well-packaged.

The house had been created within a cluster of dry-stone beehive-like constructions typical of the Luberon region, called *boris*, of indeterminate antiquity and originally used by shepherds, now a folkloric attraction for tourists. Vasarely and his wife greeted us courteously, he elegantly dressed in a silk shirt and immaculately-ironed white trousers, which somehow made me think of his painted black-and-white shapes. There followed the scheduled photo session, which Vasarely clearly enjoyed, while I spent the hour before lunch exploring the rocky landscape around the house and trying to decide what

I wanted to ask him when it came to my turn. The more I searched for ideas the more I recognised that however much I enjoyed his work, I found it almost impossible to explain why. There were kinds of art which defied being written about. Silence was enough. Yet here I was . . . I was not looking forward to the afternoon.

Lunch was late, due largely to my tireless photographer, who had found in Vasarely a willing accomplice. Around three-thirty, over coffee, as I was bracing myself for the interview, two men appeared at the open door. One of them was carrying a canvas bag which made metallic sounds as he entered the room. Vasarely rose to greet them, then introduced me. They were the butcher from Gordes and his nephew. And they came every Sunday, he explained. Would I care to join them? It would make two teams of two. Did I know how to play *boules?* Never mind, Marius would show me. So, with a mixture of apprehension and relief I teamed up with Marius, while Vasarely partnered the young nephew. We marked out the appropriate semi-circles with our shoes in the rough gravelled area outside the house, with the pine-covered landscape of Provence spreading out before us.

I did my best, trying to emulate the approved posture with knees slightly bent and a graceful flick of the wrist as I let go of the *boule*. Vasarely had mastered the gestures and grunts of the game like a native Provençal, and was clearly keen to beat his friend and rival, the butcher, as well as show the young foreigner who was boss around here. The afternoon passed with a certain tension in the air. There was little conversation. By five o'clock the game was all but over. It was my turn. Marius explained that the only hope was to knock Vasarely's *boule* clean off the court. He gave me a wry smile as he handed me my *boule*. I wiped it with a cloth in the appropriate fashion, bent my legs, twisted my hips slightly to the right, then as gracefully as I could flicked the *boule* in a gentle parabola towards the far end. It seemed to pause in the air as if taking aim, until a second later there was a sharp click and Vasarely's *boule* disappeared into the vine-terraces below.

There have been a few heroic moments in my life, and it was beyond me to explain to a gleeful Marius that for an Englishmen who has spent his youth hurling a cricket ball into a wicket-keeper's gloves from the boundary, lobbing a *boule* on target was child's-play. Or so I told myself.

Vasarely was not amused. He glanced at his watch and announced that he was due in Aix-en-Provence to prepare for the French president's forthcoming opening of his Fondation. So there never was an interview. Neither do I have any record of what I wrote for the *Telegraph Magazine*, though I do have a memory of some striking photographs of the immaculate Master of Op Art at work in his idyllic setting of mediaeval stone huts amid the golden landscape of Provence.

Strange Encounters

1 Like other 'most beautiful villages of France' Les Baux-de-Provence is dead once the tourist buses leave. But it certainly wasn't dead in September 1959. A French friend of mine in Paris had been lent a *mas* – a fairly basic stone farmhouse consisting of two or three rooms and a butane gas cooker, but not much else except a spectacular view from the Alpilles mountains right down to the Mediterranean and the distant lights of Marseille. Would I care to join him and his wife for a week's holiday? And if so might I be prepared to pick them up in Paris and drive them down to Provence? I was unattached, and this seemed a cheerful adventure in the company of people I liked.

I had a small Austin Healey sports car in my bachelor days, and somehow the three of us crammed into it and optimistically headed south. When we arrived, aching and tired, accommodation proved to be primitive and I elected to sleep in a tent which I'd brought with me as a wise precaution. I slept soundly and would wake to the sound of goat bells and the cry of eagles circling overhead. Then I'd wash in the nearby stream before taking an early walk across sun-baked hillsides amid the scent of wild thyme with every step. Later, the three of us would explore the village of Les Baux, huddled below the gaunt ruined château and bastion of the former lords of Baux.

September 14th was my twenty-sixth birthday. My Parisian hosts organised a barbecue on an improvised bonfire and invited several friends who lived not far away in Montpellier. One of these was an attractive dark-haired girl called Catherine. I suspected that my friend was match-making. Certainly I had never imagined until that evening that rescuing chunks of charred lamb from a bonfire could be a bonding experience. As darkness fell, and we were standing round the fire drinking wine and nursing burnt fingers, I noticed strange lights flashing on and off in the direction of the village, accompanied by raised voices that seemed amplified by the darkness.

'Shall we go and look?' I said, seizing my chance. Catherine smiled, and together we walked off into the night. It was a romantic adventure for about twenty minutes. Climbing up towards the village we reached a platform overlooking the valley below, known as the *Vallée d'Enfer*. I had seen it before – but never like this. The valley was swamped in floodlight, every rock face and peak picked out. And down below us was a crowd of figures, all of them dressed in a variety of strange costumes and headgear. Some wore togas, other were in Roman armour carrying shields and swords, others semi-naked in loin-cloths and sandals. I glanced at Catherine, but her face in the glare of the lights told me nothing. I suggested we go closer to the action, whereupon she

took my arm rather formally and we made our way down the road towards the crowd of figures in weird costumes.

It was obvious by now that some sort of filming was in progress. Cameras were set up here and there, yet work seemed to be finished for the day, and people were dispersing or gathered around talking. Then I noticed a small group were in ordinary day-to-day clothes. As we approached I was astonished to see a face I recognised. It could only be Yul Brynner. What the hell was he doing here? And next to him stood a tiny woman I knew instantly from dozens of record sleeves. Could it really be Edith Piaf? Next to her stood a tall dark-haired figure dressed incongruously in an elegant black suit. 'D'you recognise him?' Catherine asked suddenly. I shook my head. 'That's Luis Dominguin,' she said casually. 'The great bullfighter,' she added in case I was ignorant of such things, being British. 'I'm surprised Hemingway isn't here.'

If I was baffled before, I was now even more so. At this point a hooded figure in a white robe walked past us. He paused as he caught sight of Catherine and removed his hood, revealing a shock of grey hair. I found myself thinking quite calmly 'I am standing next to Jean Cocteau.' He leaned forward and kissed Catherine's hand gallantly, then moved on, joined by a younger man I recognised to be the actor Jean Marais, Cocteau's lover and muse. 'A friend of my father's,' was all Catherine said.

Instead of a moonlight walk with a girl on in the Provençal night I had stumbled on the set of what was to be Jean Cocteau's last film. *Le Testament d'Orphée,* an autobiographical fantasy with Cocteau the poet, is lost in time and space as he looks back at his life and work, bringing in characters and incidents from his most celebrated film *Orphée* made ten years earlier.

Catherine had enjoyed my bewilderment, she said laughing as we made our way down the hill towards the *mas* and the last glow of the barbecue bonfire. She was surprised I had no idea it was being filmed in Les Baux, she said. As for Yul Brynner, Edith Piaf and Dominguin, they are all putting in an appearance in the film as friends of Cocteau, she explained. 'Piaf surprisingly so, you might think, but he loves her and her voice. Picasso's in it too,' she went on. 'I'm surprised he wasn't there … I hope you had a happy birthday?' she added.

I had – even if it wasn't quite the romantic evening I'd dreamed of two hours before.

Catherine married a *gardien* in the Camargue, helping him round up black bulls and corral wild horses. I caught up with her forty-seven years later when I was writing a book on the history of the Camargue. I brought her a bottle of champagne and we toasted Jean

Cocteau, by now long dead. It was Catherine who told me that he had died of a heart attack in 1965 one day after the death of Edith Piaf. 'You can't always tell about people, can you?' she said.

2 For people of my generation, children of the Second World War, modern art came like the invasion Hitler had failed to mount. This was the late-1940s and 50s. We were teenagers and the storm-troopers were led by Picasso and Matisse. Britain was largely unprepared, and Dad's Army was led by the Royal Academy President Sir Alfred Munnings, who delivered a celebrated broadside on the radio proclaiming that Cézanne and his followers like Picasso had 'corrupted art'.

This was my introduction to the trench-warfare of art criticism. But not all was lost to the traditionalists. Modernists did have a few home-bred champions, and the leading one – well, not exactly home-bred, but Irish – was Francis Bacon. The painting he was best known for in those post-war years was a triptych entitled *Three Studies for Figures at the Base of a Crucifixion*. Against a livid orange background it consists of three humanoid fragments looking as if they have been retrieved from a butcher's block, grimacing hideously in pain or grief. It is a painting that makes a crude reference to Picasso's *Guernica* and to Grünewald's *Isenheim Altarpiece*. It is revolting, and was supposed to be. I shudder to think what Sir Alfred Munnings thought about it.

Bacon's reputation for disturbing our sensibilities with one scatological image after another flourished throughout the 1960s and 70s. He became universally lauded, and enjoyed a series of major retrospective exhibitions both here and in Paris and New York. He was a megastar in the art world. I knew him only slightly. He could often be encountered seated by the entrance to one of his exhibitions, immaculately dressed and entirely charming as he explained with great lucidity what his work was about to anyone who cared to approach him. It cannot have been in greater contrast to the subject matter of his paintings or to his gay and drug-stained lifestyle, or to the volcanic disorder of his studio.

One day, in the autumn of 1984, I was correcting proofs in the offices of the *Telegraph Magazine* when the editor, John Anstey, called me into his room and handed me a letter he had received. It was on two pages, handwritten, with no heading or address, and

signed semi-illegibly in capital letters that seemed to read 'W. Manners'. The letter began, 'Dear Sir, I wonder, as I have often wondered over the past two decades, why the truth about Francis Bacon has never been revealed.'

I sat down on the far side of the editor's desk and read on while John sat with arms folded with an intrigued smile on his face. The writer explained that in the 1940s a student-friend at the Royal College of Art described how 'young Francis', though not a student at the college himself, became part of the 'gay' circle of the artist John Minton, then a junior member of the staff. To senior tutors at the college, in particular the formidable Ruskin Spear, Bacon was 'a bit of a joke, a hanger-on full of fascinating yarns about his Irish childhood, and who was now eking out a precarious existence with hand-outs from Minton and from anyone who cared to use his services as a sleeping-companion.'

In an impish mood, Ruskin Spear and another senior member of the staff, possibly Robert Buhler, decided to perpetrate a practical joke at the expense of the modern movement. They decided to invent a modern painter. And Francis Bacon was chosen as the figure on whom they would bestow *significance*. This they would do by working over the young man's 'ineffective attempts at painting.' From one of his portraits the head was removed and replaced by a machine-gun. But the real test case, the letter explained, was the re-working of three large canvases 'which originally were paintings of male sex organs'. These were carefully altered into weird biomorphic forms 'with the addition of ghoulish details such as tiny teeth etc. which soon endowed them with mystical overtones. Under the influential power of such leading figures of the Royal Collage of Art there was little difficulty in getting the work exhibited and written about.'

I was reading this with ever-growing astonishment. The writer was describing the genesis of the most celebrated modernist painting to come out of post-war Britain.

The joke succeeded 'beyond its perpetrators' wildest dreams,' the letter continued. 'Over the next decades so-called Francis Bacon paintings were produced by these two professionals with great ease and much mirth, and released on to the art market at suitably spaced intervals. Francis was meanwhile free to indulge in his Irish drinking and gambling pastimes. And the profits were presumably shared. So I feel it is high time,' the letter concluded, 'that Ruskin Spear and his colleague are given due credit.'

From the look on John Anstey's face it was clear he would love to publish the letter. Every good editor enjoys creating a stir. But first he was keen to know if there was a chance of the claim being true. And this was where I came in. What did I think, he asked? My instinct was that the letter was a hoax and that it was *The Daily Telegraph* that

was in danger of being hoaxed, not the art public. But I would make some enquiries, I assured John. I knew Ruskin Spear slightly; a larger-than-life figure with a rich sense of humour and – more to the point –possessing exceptional technical gifts as an artist which would certainly make him capable of imitating the style of almost any painter. I began to suspect this was why he was nominated as the perpetrator of the hoax. Unless of course, it began to occur to me, he really was the hoaxer.

Ruskin was now well into his seventies and long retired from the Royal College. He was a deeply respected Royal Academician and it was the R.A. who gave me his phone number. I decided I had no option but to tell him about the letter, read it to him over the phone, ask him if it was true, then duck behind the parapet.

A growling voice answered the phone. I nervously reminded Ruskin of where we had met. Then I told him the story and read him the letter. There was a heavy pause, followed by choking noises down the telephone, and then an explosion of laughter. 'I love it!' he bellowed. 'I do wish you'd publish it.' There were more gales of laughter. Then, before I could utter another word he bellowed 'I have to go now.'

That was it. I was left wondering if he would like the letter published because he could then sue *The Daily Telegraph* for millions, or perhaps because it would give him worldwide fame, long overdue.

At this stage I sought wise counsel. Ronald Alley had been Keeper of the Modern Collection at the Tate Gallery in London for many years, and a trusted friend since the 60s. I showed Ronald the letter. He took his time reading it, uttering the occasional grunt. 'Well, Edwin,' he said eventually. 'I've been to Francis' studio many times while he's been painting and there's never been a sign of Ruskin Spear. Secondly, if you think what a Francis Bacon canvas goes for, I imagine the taxman would have been banging on Ruskin's door for the last twenty years. Draw your own conclusion.'

The letter was never published.

3 I have been tempted to call this piece 'How I brought down a Tory government by accident.' Well, read on.

One of the most agreeable tasks in my four-year stint on *The Illustrated London News* was making a weekly tour of the London art galleries and auction houses. I would find out about forthcoming exhibitions or sales and bring back a selection of photos.

Then I would wait for the editor, eighty-three-year-old Sir Bruce Ingram, to return from his lunch at the Ivy and put his head round the door with, 'So, what have you got for me this week, Edwin?' With the inevitable cigarette between his lips he would pore over the pictures and lay out the art pages for next week's edition. And I would go back to my typewriter and make sense of his choices with an accompanying text. Between writing short obituaries and editing the natural history column, this was my week.

In July 1960 one of my morning forays took me to the Wildenstein Gallery in New Bond Street. I had be doing this job for almost two years and had got to know most of the gallery people, including the manager at Wildenstein's, a reserved character called Brian Foster. On this occasion he took me aside to show me the work of the artist who was exhibiting here next. They were all portraits, mostly pastels or drawings, skilfully executed, some of them striking likenesses of people who were well-known public figures. I said I'd be happy to show some photographs of the artist's work to my editor and I left with a sheaf of them.

That afternoon I laid them in front of Sir Bruce, who was surprisingly impressed. The *ILN,* in its endearing old-fashioned way, sometimes liked to devote an entire page to a portrait of some prominent figure in the news. As a collector of Old Master drawings himself, Sir Bruce enjoyed doing his bit as patron of the graphic arts. It transpired that he was unhappy with the rather timid lady artist who currently did the job. He was keen to find someone with a bit more verve, he explained. Perhaps this gentleman might fit the role. What was his name, he asked?

I explained that he was not actually a professional artist, though I understood he had studied at the Slade School. He was actually a successful osteopath who sometimes enjoyed making portraits of his patients, many of whom were people of some distinction, as Sir Bruce had noticed. I got the impression that socially he was something of a high-flyer. His name was Stephen Ward.

'Well, take him out to lunch and sound him out, Edwin,' was the editor's response. 'See if he strikes you as the right man for the job.'

I had never been to the Caprice, but that was where Brian Foster at Wildenstein's suggested would be most appropriate when I told him of my editor's idea. And he got on the phone and proceeded to arrange it with the artist on the phone then and there. 'Mr Ward sounded delighted,' he said as he put the phone down. 'You'll enjoy Stephen,' he added. 'A most charming man.'

He was right. The lunch could not have been easier or more agreeable. Stephen's

charm was warm and polished, spiced with gentle indiscretions about some of his better-known patients, which had the desired effect of demonstrating just how well-connected he was. He talked with particular affection about his friend Lord Astor whose country mansion at Cliveden in Buckingham was the most enjoyable of social venues, and how his lordship allowed him to rent for a nominal sum the nearby cottage by the Thames and to use the swimming pool nearby. His face brightened as he alluded to the glamorous summer parties that were held there. It was becoming clear that the life of a society osteopath had its touch of *dolce vita*. Stephen was very evidently not a married man.

I cannot recall if the editor ever met Stephen. Probably not. But I do remember clearly Sir Bruce drawing up a short list of people he wanted Stephen to draw for the paper, and directing me to make the necessary arrangements. 'You should have little problem, Edwin,' he assured me. 'Most people in the public eye are deeply vain.' His list included a number of royals, among them Princess Margaret and the Duchess of Kent. But the first session I was instructed to set up was with a politician who had just been appointed Secretary of State for War by the Prime Minister Harold Macmillan. He was John Profumo, who I was only aware of because he had not long before married a favourite British actress, Valerie Hobson.

It was not hard to arrange. The sitting was to be in Whitehall during the minister's lunch-break. Stephen was known to work fast and I had no need to be present. All went well, he assured me on the telephone, and Stephen and I lunched again at the Caprice where he handed me the portrait in a large folder. Sir Bruce was delighted when he saw it. I passed on the editor's congratulations to Stephen, and we had another lunch, this time at the Chelsea Arts Club where we celebrated with a bottle of champagne, and where I handed him a list of further subjects Sir Bruce would like him to draw. I promised I would set up sittings for him whenever it was mutually convenient, and everything could be confirmed by telephone so as not to take up too much of his time.

I had an instinct after that lunch that I wouldn't see Stephen again. And so it turned out. We communicated from time to time on the phone, confirming arrangements, and his portraits would regularly arrive by taxi. And so it went on for several years. We often planned to have lunch together again, but somehow it never happened.

Then, early in 1963, along with most of the nation, I began to read about him. I had left the *ILN* by this time and it was in the bustling offices of *The Sunday Telegraph* in Fleet Street that week by week I followed the course of the most notorious political scandal in postwar Britain. As events unfolded and I went about my business as the paper's art critic,

it felt as though I was witnessing an improbable melodrama which I had inadvertently set in motion simply by bringing two people together in the harmless cause of a portrait.

Since that time the Profumo Affair has occupied acres of newsprint and been the subject of countless books, documentaries, dramatisations and unceasing debate about the rights and wrongs of the protagonists. But in that summer of 1963 the news struck like a series of tidal waves. John Profumo suddenly resigned from parliament after admitting to having lied to the House of Commons about his affair with Christine Keeler who was also having an affair with a Soviet diplomat – the link in this sordid chain being none other than Stephen Ward.

In June of that year, Ward was convicted of living on immoral earnings and committed suicide on August 3rd. I felt sad, and appalled. From the little I knew of Stephen he had struck me as a social climber and a sybaritic innocent: sexually a voyeur, but certainly not a parasite. In the end a man far more sinned against than sinning.

As for the aftermath, political commentators have maintained that the Conservative government could never remove the stain of the Profumo Affair. After the resignation of Harold Macmillan through illness, the general election of the following year saw the Conservatives lose power to Harold Wilson's Labour Party for the next six years.

4 A group of small woodcuts on the wall outside our kitchen often catch visitors' eyes. One of them is a wintry scene of a lone stag with its head raised in the mist. Another is of two wolves peering watchfully from the undergrowth into the half light. Occasionally a guest has been drawn to peer more closely, and been perplexed to read below the image of the stag: 'STALJE, 4.45 a.m.' and beneath the two wolves 'ULICKRIVE 4.00 a.m.'

I have only a vague idea where such unpronounceable places may be, though the artist did once tell me. He was Swiss, by the name of Robert Hainard, and he was staying with us in London in the early 1970s, where an exhibition of his work was being held at the Tryon Gallery in Cork Street, specialising in wildlife art. I need to qualify 'staying with us' because Hainard was actually sleeping in the garden. Aylmer Tryon, who owned the gallery, had begged me to put Robert up since he loathed hotels and invariably chose to sleep in the open if he was away from home. He often worked at night anyway, hence

the inscriptions on my woodcuts. Robert liked nothing more than to roam the Alps or the Carpathian mountains and lay his sleeping-bag where he could keep one eye open for passing creatures of the night, which he could then hastily draw. He would use some of these sketches to make woodcuts.

I had met Robert Hainard when I was a guest in Aylmer Tryon's beautiful mill-house near Salisbury. At the same time Robert was a guest in Aylmer's garden. We both had the same project in mind. Aylmer had been given permission by the Ministry of Defence to use a section of Salisbury Plain for a wildlife enterprise that was particularly close to his heart. This was the re-introduction of one of Europe's largest native birds long ago shot to extinction in these islands – the Great Bustard. The area concerned was Porton Down, an enclosed area of 7,000 acres given over to 'military research' of a top-secret nature no one was supposed to know about, let alone use for a private venture involving a large bird. But Tryon was not The Hon. Aylmer for nothing. The current director of Porton Down had been at Eton with him, and the British Ambassador to Portugal was a cousin. The former thought the Great Bustard scheme a splendid idea since the birds would be protected by the high security enjoyed by the place; while the latter had access to a private estate in Portugal frequented by the birds, which could be trapped by local gamekeepers and flown to Britain in a diplomatic bag. As Aylmer drove us past the open gates of Porton Down to a military salute, I found myself savouring my first experience of the English Establishment triumphant.

Robert Hainard seemed to take it all in his stride. I watched him deftly sketching the movements of the giant bird, who responded to his attentions by displaying its magnificent tail feathers in peacock fashion. It was remarkably tame for a wild bird that had just been netted in the Portguese sierras and flown here in a diplomatic bag. Aylmer even had a name for it – Percy. And he would feed it corn from his hand while the bird wound itself round his legs. No wonder the Great Bustard had been shot to extinction.

After the exhibition in Aylmer's gallery I came back with Hainard's precious woodcuts of wolves in the dawn and a lone stag in the mist, which I had just bought. I couldn't help reflecting on the sharp divisions that severed the art world – then in the 1970s just as they do today. I knew no one writing seriously about contemporary art at that time who would give a second thought, or even a first thought, to this dedicated artist whose undying ambition was to spend his nights on a bare mountain waiting for the chance to sketch a prowling wolf or a stag at bay. On the other side of the divide here was Robert Hainard who, as I drive him to the airport, fulminated against just about every modern

artist since Cézanne he could think of. Never the twain shall meet.

Before he left Robert invited me to visit him where he lived, a short distance from Geneva. By this time I knew that besides being a leading wildlife artist he was also a prominent conservationist. His most recent achievement, he explained, was to have re-introduced beavers to the Camargue in southern France, also into the forest close to where he lived in Switzerland. He would very much enjoy showing me where they now thrived.

This struck me as an ideal story for the *Telegraph Magazine*. John Anstey, my editor, agreed and assigned me a young photographer, John Perkins, and together, that autumn, we flew out to Geneva to stay with Hainard. I was surprised to find that he actually lived in a conventional suburban house with a gracious wife who produced a delicious dinner for the four of us, then disappeared. As John and I sat by the log fire drinking coffee, Robert cleared a space at the table and laid out a sketchpad, several chisels and a block of wood which I could see was already partly carved. He had turned out all the lights in the room except for a powerful reading lamp which he placed beside him. Still not saying a word he began to work on the wooden block, his face scarcely six inches from the chisel in his hand and puckered in concentration.

I realised this must be the regular pattern of his evenings. There is a certain magic about watching a craftsman at work. It is to do with something being created with the human hand before one's eyes. An image being painted can never convey quite the same sense of physical involvement. I watched Robert in his oasis of light working deftly at his woodcut with the same pleasure as when I have watched Bernard Leach creating a bowl on a potter's wheel, or Barbara Hepworth chiselling the thinnest flakes of wood to shape the precise curve she needed on a standing form. I watched Robert until late. He was a man who loved the dark. This was demonstrated forcefully not so many hours later when he appeared at my bedroom door fully dressed to announce, 'Half an hour if you want to see the beavers. I'm making some coffee.' My watch said 4.10.

Robert had already roused John, my photographer. We sipped hot coffee in silence, then Robert herded us into his Deux Chevaux and we sped noisily into the night. Robert explained that beavers are often invisible except at dawn and dusk and we needed to be quiet.

Soon I began to understand how this indomitable man had managed through all the decades of the Cold War to sweep aside the Iron Curtain and wander unhindered across the mountains at night to observe wolves, while other vagrants were being shot or sent to

the gulags – all in the interests of art. The Deux Chevaux pulled up at the main entrance of the Geneva International Airport. Robert waved cheerfully at the guards who peered suspiciously at the number plate, then to my astonishment opened the gate wide and saluted just as I remembered us being received at Porton Down.

As the first streaks of dawn were beginning to lighten the sky Robert set off on a cautious circuit of the airfield, keeping his distance from parked jumbo jets and refuelling tankers. Finally, he pulled up close to the perimeter fence and got out. I watched as he walked over and began to unhook a section of the wire, dragging it apart until the gap was wide enough for his Deux Chevaux. 'They always leave this open for me,' he explained as he got back into the car. And we drove out of the airport into the forest.

As he parked the car there was now just enough light for Robert to lead us through the undergrowth to where a stream wound its way through the trees. He gestured to us to be very quiet, and we made our way cautiously along the bank. Suddenly there it was, a dam made of wooden branches and sizeable logs stretching right across the stream. We stopped. Robert whispered, 'We need to wait.'

What I remember most vividly about the next half hour is the electric intensity surrounding Robert as he worked. The beavers appeared, a pair of them, only their sleek heads above the water, until they scrambled on to the dam dragging lengths of wood to add to the structure, their tails thrashing, their powerful teeth hauling the logs into place, occasionally breaking off to box one another in play. And all this time Robert was filling sheet after sheet of his sketchpad, while John was stalking silently around the area with his camera. It was a duet of utter concentration, as the pair of beavers cavorted and played before our eyes quite unaware.

I never saw Robert again after that most improbable of excursions. Neither did I see what he may have made of it: otherwise, next to STALJE 4.40 and ULICKRIVE 4.00 on our wall a woodcut might today read GENEVA AIRPORT 6.15.

Index

First published by Unicorn,
an imprint of the Unicorn Publishing Group LLP, 2016
101 Wardour Street
London
W1F 0UG

www.unicornpress.org

ISBN 978 1 910787 14 4

10 9 8 7 6 5 4 3 2 1

20/19/17/17/16

Picture Credits
Author's own collection pp: 4,6,21,33,38,47,58,59,60,67,70,76,78,86,92,102,143.
Creative Commons License pp: 8 (Henry Moore Foundation) 16,18,28,40,55,62,87
(poemhunter.com) pp: 107,117,119,128.
National Portrait Gallery pp: 56,65,95,103.

Cover design and typeset by Vivian@Bookscribe
Indexer Nicola Smith
Printed in Spain by GraphyCems